Artists in Print

an introduction to prints and printmaking

Pat Gilmour

British Broadcasting Corporation

Published to accompany the BBC
Continuing Education Television series
Artists in Print produced by Suzanne
Davies. The book was edited by John
Radcliffe. First broadcast on BBC-2 on
Mondays from 9 March 1981

Published to accompany a series of
programmes prepared in consultation
with the BBC Continuing Education
Advisory Council

© The Author 1981
First published 1981

Published by the British Broadcasting
Corporation, 35 Marylebone High Street
London W1M 4AA

This book is set in 10/11pt Ehrhardt
Monophoto
Printed in England by Balding + Mansell
Wisbech, Cambridgeshire

Colour separation by Adroit Limited
Birmingham

ISBN 0 563 16449 2

Contents

Introduction

The word 'print' has many uses: it can describe words written in capitals, type set in books and newspapers, repeat patterns on fabrics, as well as images multiplied in every conceivable manner from a potato cut stamped on paper by a child at school, to complex photo-mechanically made colour pictures utilising equipment costing thousands of pounds. A print may be mass-produced in half a million copies, or preciously confined to a limited edition. Photographs are prints, stamps are prints, cheap reproductions of Van Gogh's paintings are prints, so are rare and priceless Rembrandt etchings.

Historically the role prints played in conveying information was of far more importance than the occasional interest an artist may have taken in printmaking for its own sake. The scientific revolution would not have taken place without exactly repeatable pictures.

Before photography was discovered in 1839, artists' prints were used mostly to circulate information about unique paintings and sculptures, rather than to express original ideas. But when the camera took over the job of reproduction, artists began to realise that printmaking could become a primary and independent means of expression. In many ways, the results were beneficial. As artists became more and more personally involved, there was a tremendous inventive expansion in printmaking techniques. In other ways, however, reaction to the shock of photography was defensive. Reproduction, which had been an honourable pursuit, became, in competition with the original print, a dirty word. Photomechanical procedures, which we now realise can be used as creatively as any others, were outlawed. Mystique, worship of the personal gesture, the artificial limitation of edition size which restricted the print's potential for democratic distribution, were among the results of an élite connoisseurship that grew up from the mid-nineteenth century. It was only during the 1960s that this glorification of the hand-made diminished, and artists established the right to communicate whatever they wanted to say, using whatever technology they could afford to command.

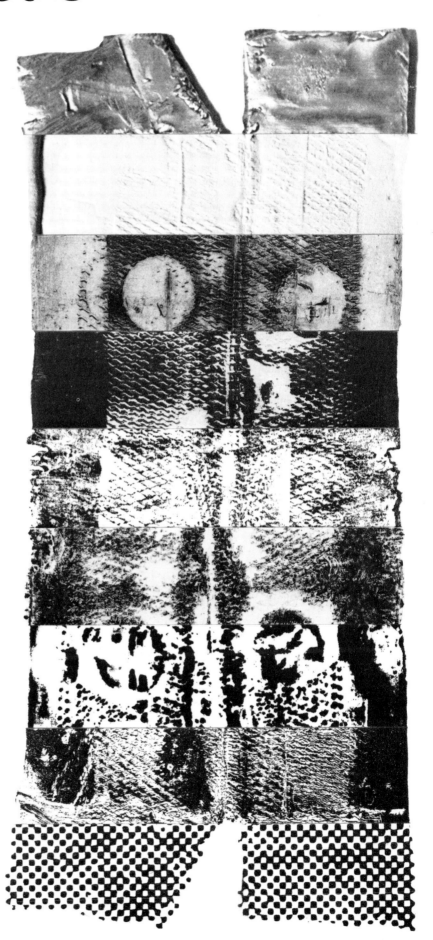

Whereas a painting or drawing is made directly, an artist works on a print at one remove, fashioning what an engineer would call a 'tool' (or a set of tools in the case of colour) in order to produce a series of identical images. The 'tool' (the printing block, plate, or screen) is not the original. Indeed, it might be difficult to connect it with the image it is able to print; it is merely a means to an end. The advantage of making the tool is that it is possible with it to produce many impressions, each of which can be sold at a fraction of the price of a unique painting. This widens the artist's influence and gives

even relatively hard up people a chance to live with art in their own homes.

The three major traditional techniques can best be described by imagining that a simple black line is to be printed by each. In a *relief print* the ink is conveyed to paper by means of a ridge of wood left standing in the block after surrounding areas have been cut away. An *intaglio* line is printed from an incision in a metal plate. This is made either by engraving the metal directly with sharp pointed instruments, or allowing acid to etch the incision. A *lithographic* line is printed from a mark crayoned or painted in a

greasy medium on a slab of porous limestone, or nowadays a metal plate grained to resemble it. The printing surface has neither ridge nor indentation, but is chemically treated so that only the greasy line will carry ink. These three hand processes were used for all printing before the commercial developments of letterpress, rotogravure and offset lithography superseded them.

The metal plate used to make the images running along the bottom of these introductory pages was not specially made as that for an artist's print would be, but was picked up off

1 The aluminium plate used to print this sequence of nine images, has been reproduced by *photolithography* – the technique used throughout this book. A photograph of the object has been converted into a dot system by rephotographing it through a criss-cross grid having 155 lines ruled to each inch. The way the dots are distributed – thickly to suggest dark passages, thinly to suggest light ones – gives an illusion of tonal gradation. This dot system, just visible to the naked eye, is called half tone. It is normal in photographic reproduction whatever printing process is used.

2 The metal plate has now been directly printed by *intaglio* process. Using an etching press which exerts a pressure of several hundred pounds per square inch, the plate has been impressed into a thick sheet of slightly dampened paper. The negative incisions in the surface of the metal have become a positive cast in the paper and stand proud as raised lines in the print. When, as here, no ink has been used, such a method is called blind embossing. The rough paper has been made smoother where the plate was driven into it; the impression left by it is a hallmark of intaglio printing.

3 The *intaglio* method is repeated. This time a stiff *etching* ink has been daubed all over the plate, then mostly wiped away, leaving a deposit in the incisions and a slight film on the surface of the metal. This ink is transferred to dampened paper under heavy pressure. A finger drawn across the surface of the original (as opposed to this reproduction of it) would detect the indented platemark and within it the raised structure of the image. This becomes a positive cast of paper topped by ink. The fine film of ink on the surface of the metal transfers to the paper as a lighter tone.

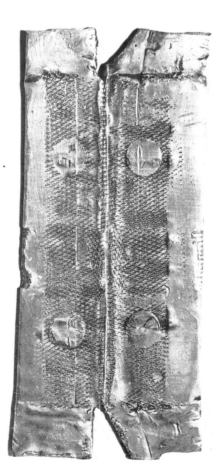

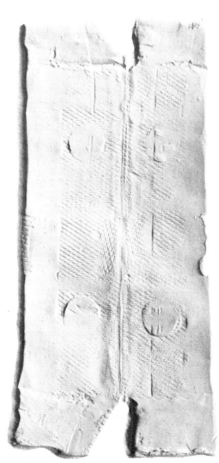

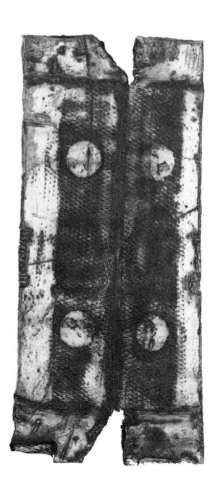

the floor of a metal workshop. A simple rectangular offcut of sheet aluminium, it had been right-angled round the jaws of a vice as a protective cladding. After being hammered flat it still bore on its surface serrations and screw hole marks from the vice's hardened steel jaws.

Using this readymade plate, it has been possible to demonstrate a range of printing methods related to each of the four major processes. If one imagines the added seduction of colour, or the way drawings from the object could be translated into woodcuts, etchings or lithographs, one

begins to appreciate the range of possibilities open to printmakers. Such possibilities are the subject of this book.

The captions to each of the images reproduced here describe how the prints were originally made. These photolithographic reproductions of them however, no matter how much care the printer of the book lavishes on them, can only roughly approximate the originals. Nine varied representations from a single source nevertheless provide a fascinating insight into the extent to which any information is conditioned by the medium

through which it is relayed. The reader will not be able to feel a platemark on images 2 and 3, nor is one ink deposit actually thinner or thicker than any other. The subtle difference in the originals between one black ink and another, the varying weights and shades of paper from deep cream to pure white, have inevitably to be conveyed in this book by one ink and one paper. Only by putting these pages through eight other printing processes, a prohibitively expensive undertaking, could the results have been otherwise.

The three traditional techniques already described were joined at the

4 This time the plate has been printed as a *relief* print. It has been inked with a rich black letterpress ink applied to the surface by roller. The ink does not fill the incisions and can be transferred to paper by a platen press, or even by direct rubbing. Much less pressure is needed to transfer ink from a relief surface than from the intaglio incisions in the plate. For that reason, relief blocks do not obviously emboss the paper or leave a platemark in it.

5 A second *relief* print has been printed, this time in imitation of the Japanese. The ink has been thinned and brushed (rather than rolled) on to the surface of the metal. A sheet of soft mulberry paper has then been placed over it and the image has been transferred by gently rubbing it with the softest part of the hand, being careful not to shift the paper meantime. The Japanese use rice paste inks printed from wood and a special pad called a baren to burnish the back of the paper.

6 For this print, the metal was inked with *lithographic* ink. The impression was taken first on a sheet of plastic and then 'offset', or transferred onwards from the plastic to a sheet of paper. The film of ink is thus thinner than that deposited by most other processes. Nor is the image reversed (as it was in direct prints 2–5) because it has turned twice – once when it went to the plastic and then again when it transferred to paper. The *offset lithography* in this book is based on the same principle.

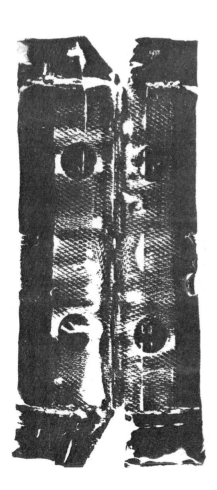 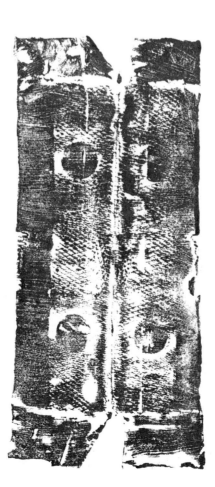 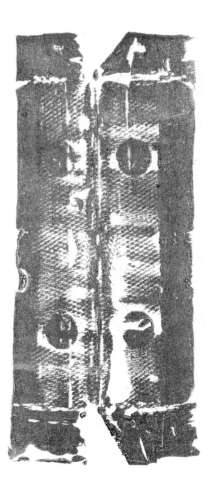

beginning of this century by a fourth, called screenprinting. Used in particular for advertising, it was despised as an artists' medium until a generation of Pop painters took it up in the 1960s. Since that time, artists have used photographic images in all printmaking techniques and have even editioned photographs themselves, to the extent that the false distinction between fine art and other kinds of printing could begin to break down.

Art has many uses. It has been propagated by the state for its reputed moral uplift, although the way it is marketed frequently makes it seem a mere money-making device for the greedy. It is often hung on the wall not for any essential qualities, but to demonstrate its owner's superior taste. Yet if it is important at all, it is surely because it is one of the ways men try to communicate with one another; about being human, about shape and colour and the ways these are perceived, not to mention the life of the imagination.

Unless the artist designs directly in the reproductive process, commercial printers are unlikely to be able to convey the nuances and subtleties that fine artists think it important to spend their working lives cultivating.

Although it is to some extent true that the marketing of hand-made prints has often been guided by an élitist response to photography, the sensitivity artists now bring to all processes can be interpreted as a resistance to standardisation in modern life.

While this book describes the various ways artists have made and still make prints, it also suggests there is something essentially worthwhile in creative activity, and that, moreover, professional artists need not have a monopoly on it.

7 The images on this page are *screenprints* – a development of stencilling. Buttery ink has been wiped with a blade called a squeegee through the open parts of a fabric mesh stretched taut on a frame and set down on a sheet of paper. To make the screen for this print, the metal plate was placed beneath the fabric. An impression was taken by rubbing the mesh on top of the metal with a wax crayon, much as one would make a brass rubbing. A water-based glue, repelled by the wax, was then used to fill the pores of the mesh. When the glue dried, the wax rubbing was removed with a solvent so the ink could be wiped through the open spaces in the glue stencil that the wax had once occupied.

8 One photomechanical print does not necessarily look like another, for the controlling artist or technician can affect the image at all stages. A 35mm photographic negative made from the metal object has here been enlarged to 115 mm height, using a special high-contrast film to produce a transparency bearing an opaque black image with no intermediate tones. This image is contact-printed on to a thin layer of light-sensitive gelatine, later to become the *screenprinting* stencil. Light hardens the gelatine except in those places where the dark image has protected it. The protected areas are later dissolved away to allow the passage of ink when the gelatine is taken from its temporary support and adhered to the screen mesh.

9 The tonal range an artist might achieve by hand drawing can only be suggested in a monochrome photomechanical print by illusion, as shown in print no 1. In this print, the image has been translated into a system of dots once again, but this *photoscreenprint* uses a very coarse and obvious half-tone dot which quite transforms it. It is interesting to compare this much more abstract image with the first print which is closer to photographic realism. In fact, however, all printed images are two-dimensional abstractions.

Relief

History of relief printing

Many people make relief prints every day without realising it. For dirty thumbprints, a rubber date stamp, or even typewriter keys employ the relief principle – that of a mark made by an upstanding surface after surrounding material has been cleared away.

Relief printing evolved slowly over several centuries. The Chinese had paper and made prints on it with wood blocks long before the West. In Europe the process probably began in the Bavarian region. As well as being used on textiles and for books, woodcuts provided separate sheets for distribution. Medieval man, for the most part unable to read, must nevertheless have enjoyed pictures.

Relatively few have survived, and then often only by being pasted into manuscripts and books, as was the famous 'St Christopher'. For a century this was called the earliest dated print – until an earlier one was found. The extent to which such devotional images were copied makes scholars distrust any date before the mid-fifteenth century, even though this one bears the Latin inscription 'millesimo cccc xx tercio', or 1423. It shows St Christopher striding with the Christ Child on his shoulders through the waters of a small bay.

People believed the saint acted as a charm against sudden and therefore unsanctified death, so he was very popular. Nearly a century later he is featured again in a chiaroscuro print by the German, Lucas Cranach. Such woodcuts (the term comes from the Italian words for light and dark) represent the earliest printed colour, for hand colouring within the printed black outline was more usual. Here, cloud and highlighting have been cut away from the block printing the middle tone so that they show as unprinted paper; then a second block carrying the black outline has been overprinted. Since we know from records that Cranach's coat of arms was not granted until 1508 it seems the artist faked the earlier date on it possibly to try and establish that he beat the Italians to colour printing.

1 ANON *St Christopher* woodcut 1423

2 L. CRANACH *St Christopher* chiaroscuro woodcut 1509

1

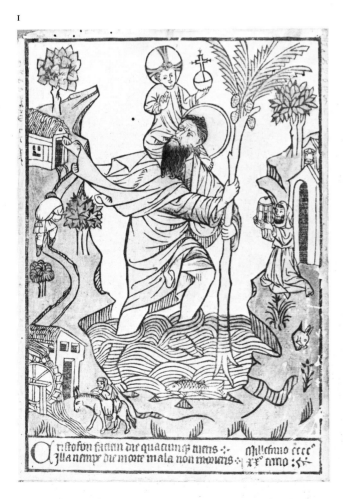

2

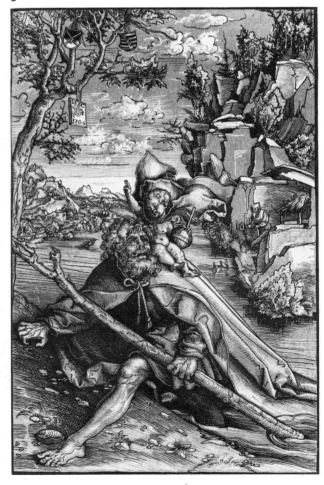

If woodcuts, as portable altarpieces and souvenirs of pilgrimages, helped comfort man and exhort him to live and die well, they also had a secular use – gambling. A woodcut outline, sometimes filled in with stencilled colour, was used to print playing cards. Those illustrated are French humanist cards of 1544 in which our usual suits are replaced by symbols for four classical authors – including Cupid to represent Ovid the erotic poet. The muses inspiring poets represent the Queens, while an appropriate number of lines from each author indicate values from ace to ten in each suit.

Metal was occasionally used for early relief prints, including those called 'dotted prints' which date from the second half of the fifteenth century. A tool called the burin would be used to engrave lines while various punches – dots, rings, stars and other ornaments – were hammered into the soft metal used, often pewter. In this print, only three copies of which have survived, Christ, accompanied by sleeping disciples, is seen praying just before Judas betrays him.

The German artist, Dürer, one of the outstanding graphic artists of all time, made this woodcut for a suite about the life of the Virgin Mary. It was published in 1511 after Dürer's second trip to Italy during which he finally mastered perhaps the most important lessons contemporary Italians had to teach him about constructing an illusion of space by means of perspective. The design ranges brilliantly from whites where the wood has been totally cleared, through parallel hatching which models rotundities and hollows, to densest crosshatching (difficult to cut in relief) in the shadows. Dürer evolved the tonal gradations in this, his mature style, after making dark pen drawings heightened in white on a blue tinted paper. The range he achieved made colour printing largely irrelevant. The artist and his cutters took the woodcut, made by knife and gouge on plank, about as far as it could go, obtaining a wealth of detail subsequent artists were virtually unable to improve upon, unless in intaglio prints from incisions in smooth metal instead of the relatively coarse and grainy wood.

In the late eighteenth century however, Thomas Bewick developed a way of cutting not the plank (coming vertically from the tree) with coarse

3

6

Vſus edocto ſi quicquā credis amico, Triſt.3.

Viue tibi, & longe, nomina magna fuge.

Viue tibi, quantūq; potes, præluſtria uita.

Sæuū præluſtri fulmen ab arce uenit.

Nam, quāquā ſoli poſſunt prodeſſe potentes,

Non proſunt, potius plurimum obeſſe ſolent.

VI

Carmine fit uiuax uirtus, experſq; ſepulchri. Pon. 4

Notitiam ſeræ poſteritatis habet.

Tabida conſumit ferrum lapidemq; uetuſtas,

Nullaq; res maius tempore robur habet.

Scripta ferunt annos, ſcriptis Agamēnona noſti:

Et quiſquis contra, uel ſimul arma tulit.

Quis Thebas, ſeptēq; duces ſine carmine noſſet?

Et quicquid poſt hæc, quicquid et ante fuit?

Dij quoq; carminibus, ſi fas eſt dicere, fiunt:

Tantaq; maieſtas ore canentis eget.

4

tools, but the end grain wood (cut horizontally across the trunk) with finer metal engraving tools. His highly individual cutting combined conventional black outlines with a white line negative technique used for contrast. His enchanting wood engravings, illustrating his own 'History of British Birds' are remarkable not only as a contribution to natural history, but for the marvellous tail pieces at the end of chapters, showing country life in his day, with boys riding tombstones or a cock aghast at seeing itself in a mirror. Such wood engraving enabled more information to be packed into relief prints. Unlike intaglio, they could be printed at the same time as the text, thus serving the mass-circulation periodicals which thrived throughout the Victorian period as more and more people learned to read. Whole schools of Victorian artists, particularly in the 1860s, drew images on or for the woodblock to be interpreted by specialist cutters. 'Wayside Poesies' for example, a book of rather pedestrian verse, abounds with lyrical little engravings drawn by the artists North, Pinwell and Walker, for whom the amazing Dalziell brothers achieved a delicacy and refinement formerly unimaginable from wood.

3 ANON Humanist playing cards, woodcut with stencilled colour 1544

4 ANON *Christ on the Mount of Olives* dotted print c.1470

5 A. DURER *Death of the Virgin* woodcut 1511

6 T. BEWICK *Great Snipe* from 'A History of British Birds' wood engraving 1797–1804

7 J. W. NORTH *Visions of a City Tree* from 'Wayside Poesies' wood engraving 1867

5

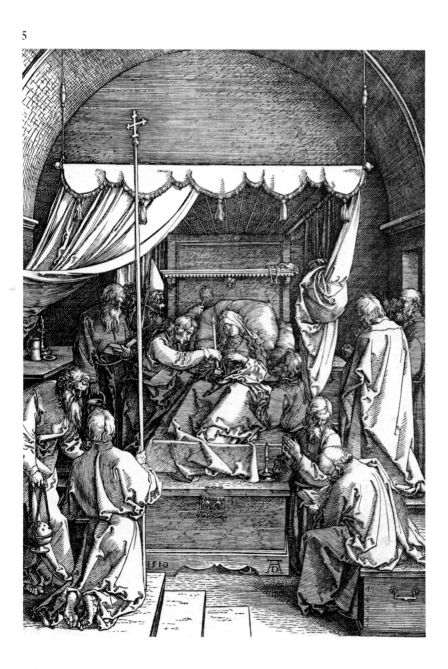

6

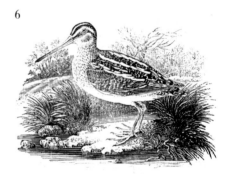

7

Photography had by now however begun to threaten some of the tasks artists and craftsmen had previously undertaken in print, and towards the end of the nineteenth century they began to seek other justifications for their existence, challenging the encroachment of all they regarded as mechanical by glorifying the handmade. Perhaps most importantly, they looked back at four centuries of Renaissance tradition and decided it was time for another beginning – away from a realist portrayal of the world as perceived by the eye and towards expressive distortion and symbolism as a mirror of inner feelings.

Several artists looked to sources of imagery outside their own culture and the Japanese prints, which began to arrive in Europe as wrapping for porcelain imports from the mid-nineteenth century, had great influence. Regarded as expendable in Japan, pictures such as Utamaro's diptych (which shows Japanese prints being made) delighted French artists with their bold flat patterning and subtle colours. They were printed not by the western method of rolling an oily ink evenly on the block, but by rice paste water inks brushed on to the cherry wood and transferred to the sheets of beautiful soft mulberry paper by rubbing with a flat bamboo pad called a baren.

Partly inspired by them, Gauguin made perhaps the most inventive woodcuts of the nineteenth century to accompany a text about his exotic travels in the South Seas. He combined bold cutting with sensitive grazing of the surface of the block in a way he could have learned from contemporary lithography. Vallotton, a Swiss artist living in Paris, ran his black shapes together equally boldly – a feature possibly owing something not only to Japanese prints but to high contrast photographs.

Minutely detailed and in the end perhaps rather fiddly wood engravings were abandoned in favour of prints from the plank in which even the grain was welcomed. Munch's girl in the moonlight answering some inner call shows a desire to understand and interpret the psychology of human beings rather than simply recording their outer shell. The artist printed his block by cutting it up like a jigsaw, colouring the parts separately and reassembling them before they

8

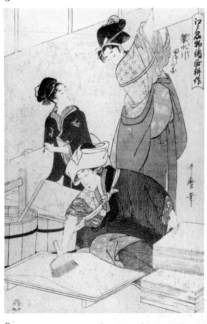 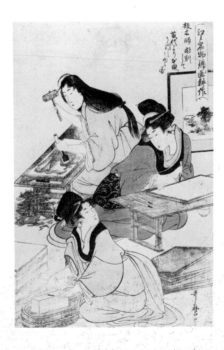

9

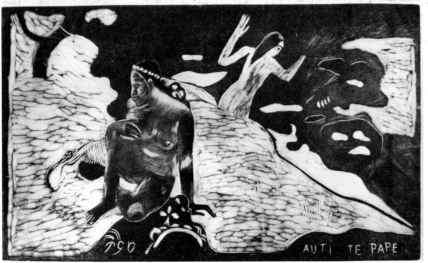

10

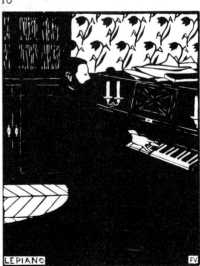

travelled through the press. A Norwegian travelling in Europe, Munch helped transmit new ideas about the nature of art from Paris to an early twentieth century Expressionist group known as Die Brücke (The Bridge) in Germany.

Kirchner and Heckel were founder members of this revolutionary group and were inspired not only by the artists already mentioned, but by sources as different as Van Gogh, African sculpture and the earliest German woodcuts. The group cut their own posters, letterheadings, gift prints for financial supporters and even a book which chronicled their movement. They were great printmakers, often painting ink on to their blocks experimentally in the manner of the Japanese and using them to create not

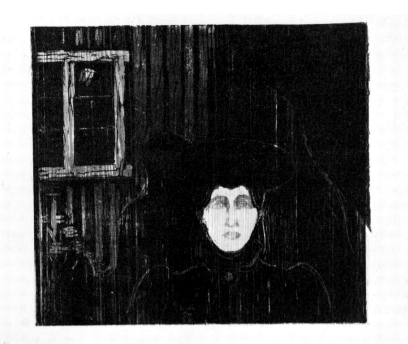

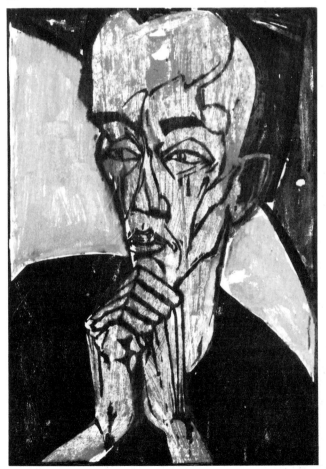

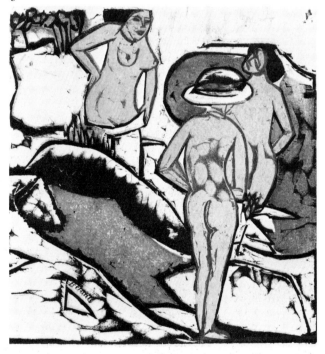

identical editions, but series of slightly different impressions. Heckel experimented in this way by painting an unusual olive green on to the block for the face in his portrait. The whole group made prints and paintings based on country holidays in which they seem to have indulged a kind of nudist nature worship.

11 E. MUNCH *Moonlight* colour woodcut 1890s

12 E. HECKEL *Man's portrait* colour woodcut 1919

13 E. KIRCHNER *Bathing women by white stone* colour woodcut 1912

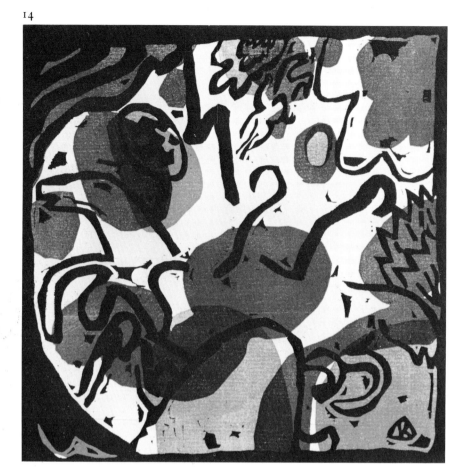

The reductive and simplified images, with which artists hoped to communicate spiritual feeling rather than material reality, led eventually in the hands of the Russian, Kandinsky, to complete abstraction and the severance of obvious ties with nature. One can watch this process occurring in the woodcuts with which he illustrated a book of his own poems called 'Klange' (Sounds). Blue riders were featured in several of his prints and this recurring theme gave its name to a group that Kandinsky founded while living in Munich before World War I.

In England, less daring than the Continent, the stronghold of the relief print between the wars lay in entirely hand-made private press books for connoisseurs. In 1923 however, the Nonesuch Press, for which Eric Ravilious later illustrated 'The Natural History of Selborne', proposed that texts could be beautiful even if printed by machine. In 1932, John Farleigh had gone so far as to wood engrave the illustrations for a book by G. B. Shaw which was produced for the commercial mass market. In general, however, such illustration remains a luxury which, since Vollard, has been particularly associated with France. One of the loveliest post-war books in this tradition was 'A toute épreuve' – a book of Paul Eluard's poems, illustrated by the Spanish Surrealist, Miro. Miro's designs were cut and printed in the Japanese manner by his assistant, Enric Tormo. This entailed the same method as Japanese Ukiyo-e prints, with the drawings made by the artist, the blocks cut by specialist cutters and the printing also undertaken by a separate group. The most brilliant colours of the book's abstract illustrations were applied not by roller, but by brush and even for a limited edition, the pages went 42,000 times through the press in all.

The outstanding characteristic of relief printing since the war has been its growth in size and scope and its move from black-and-white to colour. The American, Carol Summers, works somewhat unusually, placing soft paper over his uninked wood blocks, rolling colour on top and then spraying the results with an ink solvent which causes the colour to spread and fuse. Michael Rothenstein, one of the best known British printmakers, has always regarded printmaking as a primary rather than as a secondary activity subservient to painting. During the 1960s he began to incorporate found objects into his prints, using planks

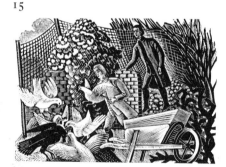

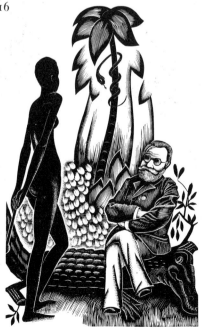

of weathered wood and massive tree trunk sections, which, in the pair of prints illustrated, he teamed with gestural marks gouged freely from lino. The same blocks printed in different colours demonstrate the enormous impact such a variation can give both to the form and the mood of the print. In such ways as this, the tiny traditional black-and-white print escaped from the book or portfolio and took its place on the wall alongside paintings.

14 W. KANDINSKY plate 8 of *Klange* (*Sounds*) colour woodcut 1910/11 for 1913 publication

15 E. RAVILIOUS illustration for 'The Natural History of Selborne' wood engraving 1938

16 J. FARLEIGH illustration for 'The Adventures of the Black Girl in her search for God' wood engraving 1932

17 J. MIRO illustration to 'A toute épreuve' colour woodcut 1958

18 C. SUMMERS *Fonte Limon* colour woodcut 1967

19 M. ROTHENSTEIN *Radial Shakes* and *Blue Black White* colour relief prints 1966

18

17

19

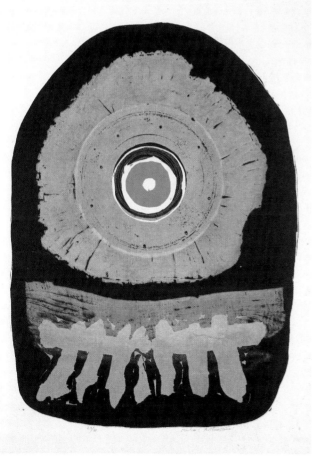

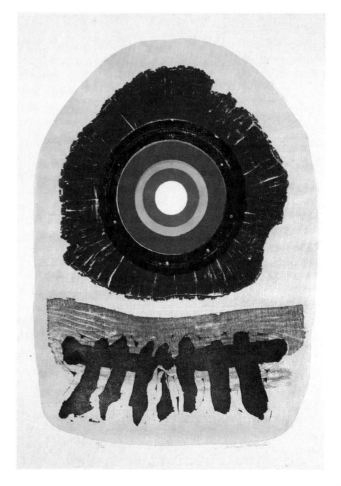

20

21

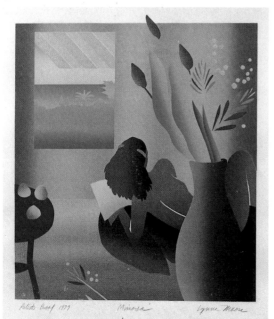

22

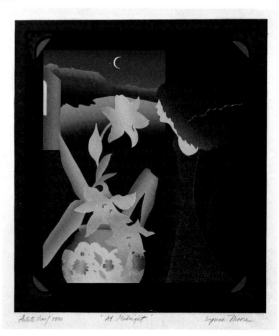

Trevor Allen and Lynne Moore are printmakers who demonstrated relief printmaking for this book. Both artists like the relief process because of the brilliant colours obtainable in letter-press inks and the inexpensive materials that can be used as printing blocks. Trevor registers several colour blocks cut from lino and completes each print with a key block based on his initial drawing printed in black. Lynne, who began using cardboard for printing when she was a student, cuts up sheets of it like a jigsaw puzzle and inks each element separately. Like Trevor she sometimes merges several shades together when she rolls out her inks, which allows her to graduate the colour printed from one block.

Like Rothenstein, who has always mixed many different printing materials together, Rolf Nesch, who fled to Norway from Nazi Germany, was equally inventive. He used perforated zinc, wire gauzes and scraps of metal drawn on in soldered wire to piece his pictures together. He would finger-ink each element, place it on an etched base-plate and then impress the whole structure into a heavy dampened paper with an etching press – a technique which broke down traditional divisions between relief and intaglio printing. His wife was a well known character actress and his two-sheet print shows a company in their temporary dressing room on a provincial tour.

Lino cutting has, in the past, been largely associated with the prints of schoolchildren, but Picasso adopted it in the late 1950s at the age of seventy-seven. A Spaniard who loved bullfight-ing, he conveyed the excitement of its ritual in this cut in which all three colours are printed in sequence from a single block.

Among the least complex of relief prints however are the tiny 'Poems for my typist' by Stuart Mills. The fine art context of these poems is obvious only from the reference to Seurat, a late nineteenth century painter sometimes, called a Pointillist, who built up his pictures from coloured dots which he meant to mix optically in the spec-

24

25

```
    Poems for my Shorthand Typist

The Pond and the Poplar Tree's Poem

                !

         The Canal's Poem

                =

       The Sea Horse's Poem

                ?

       The Sea Urchin's Poem

                *

       Georges Seurat's Poem

                .

        The Tadpole's Poem

                ,
```

tator's eye. Found more often in liter-ary magazines than art galleries, such concrete poems, which fuse poetry and painting, word and image, are often very accessible. For, once the artist has formulated his idea, it belongs to anyone who can tap it out on a typewriter and take pleasure in it.

20 T. ALLEN *Zippo* colour linocut 1971

21 L. MOORE *Mimosa* colour card relief print 1979

22 L. MOORE *At Midnight* colour card relief print 1980

23 R. NESCH *Theatre Dressing Room* two sheet colour metal print 1947/8

24 P. PICASSO *Banderillas* colour linocut 1959

25 S. MILLS *Poems for my typist* typewriter print 1970

Featured artists

Trevor Allen and Lynne Moore

The artists who demonstrate relief printing in this book, have known each other a long time. Trevor Allen taught Lynne Moore when she was a student at Brighton College of Art and she remained there subsequently as a printing technician. Both artists are attracted to the brilliant colour possible in relief printing, although they use quite different materials and techniques.

Trevor, who worked with Michael Rothenstein as a student, is attracted by the resilience of lino, as well as its suitability for printing on a large scale.

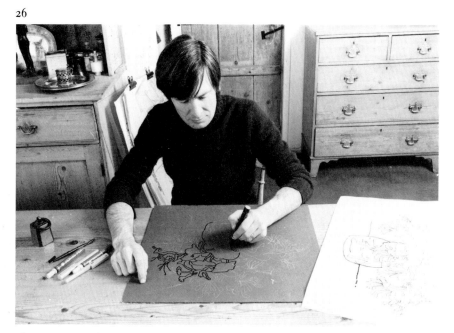

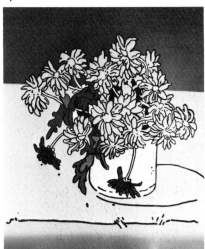

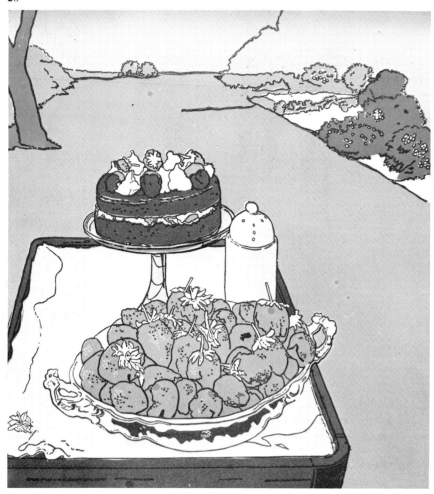

To make a print he chooses from a series of small sketches and vigorously enlarges one to create an outline which will form a key image to which all the other colour blocks in the intended print will relate. After transferring this key image to lino with the help of light-coloured carbon paper, the artist revitalises the strongly drawn line by reinforcing it with a felt pen. He then cuts it with great care so as to retain its character. This black line is the most essential element in the work.

'Honeysuckle III', the print shown in the sequence of photographs which follow, was the third and final print made from a series of drawings of honeysuckle. It is the relationship between the lines, spaces and colours which interests Trevor, who has looked at the work of many artists, among them Matisse, Picasso, and Japanese printmakers. One can also detect, perhaps, a residual memory of the Dandy and Beano comic books he read as a child.

Trevor's subject matter comes from the environment of his own home. Part of each week he spends teaching in London, so that when he gets back to Suffolk from the city, he sees his house and belongings with fresh eyes. His prints have featured chairs, vases of flowers, or even luscious food – some real, some imagined – placed outside in the country landscape. The tins containing left-over ink in his workshop have appetising labels relating to titles . . . 'Peaches and Cream', 'Ice Cream Sunday', 'Blueberry Pie' and 'Strawberries on a Summer's Day'.

29

30

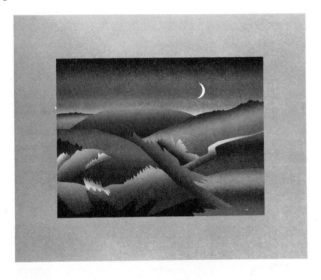

31

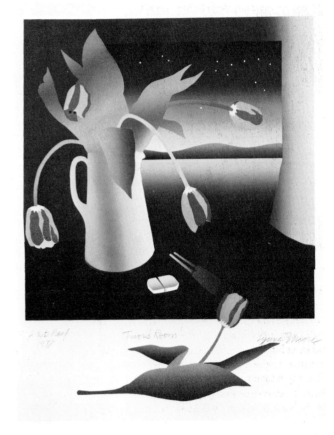

Like Trevor, Lynne appreciates the directness of relief printing, its inexpensiveness and the fact that once she has hit upon an idea she can design and cut one of her prints from a piece of ordinary white cardboard inside a day. She only reckons to edition each print in about fifteen copies because of the time printing takes. She prefers the excitement of making new images.

Listening to music as she works, she fits her printmaking into the period between 9am and 3pm when her young daughter is at school. She does the designing of each composition at home, but goes to her workshop when she needs to use her 1852 Albion press.

As well as a series featuring ancient monuments, she has been influenced by the romantic moonlit landscapes she has admired in the work of Samuel Palmer. And, like Trevor, props from her own home or the homes of her friends invade her pictures. The striped blind in the workroom in her flat (in a house, incidentally, where Lily Langtry was regularly visited by Edward VII) found its way into the print inspired by Matisse's 'Odalisques'. Fond of interiors from which one can glimpse a landscape outside, she tried in 'Mimosa' to capture the light and airy atmosphere in the south of France.

'At Midnight', the print she demonstrated for this book, followed closely after it and was intended as a darker foil for the sunlit picture. She tried to achieve a feeling of the Pre-Raphaelite period of the mid-nineteenth century,

21

a time when paintings were elaborately framed and the painters, some of whom worked in stained glass, seem to have had a particular weakness for red-haired women with swan-like necks. Borrowing out-of-season lilies from a book of plant illustrations, she enlarged one of her own small vases for the picture's foreground.

Lynne knew when she was five that she wanted to be an artist and was fortunate in being encouraged by her parents. To capture atmosphere or sensation is her dream but she feels she often falls short of that goal. 'Sometimes, compared to the really great artists, I feel I am only making decorations,' she says, 'but I keep trying.'

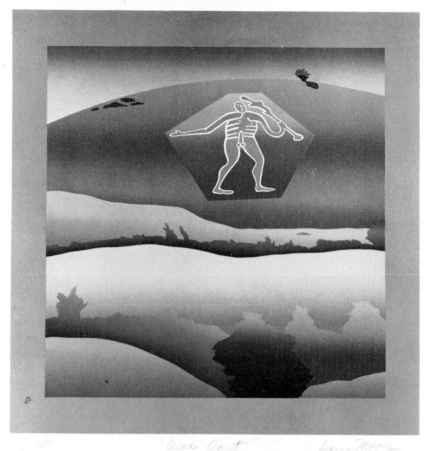

32

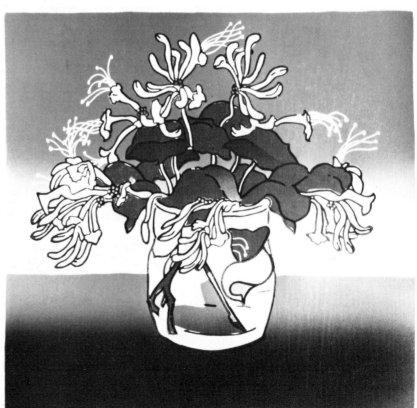

33

32 L. MOORE *Cerne Giant* colour card relief print 1978

33 T. ALLEN *Honeysuckle III* colour linocut 1980

Step by step Relief prints

The earliest relief prints were made from wood cut from the plank, but during the twentieth century artists have pressed all sorts of other materials into service. Here, we show relief prints made from lino and from an inexpensive single sheet of cardboard, as well as traditional wood engravings from end-grain wood.

Trevor Allen's linocut

Having transferred his design to the lino as shown on page 20, Trevor warms the lino to make it softer and easier to cut and then uses 'V' tools and gouges to clear the unwanted parts of the block so that the bold outline of the key drawing is all that stands proud to receive the ink.

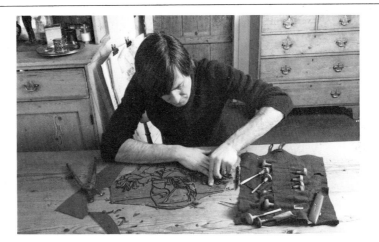

34

All unused lino in the block is then cut right away using tinman's snips.

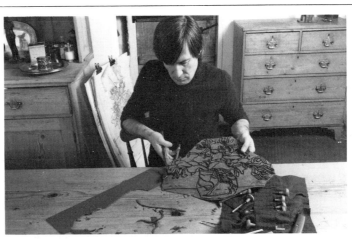

35

A print of the key block is taken on a sheet of clear acetate. When dry this will be used to help in the registration of other blocks, so that they all fit correctly together.

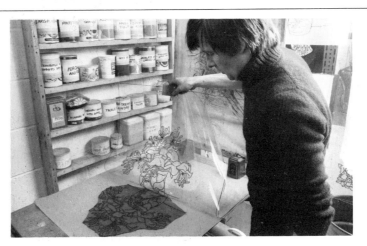

36

Wet prints from the key block made on ordinary sheets of paper are offset (which means being printed by direct contact) on to fresh pieces of lino, one for each of the intended colours. This is known as counterproofing. It is more accurate than retracing the image repeatedly on each block.

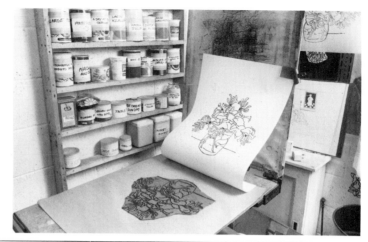

After more cutting, Trevor ends up with the key block to be printed in black, a background cut into two pieces each of which can be inked separately and from the top half of which the stamens have been cut so that they will appear as unprinted paper in the finished picture. Then there is a block to create the flowers, one for the leaves to be printed in dark green, and another to print light green for the leaves shown submerged in water in the transparent pot. Parts of the dark green leaves are overprinted by the red of the background block to give the appearance of a red-brown.

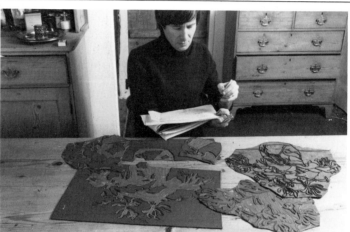

Now the time for printing has arrived. A registration sheet laid on the bed of the press is marked out with the positions that the blocks and the paper are to occupy.

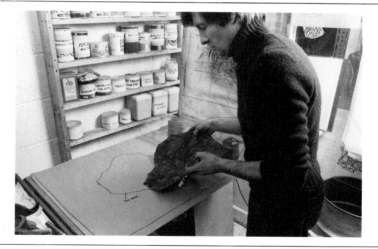

At this point the acetate overlay, printed from the key block at the beginning, helps in the placement and marking of each of the blocks in relation to the others. So that the acetate does not move and is at the same height as the block to be printed, it is held with heavy weights on a strip of lino taped to the registration sheet on the bed of the press. This strip is also used to position the paper with weights as the printing proceeds.

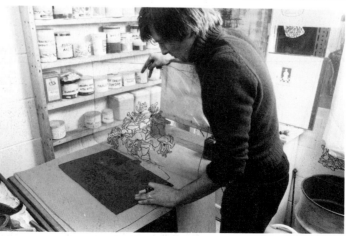

To get a shaded colour economically from one block and a single printing, Trevor puts two different colours together on a large roller with his palette knife . . .

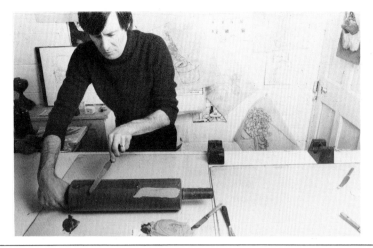

. . . merges them by rolling them together until they are in a thin film and ready to be . . .

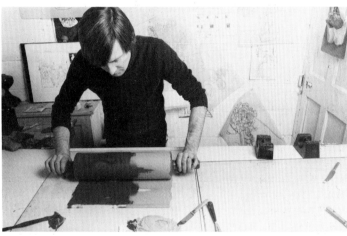

. . . transferred to the block.

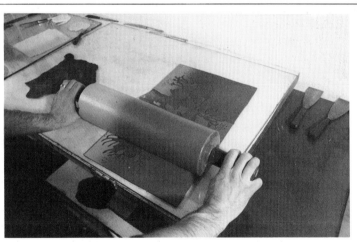

The block thus inked provides the background to the honeysuckle and ranges subtly from a mid-red at the top of the sheet to a pale pink nearer the table on which the pot of honeysuckle sits.

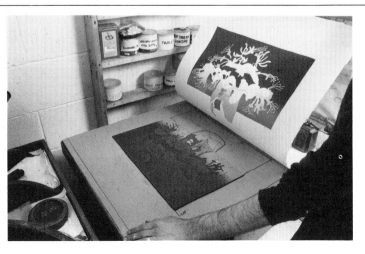

A similar merge shades the flowers themselves. By blotting off excess ink with tissue between colours, Trevor can make a complete print without waiting for the inks to dry.

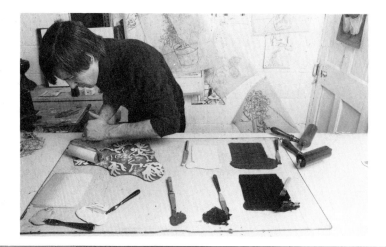

45

The key block, first to be cut, is the last to be printed, the black outline, perfectly registered, draws all the other colours together.

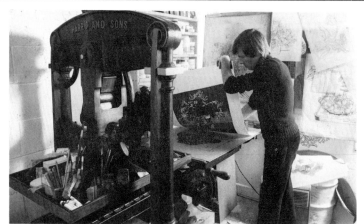

46

Lynne Moore's card relief print

Lynne works out her idea in water-colour and on a small scale.

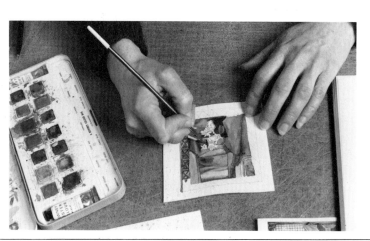

47

Then she enlarges it onto a sheet of card that will actually become the printing block.

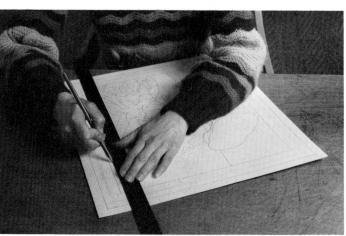

48

Using a scalpel with a pointed blade she cuts around each of the component parts. Here she is cutting the lilies and floral decoration on the foreground vase.

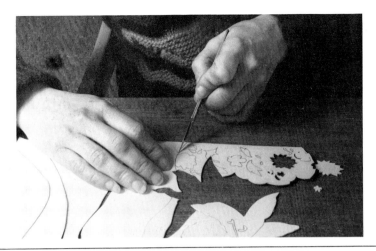

By the time she has finished cutting, the whole thing fits together like a jigsaw puzzle.

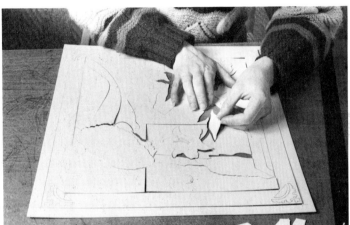

The outer edge is printed first, and then the decorative inner framework which Lynne inks . . .

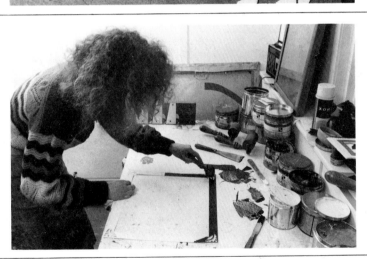

. . . using a tiny roller.

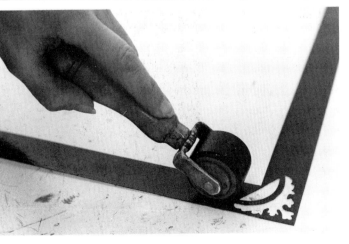

After that piece has been printed in the press, the cardboard block is carefully removed . . .

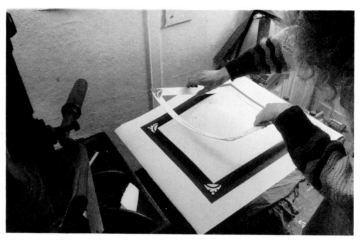

53

. . . and a sheet of tissue paper

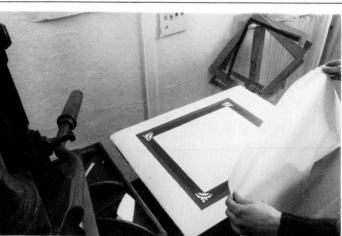

54

is used to blot off the excess ink so that the next piece of card can go down without delay.

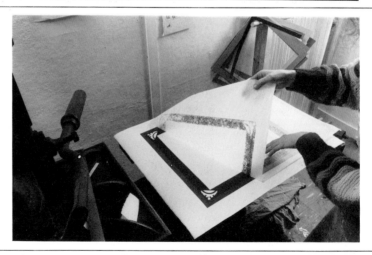

55

Little by little the picture builds up. Like Trevor, Lynne uses colour merges on certain pieces to suggest shading and depth. The lilies, among the last pieces to go down, are inked with shades blending from pale to orchid pink on the roller.

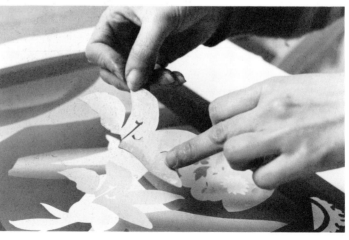

56

Before the bed is moved under the part of the press which applies pressure, the back of the cardboard is covered by a protective sheet of paper and then packed with leaves of newspaper before the tympan covers the whole sandwich (see illustration of press, page 31).

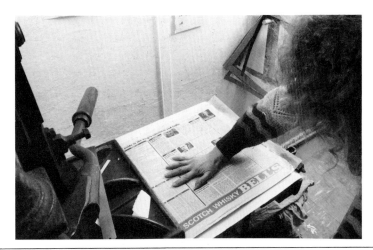

Lynne uses her leg as well for maximum leverage as she pulls the handle activating the part of the press – the platen – that puts pressure on the block and causes it to transfer its ink to the paper underneath.

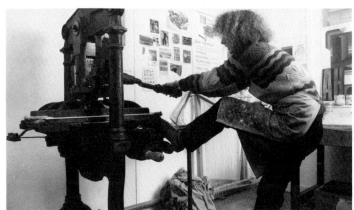

Ian Mortimer's Wood Engraving

The tools used for linocutting can also be used to make woodcuts on plank wood together with knives and chisels. Wood engraving, however, is done on end-grain wood, with finer tools.

The wood for engraving is cut across the tree and is without knots and striations so that fine engraver's tools can be used.

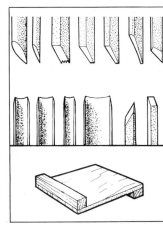

Although some artists use a bench hook which fits over the edge of the table and prevents the block slipping as it is cut, traditionally the block was rested on a pad of leather filled with sand, enabling it to be easily rotated to facilitate cutting.

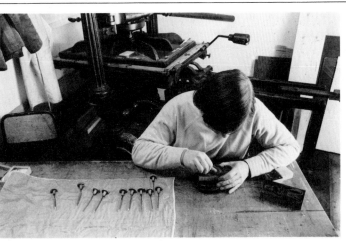

Ian Mortimer works mainly in black-and-white, calling his private press Imprimit (Latin for I.M. printed it). He shows how the burin is handled . .

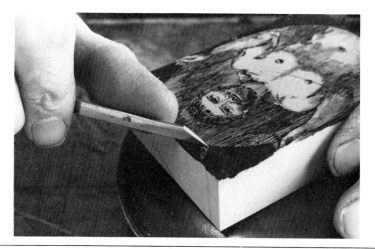

. . . and the marks other tools can produce on the wood's surface.

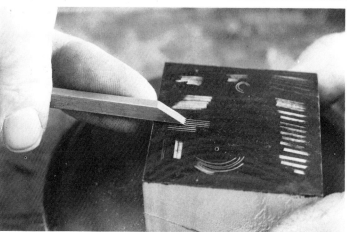

Ian also demonstrates a way of pulling proofs without a press. Using another block featuring a kneeling woman he inks the block, places the paper to be printed over it, and then a second piece of paper which acts as a buffer to protect the finely-cut ridges as he burnishes the print gently with the bowl of a spoon . . .

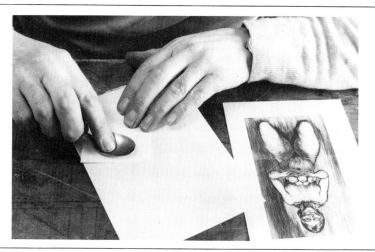

. . . lifting the corner occasionally to see that the ink is transferring well.

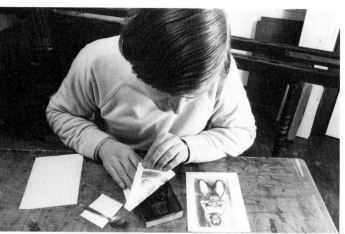

Letterpress

*The commercial
form of relief printing*

66

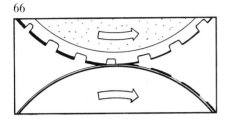

Letterpress is the commercial form of printing in relief and, until this century, it dominated all book production. In the early fifteenth century book page-texts were laboriously cut out of a single piece of wood, together with the illustrations. Later that century, Gutenburg, working with a flatbed platen press not very different in principle from those used by the

67

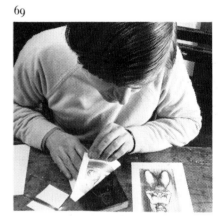

68

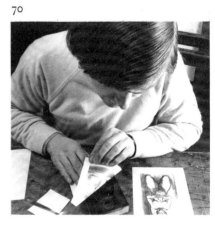

relief artists featured in this book, found a way of casting metal type so that each of the pieces representing a letter could be set up in words again and again. Nowadays, of course, all this is done mechanically.

It was the second half of the nineteenth century before it became possible to convert line drawings into relief metal printing blocks photo-mechanically. This was achieved by preparing a photographic negative which allowed light to pass through it to a metal surface covered with a light-sensitive coating. In those places where the coating was hardened by exposure to light, the metal was protected when the plate was immersed in an acid bath. The acid lowered the unprotected parts of the surface by etching the metal away to the required depth, leaving a raised image area ready to be inked and printed.

From the 1880s a way was found to convert photographs, ranging imperceptibly as they do from black to white through continuous tones of grey, into relief blocks. Since most printing uses

one ink (usually black) an illusion of tone is created by breaking the printing surface into a mass of dots of varying size. This is done by exposing the metal to light through both a normal photographic negative and a glass screen ruled with a criss-cross grid pattern of opaque lines the same width as the squares between them. Each tiny opening in the grid acts as a pinhole lens, photographing a specific part of the image in terms of its relative brightness. The open parts of the negative correspond to the darkest parts of the image and harden the most emulsion thus protecting the largest area of metal as a relief printing surface. Dark areas involve large dots running almost together, while a close look at light ones reveals widely scattered tiny black dots which, together with the white of the paper, register in the eye as a grey. This method is known as 'half tone' since the screening process has eliminated half the original image. Work on cheap newsprint for daily papers needs to be coarse, but on art paper for magazines like 'Vogue' finer

66 In Letterpress/Relief printing the ink is deposited on to the paper from the raised surface.

67 A slug of Linotype cast from molten metal.

68 This Albion Press is the type used by our featured artists Trevor Allen and Lynne Moore.

Lever
Platen
Paper
Bed

Track

69

70

69 A detail of picture 65 opposite, reproduced by a coarse half-tone screen of 80 dots to the inch.

70 Same detail reproduced using a screen of 200 dots to the inch.

31

dots are less easily detected by the eye as the code into which the image has been translated. Colour work, for which filters produce separate half tone plates for each of the three primary colours – yellow, cyan (process blue), and red (process magenta) – is described on page 109. Although discussed in the context of screenprinting, this is the basis of all commercial colour printing.

In the fifteenth century Gutenberg would have locked his type into a framework, inked it with a tacky ink and placed a sheet of paper over it before applying pressure from the platen. This method survived largely unchanged until the flat-bed cylinder press was developed to speed up the output of newspapers in the early nineteenth century. The even speedier

modern rotary press uses a curved printing plate made by taking an impression in paper pulp (papier mâché) from the flat metal text and illustration and using it to mould a curved plate from molten metal. To such a press, paper can be web-fed from a continuous roll and even printed on both sides simultaneously.

71

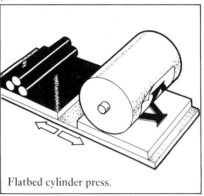

Platen (Clamshell) press.

72

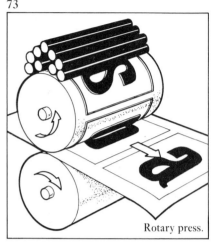

Flatbed cylinder press.

73

Rotary press.

74

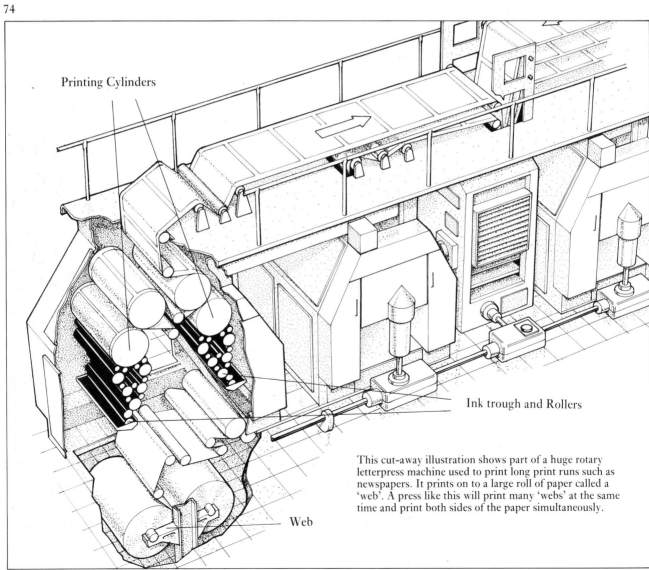

Printing Cylinders

Ink trough and Rollers

This cut-away illustration shows part of a huge rotary letterpress machine used to print long print runs such as newspapers. It prints on to a large roll of paper called a 'web'. A press like this will print many 'webs' at the same time and print both sides of the paper simultaneously.

Web

Intaglio

History of intaglio printing

Produced at a time when most men did not know how to write, cylinder seals were a neat way for illiterates to mark their documents. With the designs hollowed out negatively so as to produce positives when rolled in clay, they can be thought of as an early equivalent of rotary intaglio printing which existed several thousand years before Christ.

Throughout time men have incised patterns. Cavemen incised reindeer horns, Etruscans engraved mirrors, and medieval artisans etched designs into armour. Only when paper became plentiful in the fifteenth century, together with oil-based colour, did the idea of rubbing stiff ink into the incised lines and then transferring it to a dampened sheet of paper under considerable pressure, bring intaglio prints into being.

The earliest date on an engraving is

1 Cylinder seal and impression, mythological scene, c. 2300 B.C.

2 MANTEGNA *Virgin and Child* (detail) engraving 1480

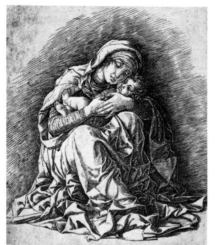

3 MASTER ES *Madonna with child playing and saints* engraving c. 1466

1446. The engraver using the monogram ES and working about twenty years later, is celebrated for the delicate stippling and shading which he used to enrich subject matter ranging from fantastic alphabets and courtly lovers to religious themes. One of his religious prints shows Mary, sitting in an enclosed garden, symbolising her virginity, accompanied by the baby Jesus, saints, and music-making angels.

Like most of the early engravers, Master ES, who probably lived on the Rhine, was a goldsmith rather than a painter. As the Renaissance moved into top gear however, several Italian painters tried the engraver's burin. Mantegna, fitting his Virgin into a classical pyramidal composition, has engraved her with an austere simplicity nevertheless full of tenderness. North of the Alps, Dürer used craftsmen to cut his woodblocks for him as was then the custom.

4 A. DURER *St Jerome in his study* engraving 1514

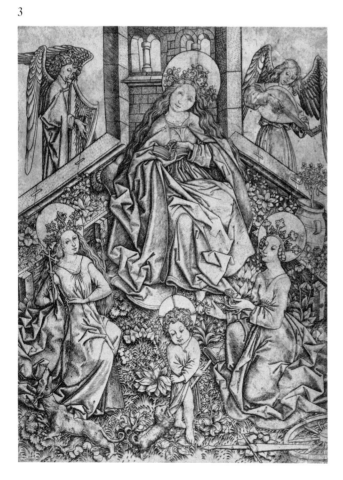

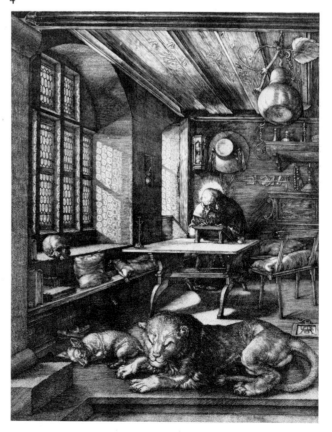

He engraved his own metal plates
however, intending them for a more
sophisticated audience and charging
four or five times as much for them.
St Jerome, sitting serenely in his
study, the walls dappled with light
from the mullioned windows, is one
of his masterpieces.

Engraving rapidly became a lucrative
industry with painters who, rather
than creating their own prints,
employed professional engravers to
reproduce their unique pictures.
Marcantonio Raimondi, in circulating
the ideas of the great Italian painter
Raphael, devised a system for suggest-
ing three-dimensional forms by an
engraved network of intersecting lines
which became standardised through-
out Europe.

 Sir Peter Paul Rubens – a Flemish
painter, diplomat, and astute busi-
nessman – organised a whole school of
engravers around himself, enormously
increasing his international influence.
Schelte à Bolswert translated several
dynamic landscapes for him into the
engraving conventions of the day.
His energetic swelling and diminish-
ing parallel lines and meshlike grids
created a fabulous tonal range to
suggest daylight turning into moon-
light as the carters try to shift their
waggon from the mud.

 Conditioned to relish spontaneity
and chance, the art world nowadays
fails to appreciate such disciplined
cutting. In Hogarth's time however, it
was still the ideal. He often etched his
own prints after preparatory paintings,
but because he regretted that his
impatience prevented him attaining
'that beautiful stroke on copper',
he sometimes engaged professional
French engravers. His 'Harlot's
Progress', showing the demise of a
country girl turned prostitute, was the
first 'modern moral subject' he hit
upon to 'strike the passions' and make
'small sums from many'. While all six
paintings on the theme brought him
only eighty-four guineas, 1200 people
had each subscribed a guinea for the
suite of prints before they were issued.
Hogarth achieved such popularity
that he had to instigate a copyright law
to prevent the pirating of his works.

 Hogarth, who had an earthy
humour, has been called the father of
caricature and Rowlandson came into
that inheritance. He loved drawing the
kind of 'overgrown puffy greasy human
hog' shown here crowding into a coach
that first-comers had hoped to retain
for themselves. Such satirical etchings

5

6

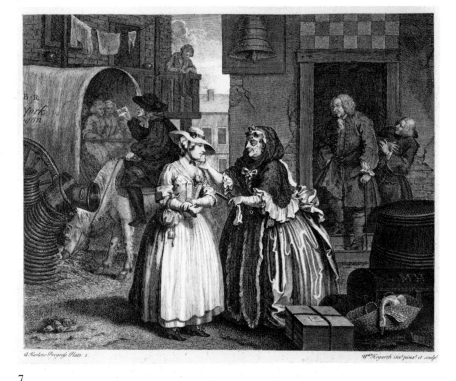

7

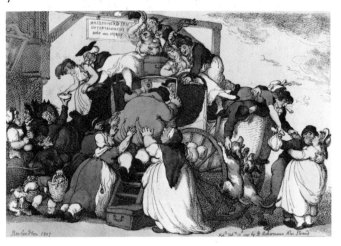

were hand-coloured to his specification by refugees working for his Strand publisher, Ackermann.

During the eighteenth century there had been many attempts to print colour and Le Blon had tried to mix the three primaries – red, blue and yellow – in a way only twentieth-century technicians were able to perfect. French engravers, satisfying the vogue for reproductions of drawings, were more likely to use many plates. Louis Marin Bonnet needed eight to imitate Boucher's pastel 'Head of Flora'. This century colour has become much more widespread, although Norman Ackroyd has used it sparingly for the rainbow illuminating his aquatint of 'Pentland Firth'.

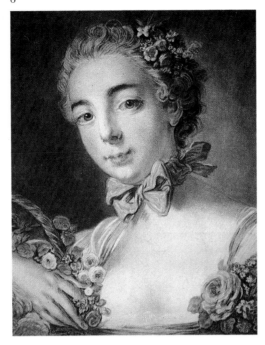

5 S. BOLSWERT after RUBENS *The Carters* engraving c. 1638

6 W. HOGARTH *Harlot's Progress* (plate 1. first state) etching and engraving 1732

7 T. ROWLANDSON *Miseries of Travelling* etching with hand colouring, published 15 Feb 1807

8 BONNET after BOUCHER *Head of Flora* colour crayon manner engraving c. 1750

9 N. ACKROYD *Pentland Firth* colour aquatint 1974

9

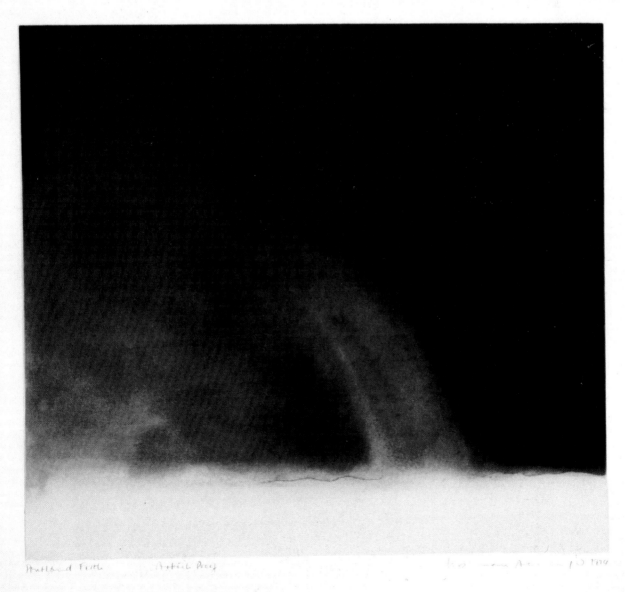

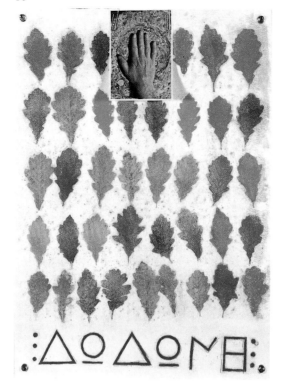

Rouault, a French artist trained to work in stained glass, illustrated several books including one on the circus. He created powerful black outlines by means of a process called sugar aquatint, described on pages 53 and 54. His printer then made colour plates as indicated on a proof in watercolour by the artist.

Miro, for whom spontaneity when he creates his child-like signs and symbols is of paramount importance, relies not only on aquatint, but on an easily brushed catalysing resin containing a fine carborundum powder. This provides the necessary roughness to hold colour.

Joe Tilson invites contemplation of the fascinating diversity in the forms of supposedly similar oak leaves by

11

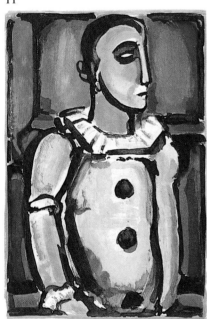

12

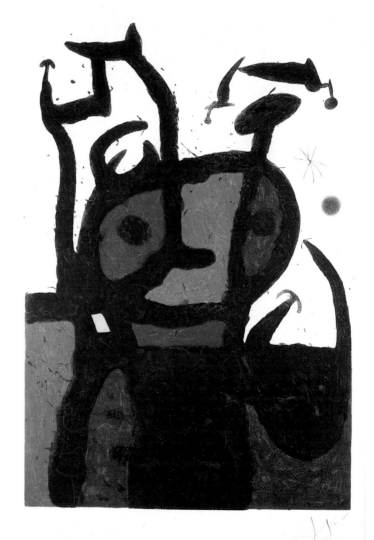

10 J. TILSON *Oak Oracle* soft ground etching, aquatint with collage 1980

11 G. ROUAULT *Pierrot* Pl. XIV from *Cirque de l'etoilé filante* colour aquatint 1935

12 J. MIRO *The Matador* colour aquatint and carborundum print 1969

pressing them into a soft ground on his etching plate, so as to clear a path for the acid to bite an echo of their impressions. Printed in a variety of greens, and accompanied by other images, they celebrate a journey through Greece taken by the artist.

The etched views in which Piranesi, with his passion for archaeology, shared the grandeur of ancient Rome, were among the great undertakings of the second half of the eighteenth century. Sold to those doing the Grand Tour, these huge, ruggedly bitten and awe-inspiring prints were modestly priced forerunners of today's picture postcards. They influenced generations of architects whether they borrowed detail, as Robert Adam did, or major

ideas for nineteenth-century railways, banks and prisons.

William Blake, who was far removed from the materialist thinking of his day, made his visionary illustrations for 'The Book of Job' at a time when England was on the threshold of the Industrial Revolution. He was so poor that he had to resort to second-hand plates, but he created a masterpiece in which he reinterpreted the Bible story to give a less arbitrary reason for Job's suffering. In it he suggested that it was Job's observance of the letter rather than the spirit of God's law which had led to his troubles. The substance and rhythms in his pictures are perfectly echoed by the marginal designs that he engraved around them. Samuel Palmer was inspired by Blake's work, and in

particular by the exquisite small wood engravings Blake had made for a schoolboy edition of Virgil. Palmer also regarded nature as a link with the spiritual and saw the 'mystic maze of enticement' in his pastoral etchings as a way to capture the dreamy glimmer he had recognised in Blake which would 'kindle the inmost soul and give complete and unreserved delight, unlike the gaudy daylight of this world'.

13

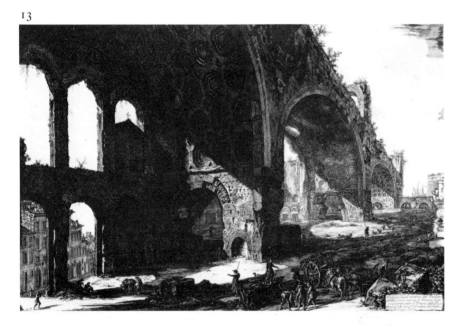

14

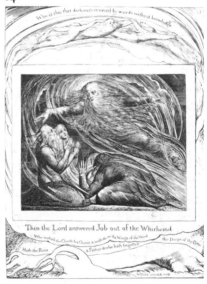

15

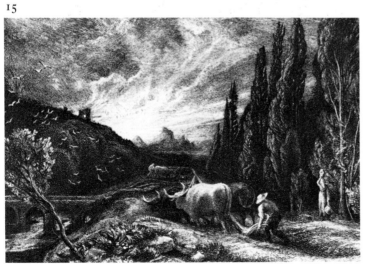

13 G. B. PIRANESI *Basilica of Maxentius* from *Views of Rome* etching 1751

14 W. BLAKE *The Lord answered Job out of the whirlwind* pl. 13 of 'The Book of Job' 1825/6

15 S. PALMER *Early Ploughman* etching 1861–8

The greatest etcher of all time, who lived from 1606 to 1666, was Rembrandt. He found the tissue of shadow he could create in his etchings ideal for the drama he wished to heighten by his use of light. Etching, which Dürer had practised on iron at its inception in the early sixteenth century, was a technique which did not need a tool to be driven directly through the metal. Since the acid did the work, less elbow grease was required than for engraving, which was now used mostly to strengthen parts of an image. Rembrandt's 'Hundred Guilder Print', which shows Christ healing the sick, is so called because of the price it fetched even in the artist's lifetime; it is his great masterpiece. He was endlessly experimental and totally disinterested in the engraving conventions of his day, but it was only after the Romantic movement of the nineteenth century had stressed just the qualities he himself displayed that his achievement was fully recognised and his example followed.

Painters worked in the open air throughout the nineteenth century in an attempt to capture nature's

16

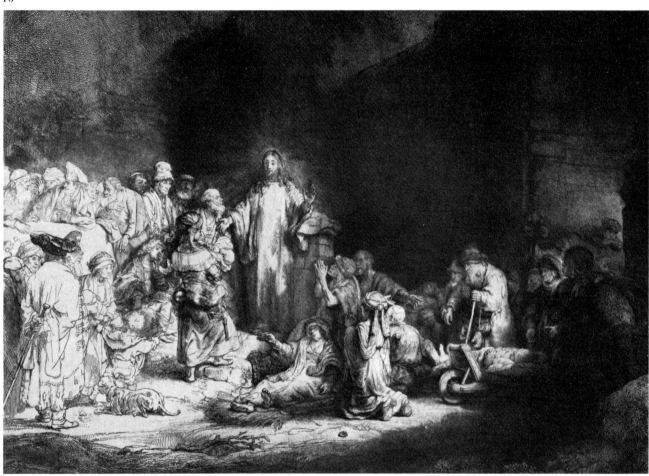

17

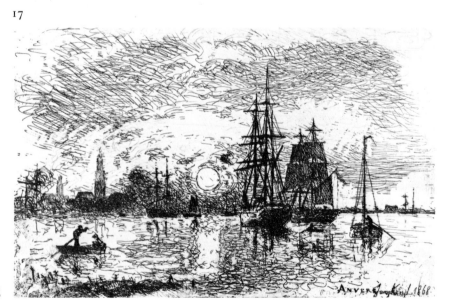

transitory effects. The same aims were reflected in their etchings. The cursively scribbled view of Antwerp harbour at sunset, etched by the Dutchman Jongkind, would have been impossible to cut with a burin. It influenced a painting 'Impression Sunrise' by the young Monet which was also shocking in its sketchiness at the time, and which, when it was exhibited in Paris in 1874, gave the movement of Impressionism its name.

16 REMBRANDT *The Hundred Guilder Print* etching 1649

17 JONGKIND *Sunset, Port of Antwerp* etching 1868

38

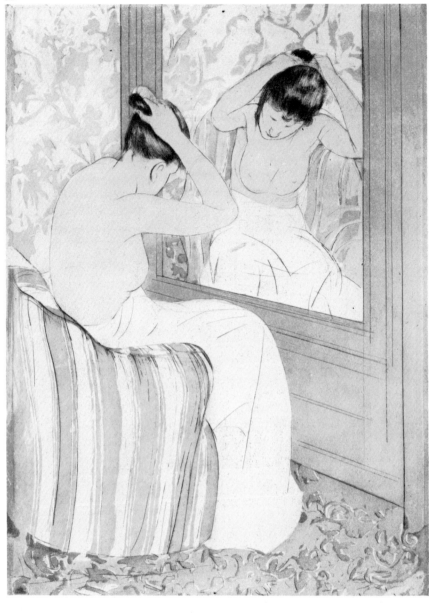

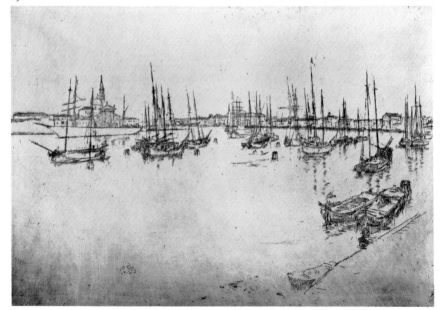

Colour printing flourished. Japanese woodcuts inspired the unusual colour aquatints of the American woman artist living in Paris – Mary Cassatt. She owned many of Utamaro's prints, and these together with the works of Hokusai and Hiroshige proved liberating for a whole school of French painters and lithographers.

Whistler, another American, who moved freely between France and England, produced a famous and luminous series of etchings of Venice, notable for their concision and elegance. Hailed as another Rembrandt, like his mentor he experimented with a variety of papers and made a fetish of films of ink left selectively on parts of his etching plates. In effect, he made monotypes, rather than editions of prints. By now, prints were produced in artificially limited editions and were aimed at connoisseurs. The limited edition was a marketing device that earlier print-makers who printed their plates until they wore out, would have found incomprehensible. Although Whistler trimmed his etching margins to foil collectors (who for some reason treasured them) his rarefied doctrine of 'art for art's sake' fashioned in the face of photography, did much to en-courage rather precious attitudes in printmaking which worked against the democratic potential of multipliable images.

It has been said that it is easier to bridge the four hundred years between the High Renaissance and Impressionism than the forty years between Impressionism and Cubism. Although the German Expressionists and a parallel group of artists in France called Fauves (Wild Beasts) had already reduced images to bare essentials in a way shocking enough, their images still dealt with the physical and the sensory.

18 M. CASSATT *The Coiffure* colour drypoint and aquatint 1891

19 WHISTLER *San Giorgio* etching and drypoint 1879/80

Cubism however was an intellectual and analytical movement playing spatially with the planes of objects in a way which retained only the most tenuous connection with reality and which introduced a completely new pictorial language.

In 1911, Braque and Picasso, joint founders of the movement, made several austere drypoints. The same year, a group of other Cubists, showing together in Paris, were greeted with uproar and derision,

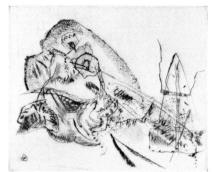

the independent vitality of which he stressed. He also devised many tricky methods of printing several intaglio colours simultaneously.

Many etchers, however, continued to find all they needed in traditional technique unadorned. The Italian, Morandi, suggested the continuity between objects and the space they occupy by nothing more complex than cross-hatching.

20

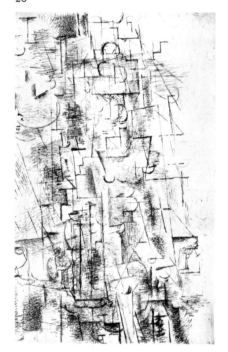

22

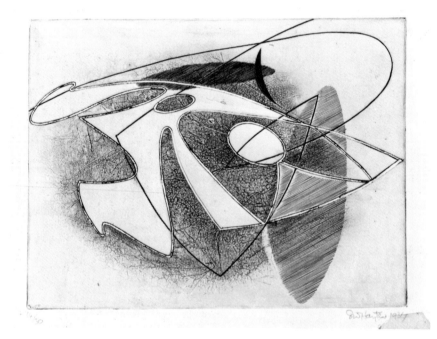

23

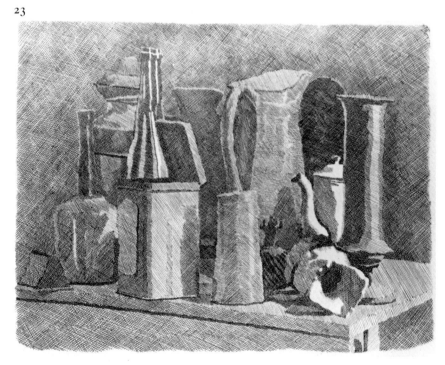

yet their revolution in seeing altered the course of twentieth-century art.

Kandinsky's relief prints had moved cautiously some way towards abstraction by 1910. In 1913 and 1914 however, he engraved several drypoints in which the link with the observable world was at last severed and the potential of line and form as a way of communicating emotion without representation was explored.

Technically, one of the most influential etchers of the twentieth century has been S. W. Hayter, an Englishman who set up a collaborative printing studio in Paris between the wars. He shared the results of very considerable expertise with many of the most famous artists there. In New York, where he lived during World War II, his interest in the automatic procedures adopted by Surrealists trying to tap their subconscious, influenced Jackson Pollock and the Abstract Expressionist generation. Hayter made much of soft ground textures used with an engraved line,

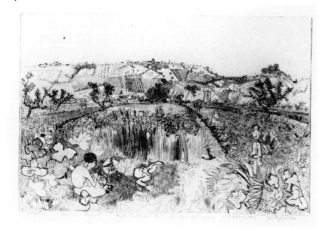

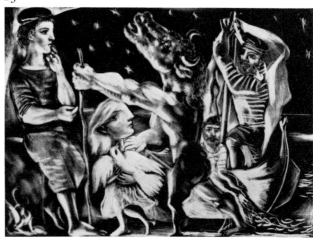

20 G. BRAQUE *Still Life I* drypoint 1911

21 KANDINSKY *Etching III*
drypoint 1913/14

22 S. W. HAYTER *Rape of Lucretia* engraving
and soft ground etching 1934

23 G. MORANDI *Large Still Life with Coffee
Pot* etching 1933

24 A. GROSS *Pujols* etching 1932

25 P. PICASSO *Blind Minotaur* no 97 from
The Vollard Suite scraped aquatint c. 1935

26 R. HAMILTON *Picasso's Meninas* hard
and soft ground etching, aquatint,
drypoint engraving, punch lift ground and
stipple 1973

26

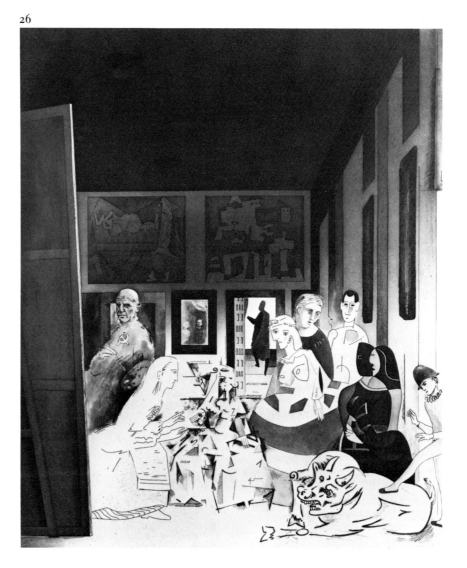

Anthony Gross, who has always
celebrated the lyrical in the everyday,
intensified his exquisitely drawn
etchings by biting parts of
them deeper in the acid for emphasis.

Picasso, instantly master of any
intaglio technique to which he turned
his hand, made a hundred etchings –
known as The Vollard Suite after the
famous Parisian entrepreneur of
printed art. Most sheets exploited the
simple neoclassical line to which he
had moved following Cubist pre-
occupations. One, featuring the blind
Minotaur – a mythical beast, half
man, half animal with which Picasso
identified – was made by scraping back
the image from an aquatinted plate.

In 1973, Richard Hamilton, more in
love with photo-technology than hand-
made prints, contributed an etching
to a portfolio in homage to Picasso
following his death. He used a famous
painting of the Spanish court by
Picasso's compatriot, Velasquez, as
a vehicle for a brilliant summary
not only of every conceivable intaglio
technique, but of Picasso's many
stylistic developments during the
twentieth century.

Featured artist
Norman Ackroyd

Brought up in the West Riding of Yorkshire, Norman Ackroyd remembers that one of his earliest etchings was a nostalgic view he made soon after moving to London looking out over South Leeds from a bedroom he had occupied for about twenty

years. It featured the city 'a bit like a scab', with miles and miles of back to back houses and railway viaducts and it initiated a whole series of urban landscapes.

After several plates based on smoky northern cities, the artist moved to a period of abstraction and photographic experimentation. Then, following travel in the United States, he featured places like Utah and Salt Lake City in his prints, as well as an amazing bulbous water tower on a derelict lot in East Michigan which he almost expected to light up electrically. It was always urban America that appealed to him for his work. Despite the beauty of ranges like the Rockies, he didn't feel the American landscape in his bones and had no desire to make pictures of it.

Since 1970 his interests have increasingly included country landscape in Great Britain. As a member of Lord Gnome's XI (associated with the magazine 'Private Eye') he often plays cricket in the counties close to London. When play is rained off, he takes the opportunity to draw. The interaction between hill, sky, and water, especially in the Scottish islands, is a constant source of wonder,

eliciting endless responses to be realised in aquatint. To him etching is a beautiful and mysterious way of drawing. He's complete master of the technique, delighting in experimenting with different porous grounds destined to achieve the atmospheric or misty qualities he is after, particularly the mood of certain places as modified by changing weather. He is adept at drawing with acid directly on the plate,

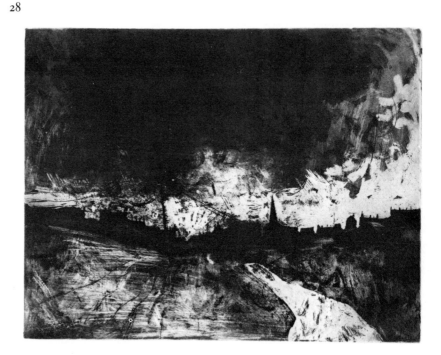

achieving more fugitive effects than by conventional immersion. In fact, the point at which the print has to be bitten with acid – maybe for fifteen seconds, maybe for an hour – provides a kind of excitement and puts him on his mettle. There is an element of risk, for some acids are vicious and bite irregularly, whereas others produce much gentler results. Norman owns one of the largest etching presses

in existence, with a forty-four inch bed.
Built in 1900 for Frank Brangwyn,
it passed to Merlyn Evans with whom
Norman worked at the Central School
of Art and Design. When Merlyn
died, the press became his.

The plate he etched for this book
was made out of doors on a wild day
looking down at the glacial valley
from the White Horse at Uffington,
The movement and slope of the hills
reminded him of a descending musical
scale. He was aware of the timeless
nature of the place and a 'presence',
the essence of which it is his ambition
to capture without slavish description.

Although he occasionally uses
a touch of colour, Norman, like
many other etchers, finds most of the
colour he needs in black and white
and regularly uses fifteen different
black pigments. 'Black and white
was all Goya, Whistler, Palmer and
Rembrandt ever used in their etchings,'
he says, 'and if it was good enough
for them, it's good enough for me.'

27 N. ACKROYD in his studio

28 N. ACKROYD *Storm over Gildersdale*
etching and aquatint 1958

29 N. ACKROYD *New Landscape* etching and
aquatint 1968

30 N. ACKROYD *Bridge and Rainbow* colour
etching and aquatint 1972

31 N. ACKROYD *East Michigan Landscape*
etching and aquatint 1971

32

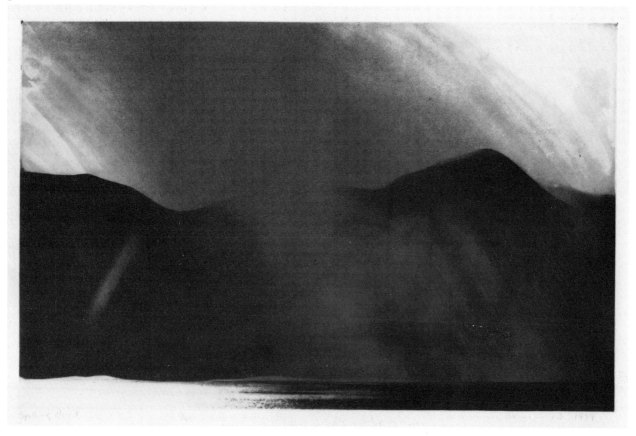

33

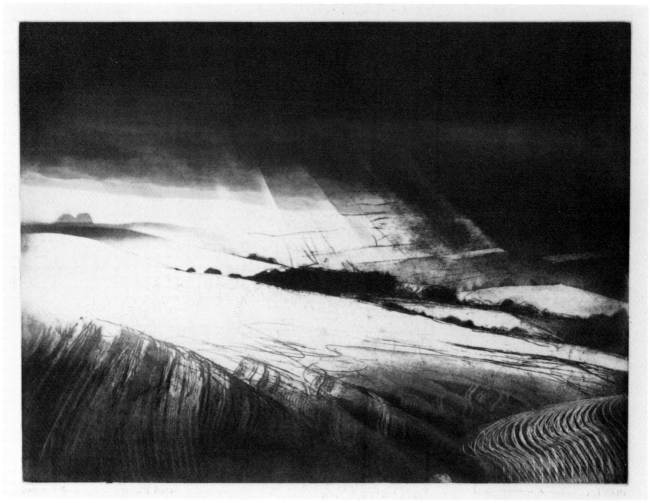

44

Step by step
Intaglio printing

Intaglio is an Italian word meaning incision and traditionally it refers to an image printed from the indentations in a metal plate.

There are two chief methods of incising the metal. Marks can be made directly in the metal using a variety of tools; this is called engraving. Alternatively the marks can be made indirectly by etching. Coming from a Dutch word meaning 'to eat', etching entails covering the metal with a wax and resin-based coating called a ground which resists acid. This is selectively removed by drawing through it with an etching needle or other tools so that acid can incise lines. The lines achieved by each method are quite different; in engraving they are deliberate with crystalline effect, in etching cursive and more like the marks possible with pen or pencil, although often finer.

The engraver's burin cannot draw cursively like a pencil. In normal usage it is driven forward by the artist's hand and, if a curve is desired, the plate must be turned accordingly. The tool can have various end sections,– square, scooped, or lozenge-shaped. It must be kept sharp and the way it is deployed on the metal affects the depth and the width of the cut and therefore the amount of ink it will hold.

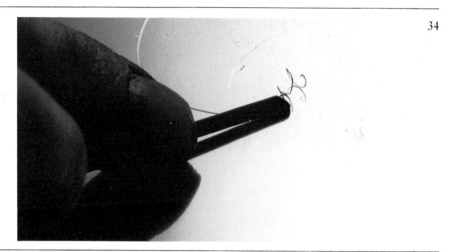

34

The curl of the metal the burin displaces can be removed with the scraper.

35

The drypoint, on the other hand, throws up a ridge rather as a farmer's plough throws up a furrow. This is not removed and when inked and printed produces a soft velvety line. The metal ridge wears down quickly with the pressure of the press.

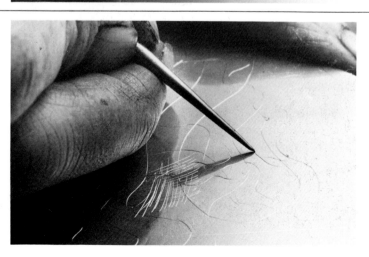

36

The mezzotint rocker, a curved
serrated tool with a number of tiny
teeth, provides a way of engraving
tones. Like the drypoint tool, it throws
up a burr as well as pitting the plate
with a roughened structure of tiny
holes to hold ink.

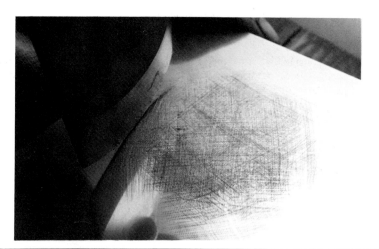

In traditional mezzotint the plate
would be roughened all over in this
way and then the drawing made by
selectively burnishing the roughness
away – partially to achieve greys,
completely to render whites from the
now smooth metal which would no
longer retain ink.

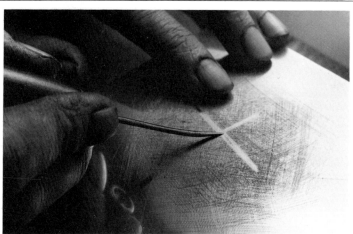

The roulette wheel works like the
mezzotint rocker but on a small scale.
It was often used for imitating a
crayon line in reproductive work.

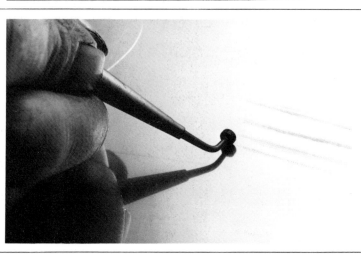

A characteristic which helps one
to identify an intaglio print is the
platemark which is pressed heavily into
the damp paper. Here Norman bevels
the edge of the plate so that it will not
cut through the paper or the blankets
which cushion the printing.

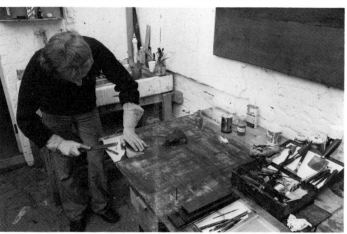

To ensure that any acid-resistant ground applied will adhere well, the plate is cleaned with a mixture of powdered whiting and household ammonia. Several metals can be used, among them steel and zinc, but copper etches most sweetly.

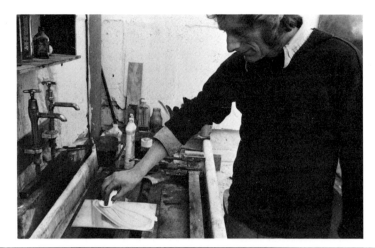

The plate is warmed to make it more receptive and a ball of hard ground, the main ingredient of which is wax, is applied to it. The copper Norman uses is supplied with a protective coating already on the back.

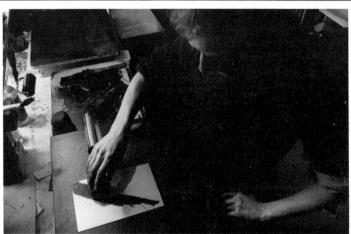

42

A leather-covered roller, used only for this purpose, is passed over the plate until a thin even film of the ground has been spread all over it.

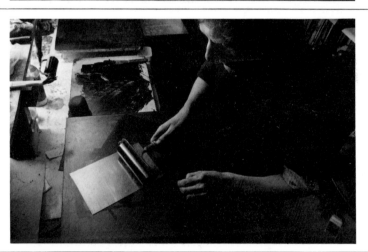

43

Now the plate is held aloft by grippers so that the rising sooty smoke from tapers can darken it. This allows the reddish-gold of the copper to show clearly against the carbon black when Norman draws into the smoked ground with his etching needle.

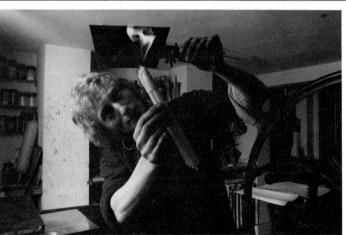

44

Among the many tools used to draw into the wax on the plate is an etching needle which can be finer than the finest pen . . .

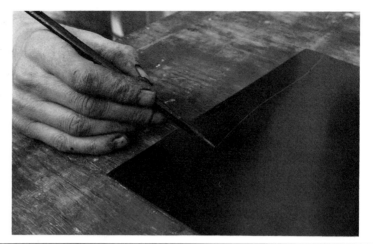

. . . or much coarser.

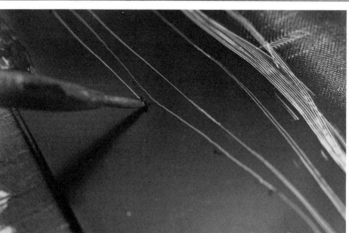

The mezzotint rocker clears a series of lines through the ground simultaneously.

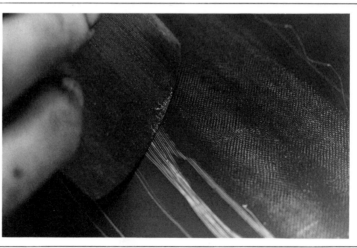

Various perforating rollers texture the ground . . .

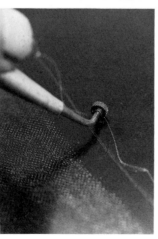
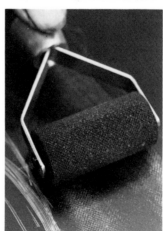

. . . as does a mace head covered in tiny spikes.

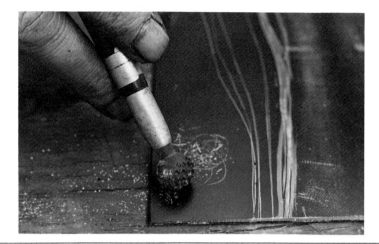

The demonstration plate, with the acid-resistant wax opened up by various tools, is placed in a bath of acid. Gases which are a hazard to health can be given off during this process as the metal erodes, so good ventilation or an extractor fan is essential. Norman uses a feather to brush away bubbles of acid gently as they form, otherwise they would distort his design during biting by irregularly obstructing the contact of the acid with the plate.

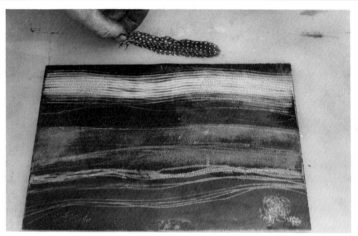

The ground is then removed with a solvent . . .

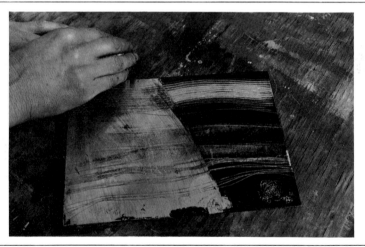

. . . and the plate printed.

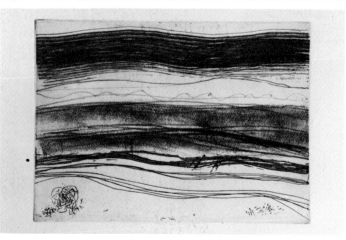

Tonal printing: aquatint

Apart from mezzotint, which is a direct but very laborious way of achieving tonal areas, the procedures described so far have mostly demonstrated how to arrive at linear marks on a plate.

In the eighteenth century however, aquatint was developed as a way of providing tone with less effort. If a large area of copper were to be bitten in acid without any prior preparation, the result would be a corroded wound in the surface only the edges of which would hold ink for printing. Aquatint provides an all-over 'tooth' or roughness for the ink to hold on to. A fine resin dust which is acid-resistant is fused to the plate and around each particle of it the acid bites its tiny channels.

Advocates of the mezzotint claim that their direct method, which throws up a burr as well as engraving a pit, gives a velvet black beyond the reach of aquatint, since the latter provides only indentations once the resin dust is cleaned off.

A fine 'snow' of dust on the plate is usually agitated inside a specially constructed box, but to make the process more visible, Norman shakes dust from a gauzy bag so that as even a coating as possible lands on the plate, covering about forty per cent of it. It is also possible to apply a liquid coating containing resin suspended in alcohol. The alcohol evaporates leaving just the dust on the plate.

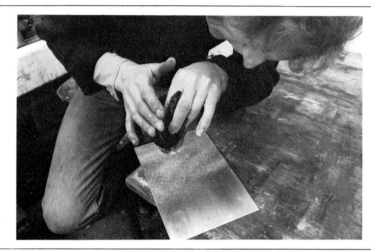

The dust is fused to the plate by heat thus making a porous acid resist.

As the flame is moved along, the resin becomes transparent. When cooled the plate is covered with a sea of tiny solidified droplets.

The longer the plate thus treated remains in acid, the deeper the indentations will be bitten and the more ink they will hold. After some biting has taken place a 'stop-out' varnish is selectively applied to prevent the acid reaching parts of the plate.

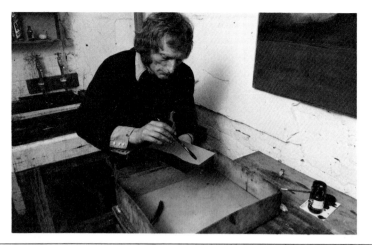

As time proceeds, fresh areas are 'stopped out' so that one ends up with a plate that . . .

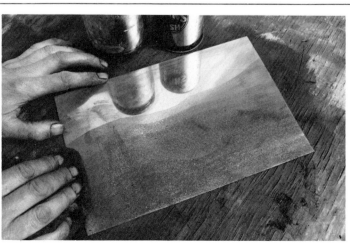

. . . once it has had the resin and varnish removed with solvents . . .

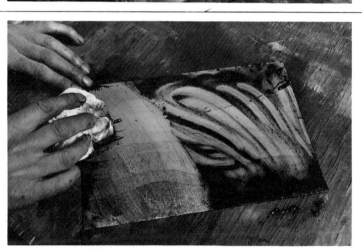

. . . and the metal polished . . .

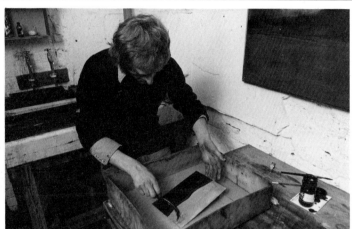

. . . will print a graduated range of
tones, the darkest bitten longest, the
lightest having had least exposure to
the acid and therefore holding less ink.

close up of the plate for the print
above, looks like this.

Lift Ground or Sugar Aquatint:

So far aquatint has entailed negative drawing. That is to say, Norman stopped out those parts of the plate that he did *not* want to print.

But there is also a way of drawing the mark that you do want in the print so that what is positively drawn on the copper will become the image (although of course, it will still be reversed by the process of printing).

For sugar aquatint the design is painted, or even fingerprinted, using a special ink made of sugar solution, soap and colourant. Because of the sugar, it never *completely* dries.

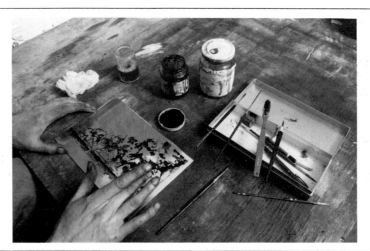

62

A liquid ground is then run over the plate including the all-but-dry drawing . . .

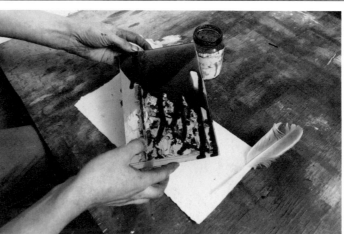

63

. . . and is teased out evenly with a feather.

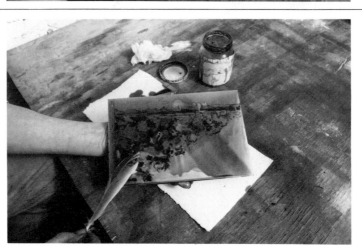

64

When the ground over the drawing seems dry, the whole plate is immersed in warm water. Water seeps in, swells the sugar solution and forces it to lift, thus baring the copper. The areas opened up are now aquatinted as shown in the sequence of pictures from 54 to 62.

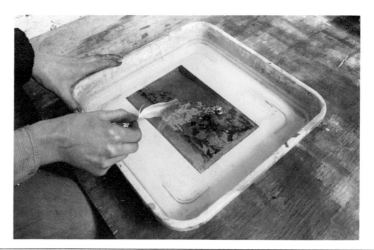

65

Picasso used the technique brilliantly, for the exquisite illustrations to 'La Celestina' which he made in 1968. Of course he disobeyed the injunction to de-grease his copper plate and made the drawing work against the resistance of some kind of oil.

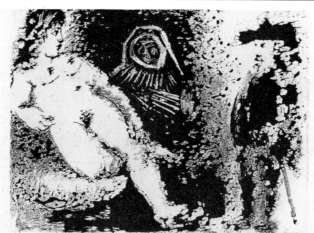

66

Norman makes his own ink. To a well in a mound of powdered pigment, he adds various oils (usually plate oils from burned linseed) . . .

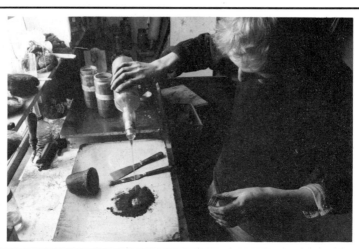

67

. . . mixing them thoroughly together with a palette knife.

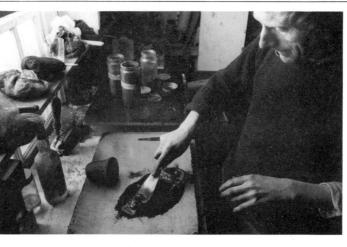

68

Then a marble muller is used to grind the mixture until all grittiness has gone and the ink has a fine buttery texture.

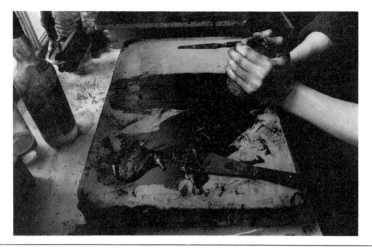

The plate is warmed to make it more receptive to the ink and a roller is used to spread it all over the surface . . .

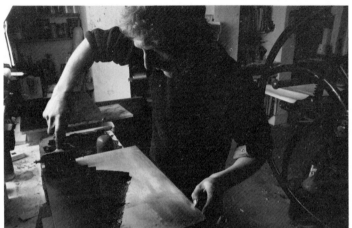

. . . where it is dabbed in until all the intaglio work is completely filled.

Pads of tarlatan, a kind of coarsely woven fabric, are rolled into flattened circular wads. Progressively cleaner ones are used . . .

. . . as wiping proceeds. They remove excess ink with a particular stroke that ensures it is not pulled out of the incisions.

73

A film of surface ink can be left to give a tone across the plate area, but if a brilliant silvery impression is desired, the heel of the palm is rubbed over a block of whiting . . .

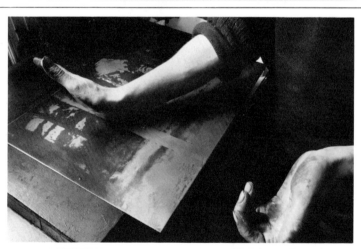

74

. . . and the plate is hand wiped during the final stages to remove all traces of surface ink.

75

The paper for intaglio printing is usually a beautiful and often expensive hand-made one and it has to be dampened before printing takes place. Here Norman sponges the surface with water, later he shuffles the sheets between blotters to distribute the dampness evenly.

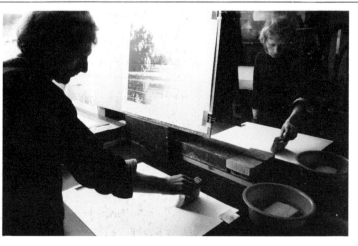

76

For accurate registration the places where both the inked plate and the sheet of paper are to be set down are marked on the bed of the press.

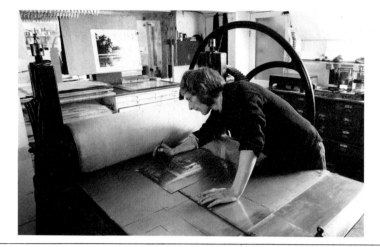

A sheet of suitably absorbent paper is placed carefully over the plate.

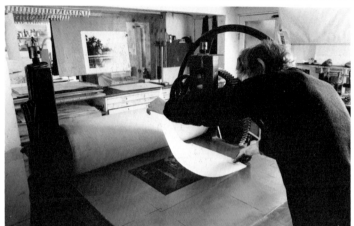

Norman places two blankets to cushion the pressure and help the paper to mould itself into the incisions in the plate and there pick out the ink.

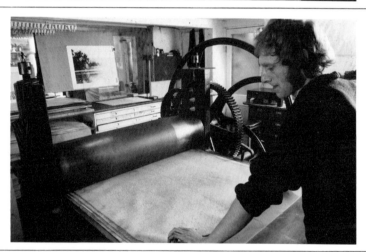

Turning the wheel causes the bed of the press to move between rollers. The action resembles that of an old fashioned mangle and pressure can be adjusted.

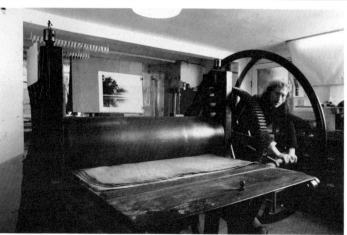

Using paper shields to prevent fingermarks on the margins, Norman peels the impression off the plate . . .

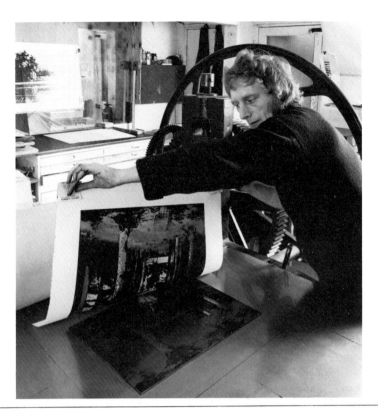

. . . and surveys his handiwork.

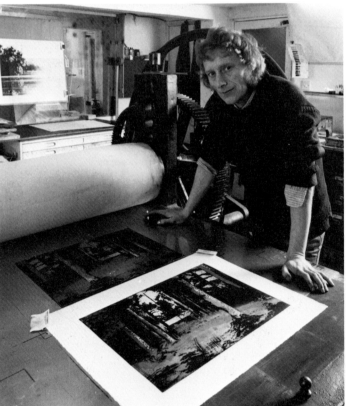

Gravure

the commercial form of intaglio printing.

83

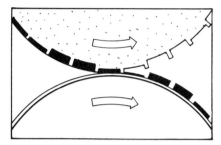

The earliest form of photographic intaglio – photogravure – was discovered in 1879. Such prints are inked and printed just like the etchings described on pages 55 to 57. Photogravure uses resin dust like an aquatint. After the dust has been fused to the plate by heat, a coating of light-sensitive gelatine emulsion applied to the plate is exposed to light through a positive transparency (which reverses the light/dark scale of the conventional photographic negative). The most open portions in the transparency (corresponding to the lightest portions of the subject) allow light to produce

maximum hardness in the emulsion and thereafter total resistance to the action of the chemical biting into the metal. The grey or darker parts of the transparency admit varying degrees of light and corresponding degrees of openness in the gelatine which the chemical eroding the metal must first penetrate. The extent to which the metal is etched away affects the amount of ink which can be held in the incisions in the surface. Hand photogravure was used in Victorian times a great deal for the reproduction of oil paintings. It has also yielded very faithful facsimile reproductions of Old Master intaglio prints, the true nature of which can only be detected under a magnifying glass.

The rotary version of this process – rotogravure – involves an expensive copper cylinder, or a plate to wrap round a cylinder, employed on web-fed presses for long runs. To make the cylinders, the reverse of a half-tone screen is used in which the grid of criss-crossed lines is transparent and the squares between them opaque. On exposure to light, the emulsion on the copper hardens in a way which will protect the grid of lines on the plate from acid, but remains soft within the squares. Exposed to

light again under a positive photographic transparency of the subject to be reproduced, each tiny square duct is now opened up by the acid in a way proportional to the amount of light striking the emulsion. These ink-holding cells are of equal area but varying depth and are able therefore to retain differing amounts of thin volatile ink producing a rich range from highlight to shadow. The grid of protected lines creates a support structure on the original surface of the cylinder across which the flexible steel scraper known as a 'doctor blade' is passed. When printing, the etched cylinder rotates in a trough of spirit ink, the surplus is scraped off by the doctor blade, the printing paper is brought round by the rubber covered cylinder and the ink lifted out into the paper to dry by absorption and evaporation. Sheets of paper are used for such reproductions as the National Gallery's version of Constable's 'Cornfield'. Web-fed machines, designed to run at tremendous speed and therefore more suitable for long runs are used for stamps, mass-circulation magazines and colour supplements.

84

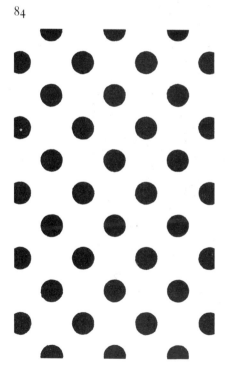

85

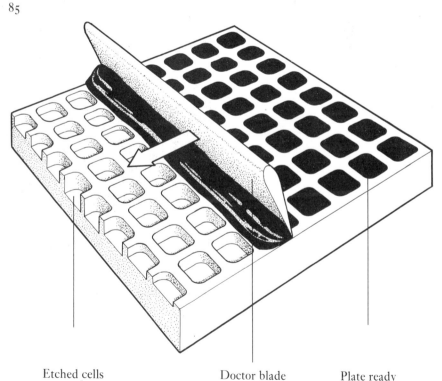

83 In gravure, ink is deposited on to the paper from the etched indentations on the plate.

84 Enlarged reversed half-tone screen.

85 Illustration of gravure plate much magnified.

Etched cells of differing depth Doctor blade Plate ready to be printed

The unique characteristic of rotogravure is that all copy whether of continuous tone, line illustration or typographic nature, must be screened, breaking the entire printing surface into thousands of microscopic squares. Magnified, letters appear slightly ragged, for although the process imitates the continuous tonal effects of a photograph most closely, even on cheaper paper, it isn't kind to the fine serifs of elegantly tapered letters.

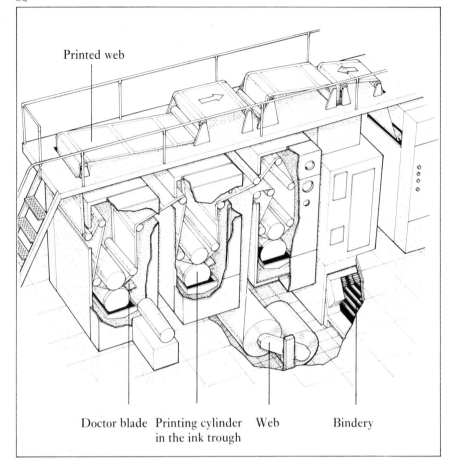

Printed web

Doctor blade Printing cylinder Web Bindery
in the ink trough

86 Cut-away illustration of a web-fed rotary gravure press.

87 Cerutti web-fed rotary gravure press, printing the colour section of the Radio Times.

87

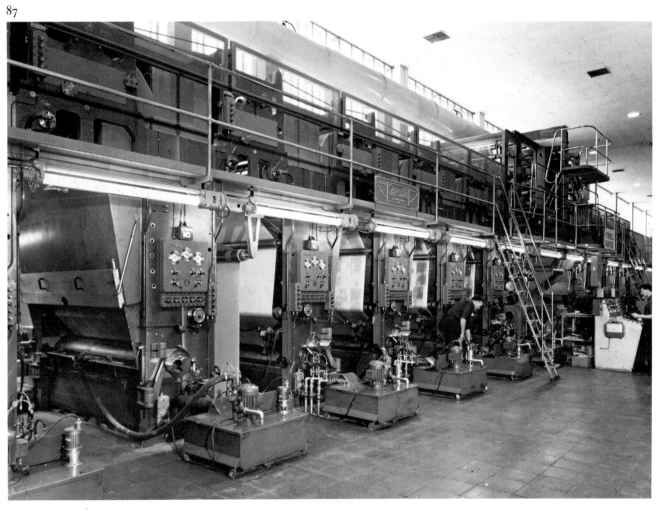

Lithography

History of lithography

Unlike relief and intaglio printing already discussed, we do know who discovered lithography. His name was Senefelder and he was a Munich playwright looking, just before the beginning of the nineteenth century, for a cheap way of printing his plays. Lithography (from the Greek for writing on stone) involved drawing or painting in a greasy medium in crayon or liquid form. This was either applied directly to the porous slab of stone, or transferred to the stone from a special paper. Nowadays, grained metal plates have mostly replaced stone.

The French Romantic artist, Géricault, was one of the early major artists to use the process. He made a series of wonderful crayon lithographs featuring tramps, workers, and horses which he had seen on a visit to London in 1820. But like aquatint, lithography coincided with the increase of tourism and the growing importance of landscape painting, particularly in watercolour. So Isabey's delicately stippled drawings, which he based on his travels in Italy, are more typical of the way that lithography was at first exploited.

Daumier however, used it as a vehicle of social and political protest at a time of great unrest in France. Several thousand prints issued from him for the periodicals of his day. He went to prison for portraying King Louis-Philippe as a Gargantua gorging public money and he had a wicked eye for the foibles of the middle classes and their discomfiture at the fickle Parisian weather. Photography was discovered during Daumier's career, but whereas our cartoonists have their work reproduced photomechanically, Daumier's public saw his marvellous draughtsmanship at only one remove from his hand. His drawing on the stone created a wonderful tonal range from silky grey to rich black.

1

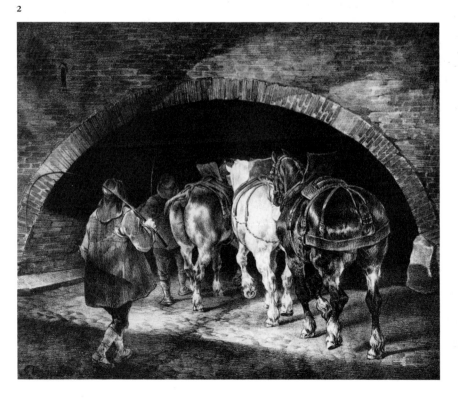

1 J. B. ISABEY *Neptune's Grotto, Tivoli Villa* from *Voyage en Italie* lithograph 1822

2 J. GÉRICAULT *Entrance to the Adelphi Wharf* lithograph 1821

3 H. DAUMIER *O Patrie* from *Emotions Parisiennes* in 'Le Charivari' lithograph 11 Jan 1840

2

3

By the mid nineteenth century the lithographic process was associated mostly with cheap commercial reproduction, but in the last quarter of the century, with the impetus given to printmaking by the influx of Japanese woodcuts, lithography enjoyed a remarkable flowering.

Degas, who was associated with the Impressionists and dedicated to capturing the 'unpremeditated gestures of everyday life', viewed his subjects from the unusual angles that photography and Japanese prints had suggested to him. Highly experimental in approach, most of his lithographs remained unpublished during his life-time, although he would work at perfecting them over the course of several trial states – six in the case of the nude seen here after her bath. Evidence suggests he transferred a greasy drawing on celluloid to the stone and there reworked it with crayon and scraper until it satisfied him.

The year Degas was experimenting with a series of nudes at their toilet, Odilon Redon made an album called 'Songes' ('Dreams') in memory of a botanist friend who had been an important intellectual influence as well as stimulating his imagination by

showing him how life looked under the microscope. The world of Symbolist poetry Redon inhabited however, was largely disenchanted with science. The realism of Zola, the attitude which had made Courbet say he would only paint an angel if he saw one, and the naturalistic approach of the Impressionists did not attract Redon who said he 'found its ceiling too low'. His mysterious velvety black litho-graphs are full of strange twilights and phosphorescent flowers poetically captioned. He treated the printing surface like a sensitive skin and obeyed the poet Mallarmé's injunction to suggest rather than describe. Imaginative fantasy was given free rein as Redon placed 'the logic of the visible at the service of the invisible'.

Whistler's view of the Thames – a wash drawing on stone – was made from an upper room at the Savoy Hotel where he lived with his dying wife. The same year that it was made, Vuillard's first colour print was commissioned by Vollard, who was destined to become one of the great publishers of the twentieth century. Vuillard and Bonnard – both Post-Impressionist followers of Gauguin who shared a studio in Montmartre – both made remarkable suites for him

that are triumphs of colour printing. They show unmistakable Japanese influence with their unusual com-positions and strong flat sense of pattern – an influence that Whistler also absorbed, but in a different way.

Bonnard illustrated the first of Vollard's notable books – a volume of suggestive poems called 'Parallèlment' by Verlaine. The artist's delicious pink lithographs, sprawling into the margins, gave apoplexy to book-lovers, who thought all illustration should be printed from a relief surface, like the text. The Imprimerie Nationale printed the elegant italic typeface but removed its name after the Director had decided the poetry's subject matter was somewhat questionable.

4 DEGAS *Après le Bain* lithograph 1891

5 REDON *Sous l'aile de l'ombre* pl. IV of *Songes (Dreams)* lithograph 1891

4 5

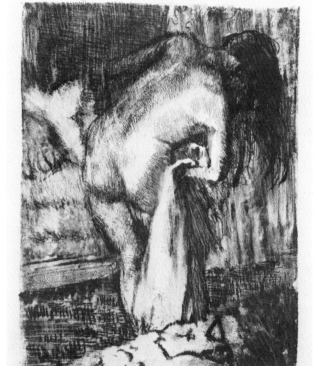

6

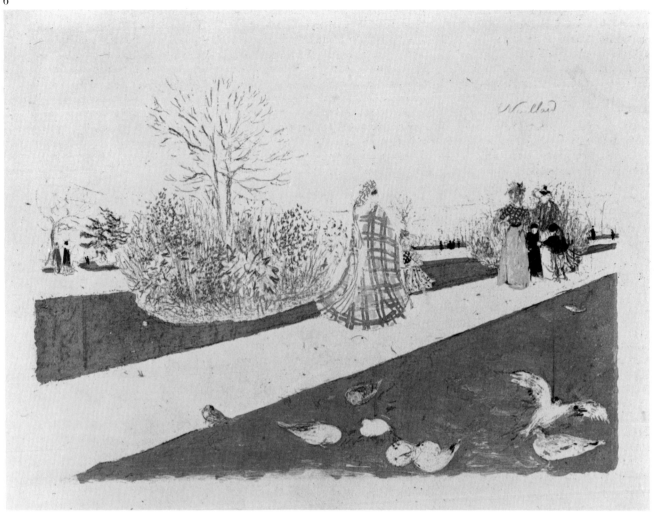

7

8

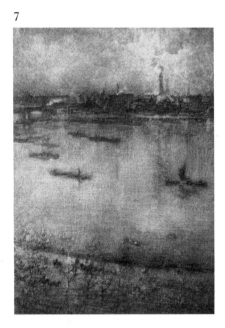

Je te veux trop rieuse
Et très impérieuse,
Méchante & mauvaise &
Pire s'il te plaisait,
Mais si luxurieuse!

Ah, ton corps noir & rose
Et clair de lune! Ah, pose
Ton coude sur mon cœur.
Et tout ton corps vainqueur,
Tout ton corps que j'adore!

Ah, ton corps, qu'il repose
Sur mon âme morose
Et l'étouffe s'il peut,
Si ton caprice veut!
Encore, encore, encore!

6 VUILLARD *Jardin des Tuileries* colour
lithograph 1896

7 WHISTLER *The Thames* lithotint 1896

8 BONNARD illustration from Verlaine's
'Parallèlment' colour lithograph 1900

Limited edition publishing was by this time widespread. The Verlaine book numbered 233 examples while Vollard's print albums appeared in editions of a hundred although even then they didn't sell. Even now artists' prints have become more popular, dealers prefer to retain the idea that they should be a limited luxury.

Between the wars Barnett Freedman was one of several artists who believed it was possible for hand-made prints to circulate widely as they had done in Daumier's day. An East-end Jew and an engaging character, Freedman was one of many artists employed by Frank Pick to make lithographic posters

9

for London Transport and the artist believed in hand drawing them. Idealists in those days saw the hoardings as the general public's picture gallery. Freedman also illustrated books in general circulation the same way, as well as ephemera ranging from publicity leaflets to the most delightful little Xmas cards for various firms.

Much of Freedman's work was printed by the famous Curwen Press, but in the 1950s, when union restrictions began to make the kind of collaboration he had earlier practised difficult, Curwen opened a special studio for artists – the first of its kind in England.

Ceri Richards, working with the master-printer Stanley Jones, made a moving portfolio of lithographs there in 1965 in memory of the Welsh poet Dylan Thomas. Metaphors for birth, love and death abound in the work of both men and two symbols for death – the owl and a spray of plucked blossom – recur in Richards' suite. Framed here by the four elements – earth, air, fire, and water – the pot of ink and leaves of paper distributed like gulls in the wind nevertheless suggest that those who leave evidence of creative activity behind them in one sense at least, survive.

Graham Sutherland also worked at Curwen, but on moving to France after the war was more often seen at the famous Mourlot atelier in Paris, where nineteenth-century lithographic traditions continued. In 1949 Picasso drew the famous dove at Mourlot's atelier which was used for a limited edition as well as for a communist congress poster. Similarly the portraits of his own children which he drew by fingerprint on lithographic transfer paper became both a limited edition lithograph and the cover for a book about his prints which Mourlot published. Sutherland's 'Predatory Form' is not without Picasso's techni-

10

11

cal influence, although this disturbing presence derives from a hybrid of organic forms inspired by Surrealism.

Formulated in 1927 the movement numbered among its first adherents the German painter, Max Ernst. In 1925, when still a member of the Dada movement, intent on shocking the middle classes, Ernst claimed to have discovered the automatic technique of frottage – a way of repeating images by placing a sheet of paper over a textured surface and taking an impression. To the bourgeoisie, for whom art was synonymous with skill, the idea that chance might enter into it was disturbing, although by 1979, the year of his

death, when frottages were still appearing in his prints, Ernst was at last accepted as a grand old man of painting.

9 B. FREEDMAN Christmas card lithograph 1956

10 C. RICHARDS *And Death Shall Have No Dominion* from *Dylan Thomas suite* colour lithograph 1965

11 P. PICASSO *Dove* wash lithograph 1949

12 P. PICASSO *Paloma and Claude* lithograph 1950

13 G. SUTHERLAND *Predatory Form* lithograph 1953

14 M. ERNST *Composition* colour lithograph 1979

13

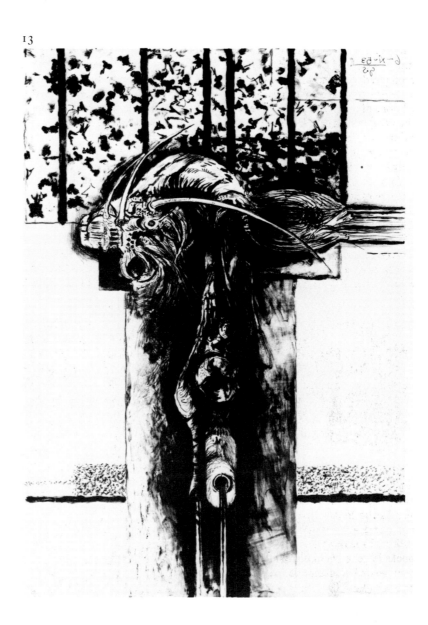

12

14

As an immigrant to New York during World War II, Ernst was one of several Surrealists who in the early 1940s decisively influenced an indigenous school of American action painters in the use of automatic techniques. Among them was Jackson Pollock, known as Jack the Dripper because he would unconventionally allow paint to flow from a variety of implements on to canvases spread on the floor. Although Pollock made a few etchings, his generation were for the most part too busy with the huge canvases to make prints. Despite lithography's suitability for recording gesture, it was

1960 before de Kooning, another of the group, briefly tasted the medium. In 1971 he tackled Walt Disney's 'Minnie Mouse' – a comic version of the brutal images of woman that had made him famous.

Printed art, however, came naturally to the next generation who formed a bridge between action painters and Pop Art. Now that prints by School of Paris artists like Chagall and Picasso were becoming popular, several lithographic studios opened in America – one of them with the explicit aim

of training master printers. Jasper Johns used banal images, such as the American flag and sets of numbers, as a foil for subtle reflections on process. As traditional lithography was insisted upon in this revival, one wit described it as 'bringing back the stone age'. And although Rauschenberg at first thought it was 'a little late to start writing on rocks' he quickly warmed to the medium. In 1963, with a lithograph called 'Accident' made from a stone that had disintegrated during printing, he won a major graphic prize. 'Accident', with its broad passages of gestural brushwork, incorporated

15

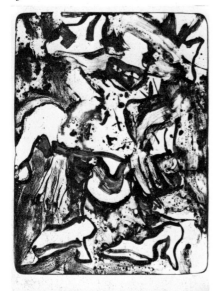

16

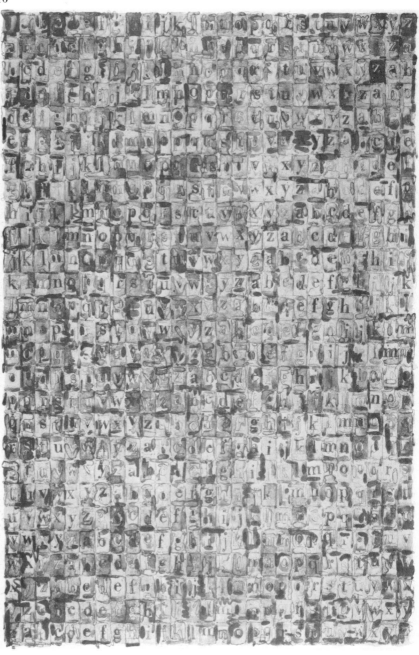

15 W. DE KOONING *Minnie Mouse* lithograph 1971

16 J. JOHNS *Grey Alphabets* colour lithograph 1968

66

photographic images as well at a time when purist dealers and connoisseurs were busy banning them.

Photographically processed imagery from the mass media however became an important ingredient of Pop Art. Fifteen years later in the Japanese Akira Murakami's 'Transit', photography is simply used as a tool to record the passage of time as the shadows of an overhanging tree mark their positions on the artist's printing plates. In this way, instead of the artist drawing a landscape, the landscape very nearly draws itself.

17 R. RAUSCHENBERG *Accident* lithograph 1963

18 A. MURAKAMI *Transit* two sheet colour lithograph 1979

18

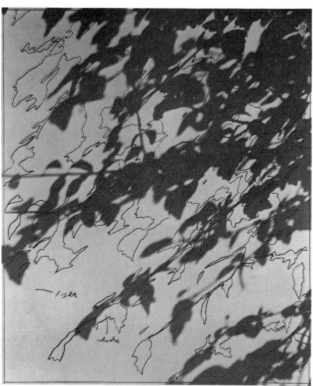

67

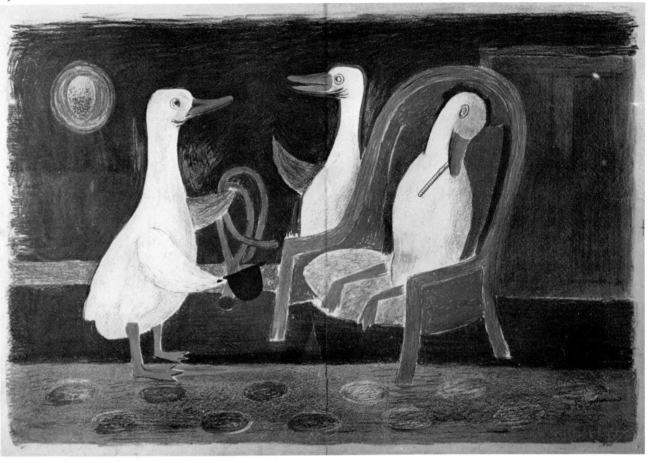

Colour lithography

Lithography is a particularly appropriate medium for colour printing, because of the beautiful way the bloom of one ink transparently modifies another. The lucid illustrations that the English water-colourist T.S. Boys made for an album 'Picturesque Architecture', published in 1839, are a great landmark in the history of printed colour. Boys, who claimed the album introduced a new epoch, said the prints had been 'drawn from nature on stone.'

The venture was not a financial success, however and the second half of the nineteenth century was well advanced before more original prints in the form of Chéret's coloured posters, set an example to Toulouse Lautrec, although reproductive lithography continued throughout the century.

Lautrec had a passion for the performing arts and frequented the night-spots of Paris in the period known as the naughty nineties, making remarkable lithographs of singers and dancers. Loie Fuller danced at the Folies Bergeres in 1892, appearing in swirling veils lit by a kaleidoscope of electric light which Lautrec tried to capture by printing various colours, then heightening the results with metallic powders. Loie Fuller was the first 'connoisseur print' Lautrec made, for he established his reputation as a master of printmaking with the magnificent posters which took high art to the hoardings in the early days of street advertising.

But despite the great flowering of the medium at the end of the century, relief and intaglio printmaking dominated the early part of the twentieth century while lithography developed chiefly as a reproductive process. Although occasional original lithographs were produced, these did not start to become popular until after World War II when several publishing houses began to advocate modestly priced lithographs by contemporary painters as an alternative to photo-mechanical reproductions of famous old masters. Indeed, it was even suggested that reproductions had no qualities at all and that originals were in some way morally superior to the photomechanical prints that most people might have had on their sitting room walls.

A very early popularising venture in England, nipped in the bud by the outbreak of World War II, was the attempt by the artist John Piper to bring original prints to school children. Paul Nash and Graham Sutherland were among several well-known British artists that took part. Nash made a very important lithograph while Sutherland, in a not very typical image, depicted a sick duck receiving a visit from the doctor.

After the war, as modern masters like Picasso and Chagnall became highly popular, their images often served dual purposes, being used first as limited edition prints and then run on as posters or much cheaper images on inferior paper having smaller margins.

19 G. SUTHERLAND *Sick Duck* colour lithograph 1936

20 T. S. BOYS *Hotel Cluny, Paris* plate 13 of
Picturesque Architecture colour lithograph 1839

21 T. LAUTREC *Loie Fuller* colour lithograph 1893

22 P. NASH *Landscape of the Megaliths*
colour lithograph 1937

21

20

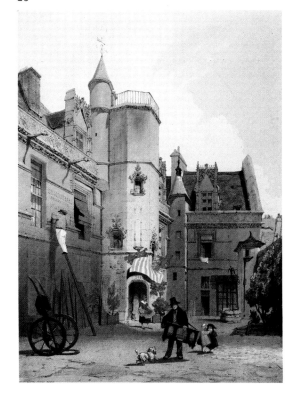

22

23 DUBUFFET *Carrot Nose* colour
lithograph 1962

24 M. CHAGALL *Nice, Soleil, Fleurs* colour
lithograph and poster 1962

25 D. HOCKNEY *Mist* from the Weather
Series colour lithograph 1973

24

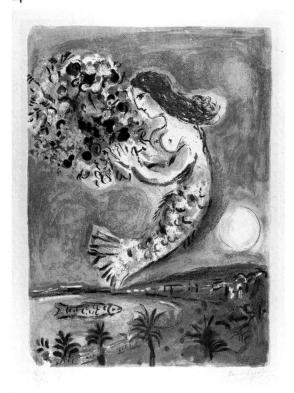

23

25

Chagall's flower-carrying mermaid
advertised Nice for the Ministry of
French Tourism after a prior run with-
out lettering as a limited edition print.

Dubuffet, interested in outsider art
by the untrained and insane, began a
love affair with lithography in 1957 in
which he allowed disparaged objects
such as grass, dust, orange peel, and
soil, impregnated in litho medium, to
be transferred to the stone with as little
conscious control as possible. Once the
impression was on the stone, a print
could be taken from it. Dubuffet used
this library of some 2000 textures, to
make printed collages in colour, such
as his amusing 'Carrot Nose'.

David Hockney, among the most
popular British artists, lived for part
of 1973 in Los Angeles. He made two
related images of that city in a mist –
one in which palm trees loom out
of dark washes, the other in which
the mist swathes them in tangles of
coloured crayon strokes. Ken Tyler,
the printer with whom Hockney then
worked, is one of the world's outstand-
ing lithograph printers.

for picture details see page 72

Picture captions from previous page

26 G. B. HARTE *Mr. Dodd's Auricula* 1979

27 G. B. HARTE *P. Herbert, Paris* 1978

28 G. B. HARTE illustrations from *Metroland*
a poem by John Betjeman 1977

29 B. NEILAND *Citti Corp* lithograph 1980

30 B. NEILAND *West Central I* lithograph 1976

31 B. NEILAND *Millbank* lithograph 1974

31

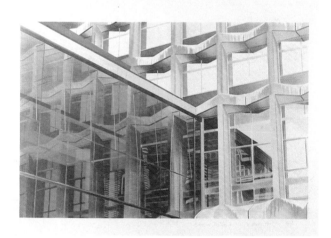

30

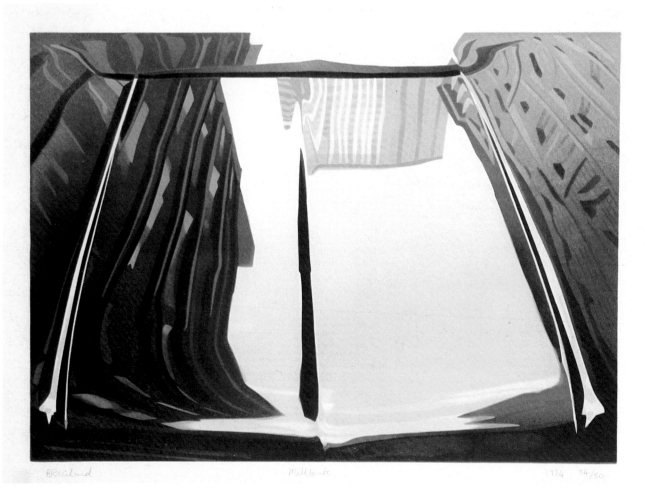

Featured artists

*Glynn Boyd Harte and
Brendan Neiland*

32

'Everyone knew more about the process than me,' said Glynn Boyd Harte after trying to explain the technicalities of lithography for television recently. 'I just did it!'

To make a lithograph without bothering too much about technicalities is something the long tradition of collaborative printing in lithography affords. It has been particularly strong in France since the end of the nineteenth century when artists were served by printers like Auguste Clot and Ancourt. The medium was revived in Britain and America during the 1950s at the outset of a particular boom in the making and sale of printed art. It was then that the Curwen Studio, an offshoot of the famous Press, was opened to give assistance to artists. Glynn made the print he demonstrates in this book at the Curwen Studio just off Tottenham Court Road in London.

Despite the fact that his father had a lithographic printing works and that he has made numerous lithographs since leaving the Royal College of Art in 1974, Glynn is glad to leave all aspects of the printing to others so that he can concentrate on the image. He has a great nostalgia for the 1920s and 1930s when the Curwen Press at the height of its fame dominated much book and publicity printing and encouraged artists to draw lithographs directly. His home is full of reminders of the period and many of them find their way into his work.

The print Glynn demonstrates here featured a chance arrangement of objects on his kitchen table. It had as its companion piece 'Mr Dodd's Auricula' in which some of his favourite drawing implements and a trio of books evoke a typical period flavour. The artist is fond of Paris and has lithographed a suite of prints featuring Parisian shop fronts. He has also illustrated a book about power stations as well as an amusing poem about suburbia called 'Metroland' by John Betjeman, for which he has exactly the right tongue-in-cheek approach. Although it's true to say his prints are essentially conceived as coloured pencil drawings the artist relishes the luminosity and the unification of various different drawing materials that lithography offers.

33

Brendan Neiland's lithographs are made in a way closely related to his painting, using stencils and a spray gun in both cases but for works of very different scale. Whether he paints or prints, the subject has to be analytically thought out in terms of separated colours. These are built up in layers with an understanding of all the subtle tonal nuances possible from a spray gun. A stencil is not related to one single colour. Each one may be used as a mask through which to apply any or all of the colours used in the print. Knowledge of how to combine this complex layering is something that comes only after long experience.

When he began painting Brendan was fascinated with motor cars and the way surrounding buildings were reflected and distorted by the curvature of their shiny bodies or windscreens. More recently he has looked upwards at glass panelled office blocks in the urban environment and observed reflections in their glittering surfaces. Although labels are really only rather crude attempts at categorisation that make art historians feel more comfortable without saying a great deal about the infinite variety of artists, Brendan's work has some affinity with those painters the Americans call Photorealists. These painters are not interested in painting directly from nature, but in the world as it appears frozen and composed in a photograph. Such painters often record, as Brendan does, the apparent dematerialisation of a building when a passing cloud or neighbouring structure is reflected in its raked glass surface. They delight in the ambiguity that can exist between the inside and the outside, and in the surprising compositions that the angled camera can capture. But despite the fact that the starting point is invariably a photograph, it is a photograph interpreted rather than reproduced.

32 G. B. HARTE in his kitchen with his still life

33 B. NEILAND looking at his cut stencils

Step by step Lithographic prints

The principle behind lithography is quite simply that a greasy drawing on a porous stone or specially grained plate will accept ink, while the surrounding non-printing areas, having been chemically treated and then dampened, will reject it. The surface is not raised or lowered and for that reason the process is sometimes referred to as 'planographic'.

On a direct press, where the image is picked up by paper in contact with the inked stone or plate, the image will be reversed. On an offset press however, including the commercial photographic process used for printing this book, the ink from the image is first picked up on a blanket or roller and then transferred to paper. This means an artist can draw his design the right way round in the first place since it reverses on to the roller and is set back the right way again upon being offset. Another way an artist can print a lithographic drawing the right way round by direct printing is to make it on a special transfer paper. This paper, when dampened and placed face down on to the stone or plate and put through the press, will impart its greasy image to it. This can then be inked and printed in the usual way as if it had been drawn there in the first place.

Glynn Boyd Harte's print

For his lithograph, Glynn Boyd Harte makes a preparatory drawing in coloured pencils of a chance arrangement of objects on his kitchen table.

34

He then discusses how it will be printed with Stanley Jones, master printer at the Curwen Studio, a collaborative lithographic studio opened in England in the late 1950s. Stanley is seen here in the early days at the Press, printing a lithograph by the Welsh artist Ceri Richards.

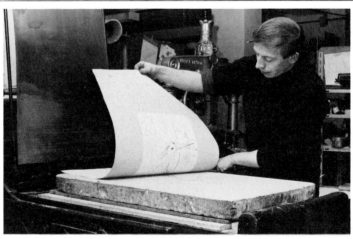

35

With Stanley's help, the artist has worked out that he needs six plates – dark blue as a basic outline; green for leaves and stripes in the teacloth; grey for shading; rocket red and magenta for the carnations; cream for the tablecloth. To facilitate the registration of all these colours, the artist makes a key tracing with a rapidograph pen which the printer Roy Silvey photographically transfers to each of the printing plates. This will not print but merely provides guide lines to assist the artist in drawing his colour separations.

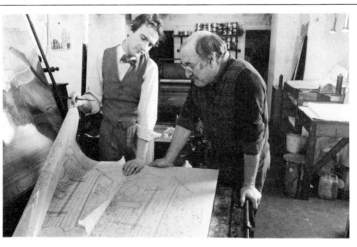

36

The artist's key tracing is first transferred to a sensitised litho plate photographically and the image is inked up for printing in the direct press.

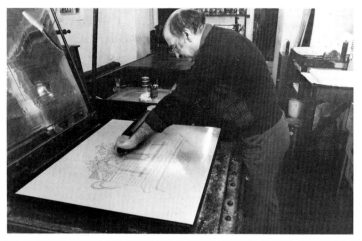

To do this a sandwich is made with the plate, the sheet of paper to be printed, some packing material and finally the brass tympan of the press. This metal sheet is well lubricated so that the leather scraper bar . . .

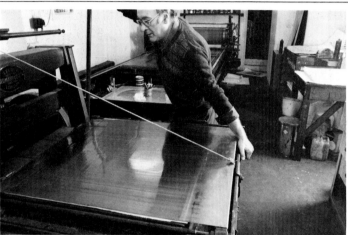

. . . will pass easily over it as Roy pulls down the lever to start the press. The whole bed of the press moves underneath the scraper which causes the image on the plate to transfer its ink to the sheet of paper.

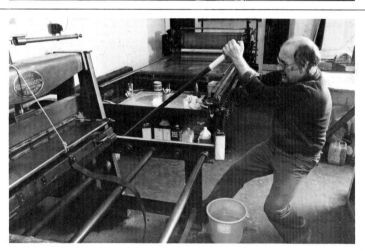

In this initial stage the print has been made on a sheet of very glossy china paper which does not absorb the ink.

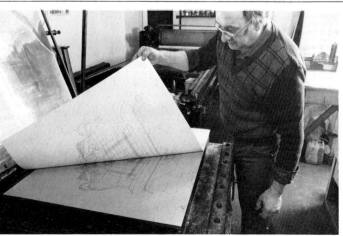

Roy dusts methyl violet powder on to this still wet impression where it adheres to the ink. The surplus is shaken off.

41

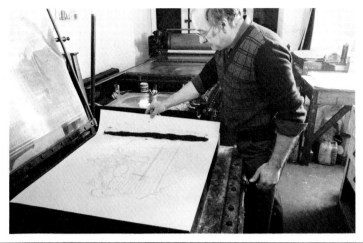

The dye powder sitting on the ink is then transferred by direct contact to a plate sensitised to accept one of the artist's drawn separations. The printed sheet powdered with dye is placed face down on the sensitised plate and put through the press to offset it. A print from the plate bearing the guideline drawing can be similarly dusted with dye and transferred to each of the plates the artist needs.

42

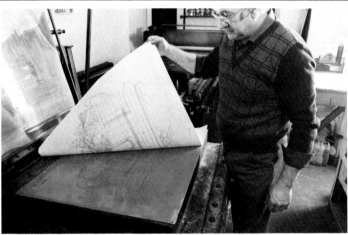

Whatever the colour to be printed, the artist draws the plate in lithographic medium – a substance made of hard wax and castile soap coloured with lamp black. While the black colorant allows Glynn to see what he is draw-ing, it washes out before printing leaving only the grease behind; the intensity of the colour printed lies therefore in the amount of grease deposited, not in the blackness on the drawn plate.

43

The artist can use the grease in the form of crayons . . .

... by rubbing a little block with a cloth and transferring it to the plate for particularly soft effects . . .

44

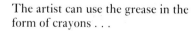

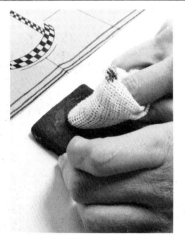
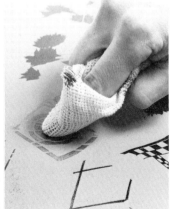

. . . and also in a liquid form – like ink – which he can apply with a fine brush or pen.

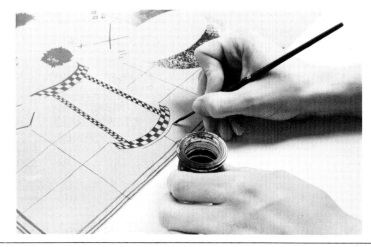

Here the bowl in Glynn's still life is being spattered by drawing a palette knife across a toothbrush charged with liquid litho medium – a technique much loved by Toulouse Lautrec. The areas the artist does not want to spatter are blocked out with gum to protect them from the grease.

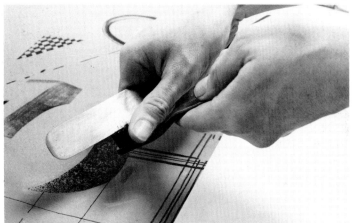

46

Here, the artist, protecting the plate from the natural grease of his skin (which can also carry ink and produce a print) is making a greasy drawing on the plate of all those parts in the original which he wants to print in rocket red.

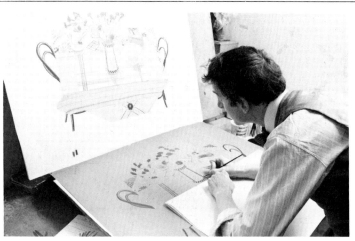

47

When he has finished the drawing it is dusted with a mixture of French chalk and resin which adheres to the grease and reinforces it.

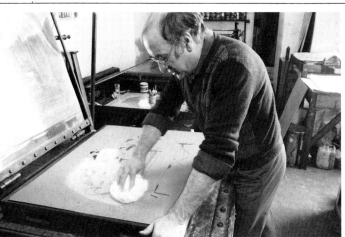

48

The plate is now desensitised with
acidulated gum. A solution of gum
arabic with a few drops of tannic acid
in it is wiped over the whole of the
plate with a soft pad of cloth. This
makes the undrawn areas more
inclined to attract water and repel
grease and prevents the drawing
spreading.

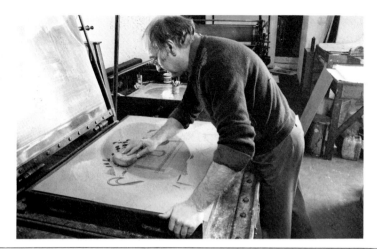

The excess gum is blotted and the
plate dried.

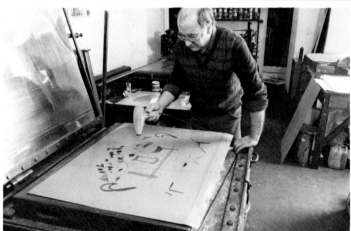

Now asphaltum – a mixture of
powdered asphalt, olive oil and
turpentine – is applied to the plate.
It washes the lamp black out of the
drawing so it can barely be seen, but
establishes the greasy element of it on
the plate.

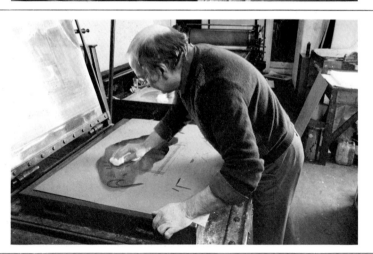

After drying again, the plate is washed
with water. It is then ready for inking
and proofing as shown in stages 37 to 40.

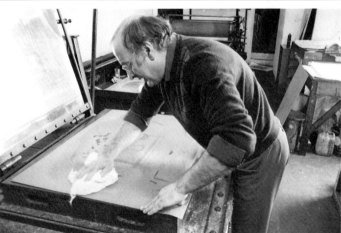

Having mixed colour to the artist's satisfaction, the printer, John White, is about to proof the complete image on an offset proofing press. He puts ink on to the rollers which distribute it in an even film as they turn.

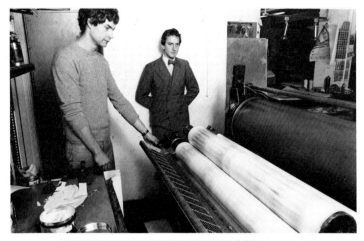

With the drawn plate gripped in place at one end and bearing the final printing for the off-white tablecloth, a proof bearing all the colours printed up to this point is set in place at the end nearest the ink.

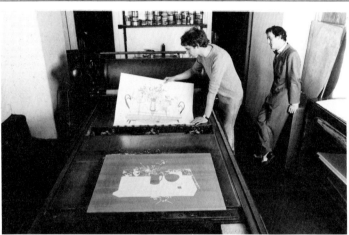

A damping roller moving from the viewer's end of the press prepares the plate and returns to its place while the inking roller travels over the print without touching it, then inks the printing plate. It is followed by the cylindrical printing blanket which picks up the ink as it passes over the plate and transfers it to the paper in its passage back along the press.

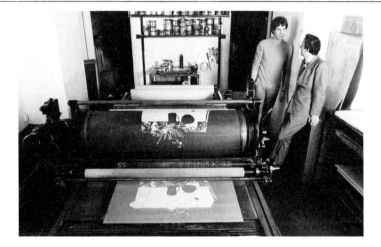

Brendan Neiland's print

The artist Brendan Neiland makes his lithograph in a very different way. He uses stencils cut from brown wrapping paper with a stencil knife and sprays liquid lithographic medium on to the plates through them.

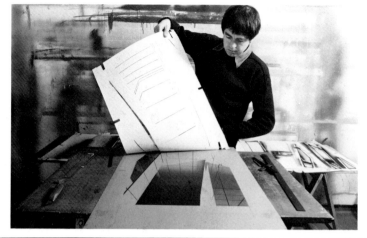

In fact, Brendan paints in a closely related way and traces of paint from a spray gun which he has used on large canvases can be seen on the wall behind him. Having placed the stencil carefully in position over the plate the artist dons a mask so that he will not breathe in the fine spray of liquid lithographic medium. The chamber of the spray has been filled with the medium and having made sure the stencil is securely fixed on the plate exactly where he wants it, Brendan sprays through the cut out areas.

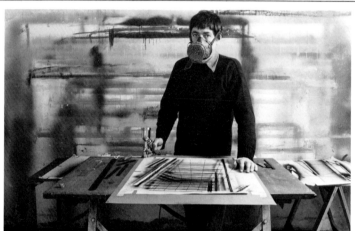

Unlike work on a canvas, that for a print is indirect, although an analysis of the layers to be built up is needed in each case. A separate litho plate is sprayed for each colour to be printed, concentrating the spray of the litho medium where one wants densely printed colour and letting it land in a finer mist where one wants a lighter tone. This is much the same principle as Toulouse Lautrec's toothbrush spatter, but in a very much more sophisticated form.

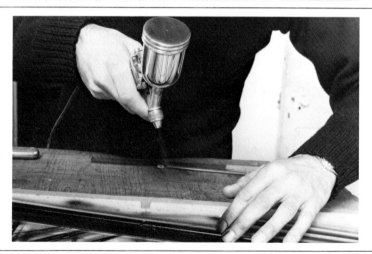

When the plate, one of seven made for the print shown here, is ready, Brendan discusses it with his printer, Alan Cox, who runs a studio called Sky Editions where he makes his own prints as well as editioning work for other artists.

Having prepared the plate in much the same way as the Curwen Studio did for Glynn Boyd Harte's print in sequences 48–52, Alan inks up the image on the bed of the press, preparatory to printing it on a direct press.

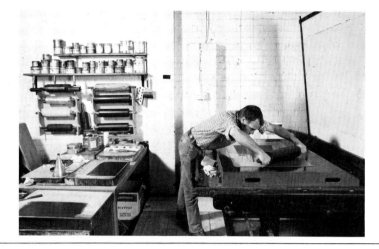

He places a sheet of paper over it, lowers the lubricated tympan . . .

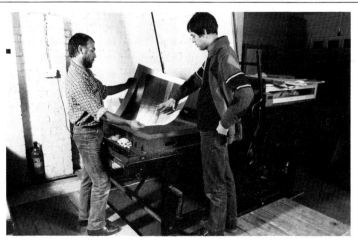

. . . sets the press in motion so the scraper passes over the image transferring it to the paper. . .

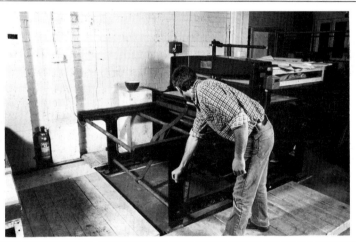

. . . and shows Brendan the result.

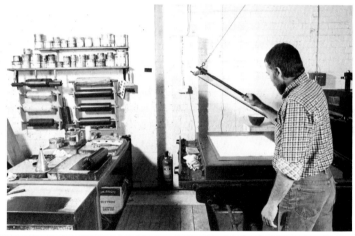

Neither of the lithographs demonstrated here show the possibilities for lithographs made with painterly washes by using diluted lithographic medium. The tusche, as it is called, can be dissolved in distilled water and other solvents to give a variety of distinctive characteristics.

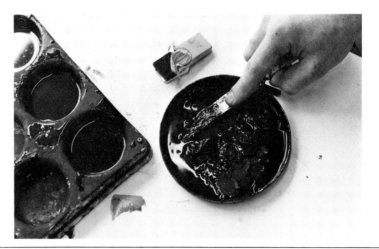

Alan Cox shows how the thinned medium can be brushed or sponged on to the plate where it dries often with very delicate eddies and tidal marks . . .

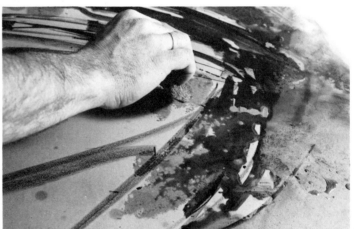

. . . all of which will be picked up in the finished print.

Offset
the commercial version of lithography

67

Photolithography was possible from 1855 when Poitevin used albumen (from egg white) made sensitive to light chemically and applied to the surface of the lithographic stone. However, the medium has only really developed this century, particularly since the 1920s, to the position of dominance it has today.

Offset lithography is much speedier than the direct lithographic press and avoids undue wear of the image by transferring the ink to an intervening rubber blanket in its passage from plate to paper, thereby making longer runs possible. Because it is transposed twice, an offset image can be made on the plate the right way round, whereas for direct printing, the image must be drawn or set down back to front. Although some artists still swear by stones, most printing is now done from thin flexible and specially grained metal printing plates designed to wrap round a printing cylinder.

As with the stone used in hand lithography, the image is made in a greasy medium for which the oily ink has an affinity. This fills some of the pores, while at the moment of printing the remainder is filled with water, so preventing the adhesion of the ink where it isn't wanted.

67 Offset lithography is so called because the image is transferred from plate to paper by means of an intermediate roller.

68 A four-colour offset litho press being made-ready with one of the four colour plates.

68

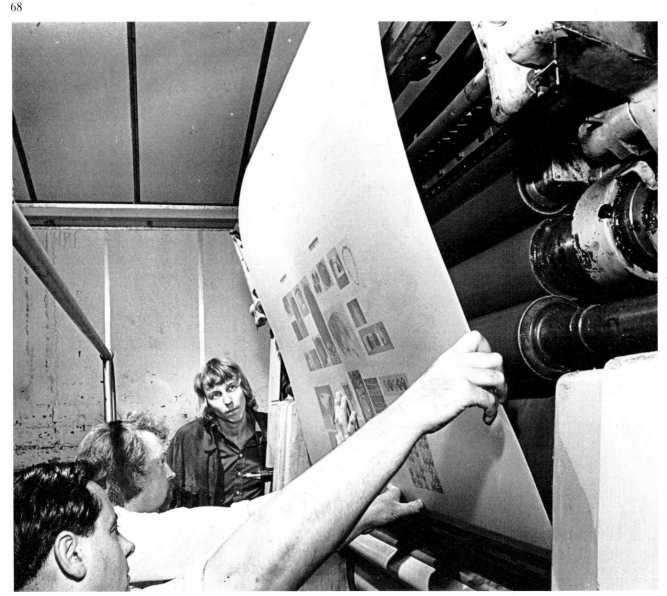

Electronics is playing an increasingly important part in the printing industry and photolithographic half-tone positives or negatives can be prepared by scanning the work to be copied with light. The degree of brightness reflected is converted by a photo-electric cell into electric signals which in turn drive a stylus or drawing point.

This stylus selectively removes an opaque coloured deposit on a transparent plastic support to make a screened image which can be printed down onto a litho plate by normal photographic means.

The first step in photolithographic offset printing is to fit together the line and half tone film positives in the positions they will occupy on the finished paper. At this stage the make-up, as it is called, can be photo-copied to provide a proof for the customer to look at before the image is developed on the printing plate. Then the negative of the page is brought into contact with the sensitised plate and exposed to a high-intensity light.

69

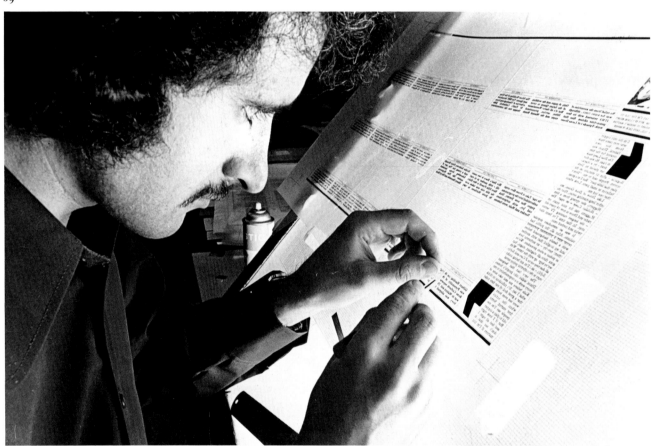

70

84

69 The elements on the page being fitted together.

70 The sensitised plate in contact with the made-up page film positives, being exposed to a high intensity light.

71 An offset litho press.

After being chemically developed it is made ready for the press.

Lithographic presses range from simple office duplicators which use special paper plates, to huge web-fed presses capable of printing paper on both sides simultaneously. All rotary presses consist of a plate cylinder which has the plate wrapped round it, a blanket cylinder onto which the image is offset and an impression cylinder that presses the paper against the resilient blanket. There are also a multiplicity of inking and damping rollers to distribute colour and moisture more evenly.

The printing plate first comes into contact with the dampened rollers and is wetted with a solution of water, gum arabic and acid. This solution is rejected by the image area but accepted by the parts of the plate that don't print. Next the plate is inked. The ink is only attracted by the image, not the surrounding dampened plate. The ink from the image is then transferred to the blanket and thence to the paper.

71

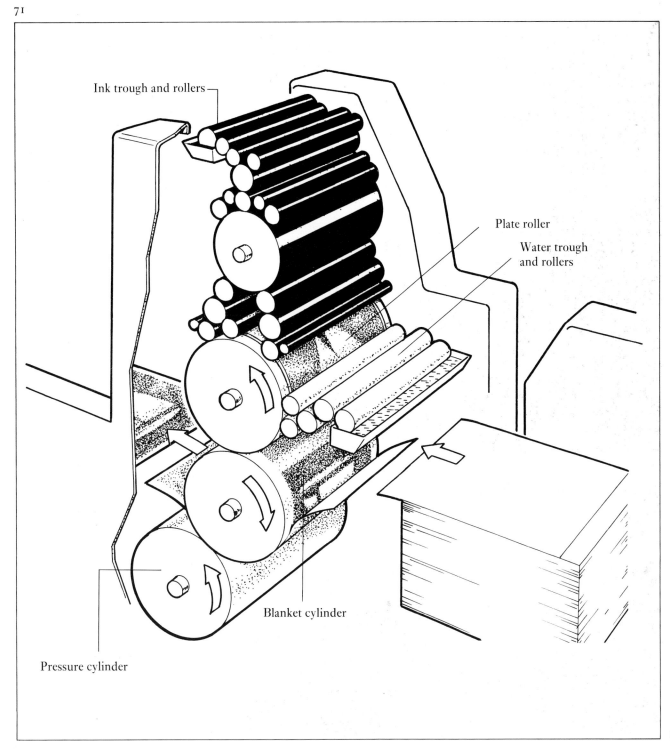

Ink trough and rollers

Plate roller

Water trough and rollers

Blanket cylinder

Pressure cylinder

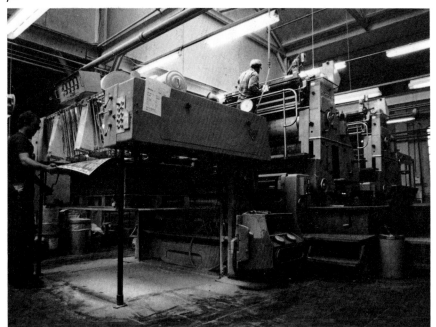

72 A four-colour *Roland RVU6* press used by the printer for the colour pages of this book. A close look at any colour illustration with a magnifying glass will reveal the four-colour dot structure.

73 This diagram shows the exposed mechanism of a typical four-colour lithographic press. In common with other techniques the press prints yellow, magenta, cyan and black usually in that order, so that when different proportions of dots in these colours blend in the viewer's eye, all the colours in the original are suggested.

73

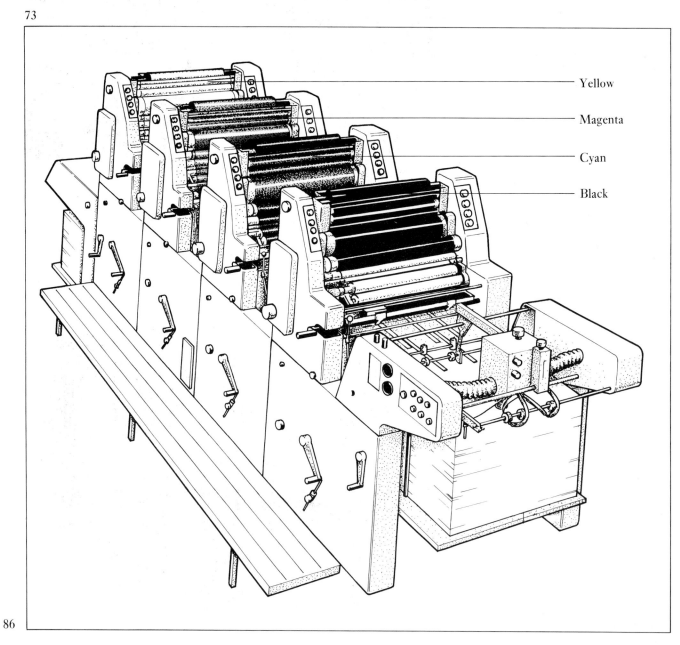

Yellow

Magenta

Cyan

Black

Screenprinting

History of screenprinting

Screenprinting is a development of stencilling. This in turn is a way of creating a design by cutting or pricking it in a sheet of tough paper, celluloid or thin metal so colour can be repeatedly painted or rubbed through it. Preceded by the Chinese, Europeans and Americans have applied it extensively to the decorative arts and some of the earliest woodcut playing cards and books were coloured in this way.

Influenced by a healthy French tradition in stencilling, the Curwen Press adopted it between the two world wars for some beautiful book illustrations. These were at their most inventive in the hands of the American poster artist E. McKnight Kauffer who conceived his designs not in feeble imitation of watercolour, but as solid areas of stippled opaque gouache the intense colour of which prefigured screenprinting.

Stencilled designs however, need ties, so that if a shape like an 'O' is cut, the free-floating centre can be held in place. The Japanese tackled this problem by joining stencil parts together with human hair. Attaching them to a permeable fabric stretched taut on a screenprinting frame, was the next solution.

That we do not know who discovered the woodcut, six centuries ago, is hardly surprising. But since museum curators so often look at art divorced from life (and then well after the event) we are almost as ignorant about screenprinting, even though its first patent was as recent as 1907.

Screenprinting developed in the United States to serve chain store and supermarket advertising and the 1930s was well under way before fine artists realised its possibilities. The first treatise on the subject was written by Anthony Velonis who led a graphics unit as part of a project run by the American state to employ artists during the Depression. In the political situation of the day prints, together with murals, were seen as a way of circulating art to a wider public and many artists made socially conscious pictures.

Eventually however, the word 'serigraphy' (Greek for drawing on silk) was coined to differentiate screenprinted 'art' from the commercial. Ways of working directly on the mesh rather than indirectly on stencils began to be exploited.

1

2

3

1 E. MCKNIGHT KAUFFER illustration for A. Bennett's 'Elsie and the Child' colour stencil 1929/30

2 Japanese hair stencil probably 19th century

3 A. VELONIS *Side Street* colour screenprint 1939

In England soon after the war, Francis Carr was experimenting with the medium, improving the effects he could obtain as the rather unpleasant inks initially available became thinner and more transparent when required. Until then, an unavoidable characteristic of screenprinting was the very heavy deposit of ink which retained the marks of the mesh it had been printed through. Such evidence can be seen in the print by Fritz Winter who was among the earliest German artists to use the medium from around 1950.

Chris Prater, the London screenprinter who was to become internationally famous in the 1960s, was trying out the medium at the Working Men's College at about the same time. In 1958, with the help of his wife Rose, he opened Kelpra Studio, setting up in business on a kitchen table using printdrying frames improvised from plaster lath and, because it was so expensive, stitching several pieces of silk together to make the screen covering. But his experimental attitude to the medium and his ability to interpret an artist's wishes, became almost legendary and by 1965 screenprints were the talk of the London art world.

In France in 1947 Matisse's outstanding book 'Jazz', though theoretically it could have been screenprinted, was produced by the longer established stencil process. During the war, Matisse had designed a cover for an arts magazine called 'Verve' by cutting up and collaging intensely coloured ink samples. The publisher prevailed upon the artist to write and illustrate a whole book in a similar way. Matisse painted sheets of paper with gouache and then cut designs from them which he accompanied with a hand-written text. This talks of 'a good day's work and the light it can bring amid the encircling gloom' and the designs were so brilliant that Matisse said he had to put his sunglasses on to look at them. Lithography, with its transparent colour, could not manage the heavy ink deposit necessary to match Matisse's originals, so the same kind of gouache was applied through stencils to run the edition of the book.

Matisse's book heralded a period in his own work in which he suggested space with colour, sometimes on a grand scale. When he had become ill and arthritic in old age and could no longer stand at an easel, he was still able to work by having sheets of paper painted with gouache for him, cutting out the shapes he wanted from the colour and getting an assistant to arrange and stick them on to the background under his direction.

These colourful large-scale works proved an object lesson for many postwar artists.

4 F. CARR *Hungerford Bridge* colour screenprint 1951

4

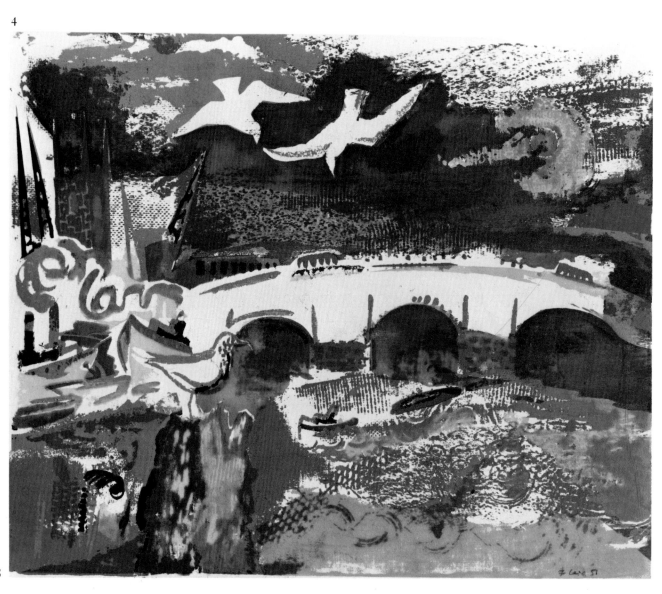

5

7

Ron King managed with simple
paper-cut stencils to take up
the suggestion Matisse offered for a
pleasure-loving art in which expression
and decoration were the same thing.

He made many single-sheet prints
based on botanic shapes using singing
colours. The smooth ink surface then
typical of screenprinting was often
contrasted in his work by mottled
surfaces, sometimes in metallic inks, an
effect the artist obtained by blotting
the print immediately after printing.

Circle Press, which he founded,
produced some of the earliest artists'
books to be illustrated with screen-
prints, among them his own Chaucer's
'Prologue', 'The Song of Solomon',
and Shakespeare's 'Macbeth'. The
latter included some photographic
imagery in the symbolic head forms
representing the various characters, for
by this time resistance to photo-
mechanical imagery was beginning to
break down.

5 F. WINTER *Rotbrauner Torbogen* from
Schwarze eichen colour screenprint 1950

6 MATISSE *Sword Swallower* from 'Jazz'
colour stencil 1947

7 R. KING *Slate Lichen II* colour
screenprint 1966

It was ironic that the American Serigraphic Society, formed in 1940 closed down in 1962 just as Andy Warhol began to screenprint paintings. Accepting mis-registration and blotches from deliberately clogged meshes, his pictures featured repeated Coca-Cola bottles, soup cans and various scenes of disaster. Although some spectators have read into them a comment on mass society, Warhol's disclaimers suggest his work is more about process than the apparent subject matter. Marilyn Monroe has appeared countless times both on canvases and in a series of prints where permutated colours imitate garishly applied make-up.

Alain Jacquet of France, using an enormously coarsened half-tone trichromatic dot of commercial colour printing, based his 'Déjeuner sur l'Herbe' on a detail of a print that has resounded countless times through the history of art since Raphael drew it for his engraver. An almost abstract collection of blobs, like Warhol's work it is more about process than a picnic on the grass. Printed on panels two metres wide and in an edition of ninety-five, it also proposed that the division between multiplied prints and unique paintings was quite arbitrary.

Pop Art – so called since it borrowed its images from the mass circulation media – erupted in England

8

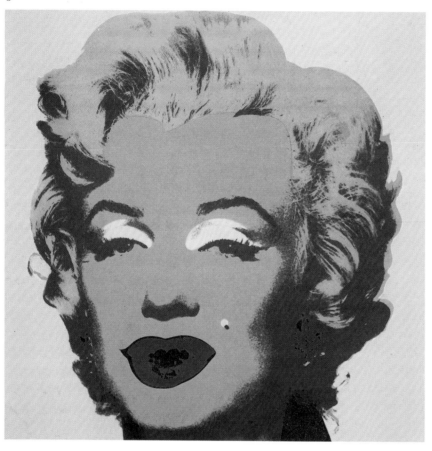

9

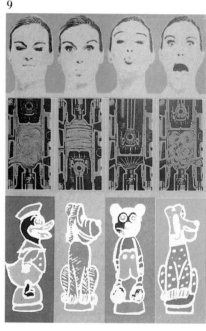

10

and America more or less simultaneously. During the 1950s Eduardo Paolozzi, son of Italian immigrants, had given a memorable lecture at the London Institute of Contemporary Arts where he projected blown-up images from science fiction and pulp magazines. He used a whole variety of such images cheek by jowl in masterly suites of screenprints.

His printer, Chris Prater, weaned on commerce, became a great interpretative technician by working with famous artists both from Europe and

8 A. WARHOL *Marilyn* from *Ten Marilyns* colour screenprint 1967

9 E. PAOLOZZI illustration from *Moonstrips and Empire News* colour screenprint 1967

10 I. TYSON nos XIII, XIV from *Screens* book of colour screenprints and poems 1976

America in a new kind of collaborative relationship. In its early stages, this new way of working aroused hostility. The prints made by Prater for Patrick Caulfield, who handles apparently banal visual clichés with deceptive elegance, were segregated from the 'hand-made' prints by the authorities when they were shown at the Biennale des Jeunes in Paris in 1965.

Latterly, Prater has become a publisher in his own right, screen-printing books such as Ian Tyson's 'screens', which was inspired by the artist looking into his garden through reeded glass. This experience is referred to in the prints by ravishing

11 A. JACQUET *Déjeuner sur l'Herbe* colour screenprint on panel 1964

12 P. CAULFIELD *Sweet Bowl* colour screenprint 1967

91

13

14

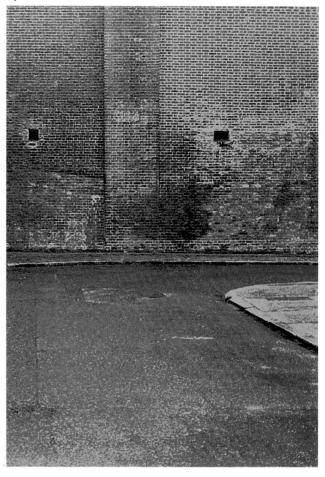

15

flowers from a gardening catalogue, which are glimpsed tantalisingly through an overprinted grid of black.

Gerd Winner, a German artist fascinated by cityscapes, has worked consistently with Prater, not only on prints and giant canvases but also on a masterly book about the East End of London. His dockland wallscapes, derived from photographic sources, demonstrate how subtle photo-mechanical printing can be.

Two other artists who have worked consistently with Prater since being introduced to screenprinting in the early sixties are Joe Tilson and Ron Kitaj. Tilson, who did several series based on the five senses, made this 'Clip-o-matic Breast' in the form of a slide transparency. Kitaj used screenprinting to realise complex and esoteric collages. Conceived like an abstraction, Kitaj's print 'The Defects of its Qualities' incorporated the cover of a contemporary leaflet which asked:

13 E. KUHN *Al Capone* colour screenprint 1980

14 G. WINNER image from 'East One' book of colour screenprints 1978

15 G. WINNER *Metropolitan Wharf* from *London Docks II* colour screenprint 1971

'What is an original print?' At the time, this question was on everybody's lips.

Although the sixties were remarkable for the new kind of collaboration between artists and printers, Ellen Kuhn provides evidence that it is quite possible for an artist to deal with the whole photo screenprinting process single-handed, as did Ian Colverson,

who, having preoccupations similar to those of Jacquet and Warhol, attached a computer printout of Brigitte Bardot to his prizewinning 'Portrait'.

16

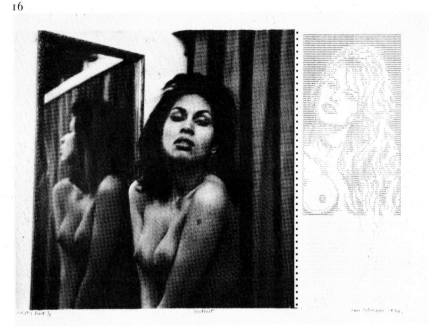

17

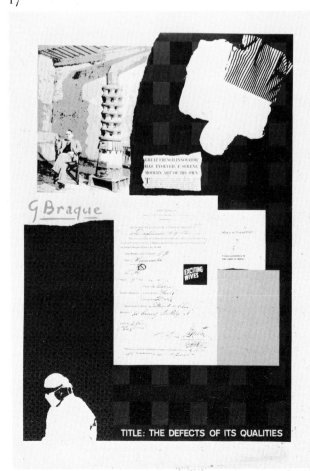

18

16 I. COLVERSON *Portrait* colour screenprint and computer printout 1970

17 R. KITAJ *The Defects of its Qualities* colour screenprint with collage 1967

18 J. TILSON Transparency *Clip-o-matic Breast* screenprint on rigid PVC Lumaline 1971

93

As well as serving the foregoing artists who collaged their photographically processed subject matter from printed or even televised material rather than working from nature first hand, screenprinting was particularly suitable for the hard edges and flat colours of geometric abstraction.

The hard-edged development came in reaction to the splash and trickle of the New York school of American painting which is known as Abstract Expressionism.

Indeed in the return to recongnisable subject matter Pop Art was also a response to an earlier period when abstraction dominated. Roy Lichtenstein's 'Brushstroke' is a huge joke at the expense of the generation of painters he followed. There is an obvious irony in painting an image of a mark supposedly made by intuitive spontaneous gesture by means of a deliberate, mechanical, impersonal technique based on photo-mechanical, half-tone.

Some artists dealing with geometric abstraction, such as Vasarely, had descended from the Constructivist tradition originating in Russia but associated with a famous German art school called the Bauhaus. In the 1920s this school tried to foster new attitudes to the use of technology and modern materials in art and between 1928 to 1929 Vasarely was a student at a Hungarian offshoot of the school. He then moved to Paris where he worked as leader of a research group studying visual art and creating numerous prototypes for architectural installations, tapestries and print editions. For Vasarely, painting is an outmoded and archaic idea which cannot reach

beyond galleries and collectors' apartments. His works, whatever their initial forms, are intended for multiplication by modern methods in a variety of formats. He is associated with a phenomenon which, in the mid 1960s was called 'Op Art' but which might be better called perceptual abstraction. Typical of his earlier work is the black and white image which, when scanned carefully, begins to reveal hidden forms one had not previously noticed.

Bridget Riley, whose fame was established after a New York exhibition called 'The Responsive Eye' which gathered together related works of this kind, has made a number of black and white prints which stimulate the viewer's eye to activity. Perhaps

her masterpiece in printed form, however, was the irreproducible suite of 'Nineteen Greys' which she made with Prater in 1968. In the four prints, ovals gently mutate through minute gradations of grey and change direction as they move across the flat ground.

The Photorealists who emerged in the wake of Pop Art, produce detached highly finished hand-painted or printed illusions of the world as it is seen in colour photographs. Richard Estes is fascinated by the reflective shop windows in city streets. Yet despite its literal photographic look, the Chinese lady in the left hand window of his large screenprint had her fur coat removed and put back on sixteen times during the course of 106

19 VASARELY *Andromede* screenprint 1961

20 B. RILEY *Fragment no. 10* screenprint on perspex 1966

21 R. LICHTENSTEIN *Brushstrokes* colour screenprint 1967

22 R. ESTES *Untitled* colour screenprint 1973/4

23 K. DANBY *Early Autumn* colour screenprint 1971

22

23

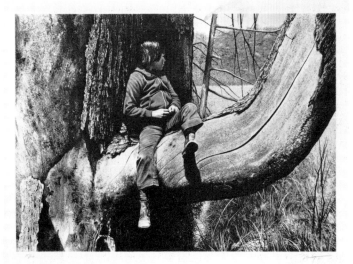

printings which means the print was worked on rather like a painting. Equally Ken Danby, whose picture of his son was voted the most popular when shown in the British International Print Biennale in 1973, stresses that it is entirely hand-made. Each stage in the print is dictated by the last and so a succession of pen and brush drawings in opaque ink on transparent acetate are transferred to printing plates by light. The finished image depends for its success on the artist being able to imagine the cumulative effect of colour.

Since Domberger in Germany and Chris Prater in England began working with artists, many other screenprinting studios have opened. Christopher Betambeau of Advanced Graphics is another fine London printer who has worked consistently with artists, among them the abstract painter, John Walker. Walker made a magnificent suite of ten huge screenprints in 1974 which were based on the combination

under the de Gaulle government in France, it was one of the techniques used at the Atelier Populaire by Fine Art students who wanted a speedy method for getting revolutionary posters and information on to the streets. Forceful images and slogans were thought up by a central committee whose aim was to transform society. They attacked capitalism, encouraged the many striking factories

24/25 J. WALKER images from *Ten Large Screenprints* 1974
26 ATELIER POPULAIRE poster of 1968

24

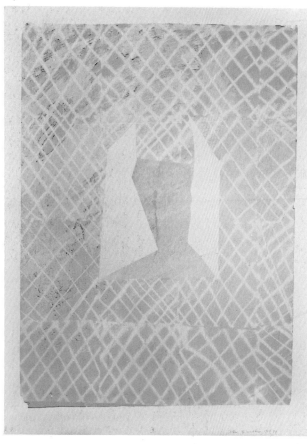

25

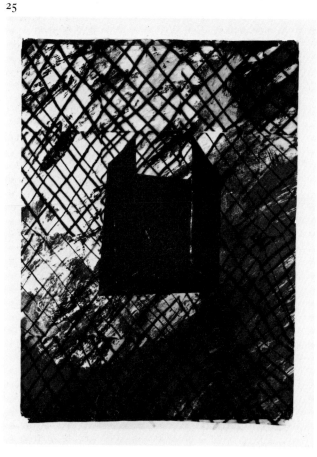

of a painting of 1965 and an earlier drawing. Using the serial possibilities of printing once the screens had been made, he employed them to produce a group of ten different prints ranging tonally from a pale image lost in a ghostly white mist, to the darkest full of marbled dun and chocolate brown against a trellis of charcoal grey.

For all the technical complexities that printers have developed over the last twenty years, however, screenprinting remains one of the easiest techniques for either artist or amateur to set up, given no more than a wooden frame and some suitable material to cover it.

In May 1968, when students and ten million workers rose to protest about unemployment, poverty and repression

to prolong their struggle, drew attention to police brutality and, after successful appeals from the state for a return to normal, symbolised the obedient public as a bunch of sheep.

The days of 1968 are gone, but the idea that print is a tool that might be more readily accessible to ordinary people – whether for art, for political activity, or for something as modest and innocuous as advertising a dance – has not. A network of community workshops which developed during the 1970s in Great Britain, are open to anyone wanting help with a project; as one of the earliest and cheapest techniques to operate, screenprinting has thus widely extended its frame of reference.

26

Featured artists
Gerd Winner and Ellen Kuhn

The German artist, Gerd Winner, lives near Goslar in the Harz mountains in a magnificent 'stately home' complete with chapel decorated by a pupil of Tiepolo. He has renovated and restored the former archbishop's palace to provide himself with an enviable amount of space for studios, printing workshops, living space and storage. Since 1970 however, he has also worked extensively in London with the printer Chris Prater of Kelpra Studio. The association came about when the British Council invited him to England after he had won a graphics prize. Since then artist and printer have become great friends. On frequent visits to London to supervise the proofing of his prints, Gerd has made yet more camera studies of London's dockland. Such images end up not only in prints that Chris editions for him but on canvases and in vast mural projects in Germany printed by his Goslar printer, Hajo Schulpius.

Gerd's fascination for urban landscape began with his experience of England but he has continued these preoccupations in New York and more recently in Saudi Arabia and Japan. 'Autumn in New York', the colour printing of which is analysed on page 110 was created from a colour transparency the artist took of tenement buildings in the Italian quarter of the city, while the suite on Arabian Walls is related to a mural project for government buildings in Riyadh – a Saudi Arabian walled town surrounded by date palms.

27 GERD WINNER
28 ELLEN. KUHN

28

Ellen Kuhn is an American artist married to Professor John Charap and living in London. Occasionally she pushes the boat out and enjoys the luxury of a printer to do all the work for her, but more often she carries the process through from start to finish herself using professional help only to make the photographic half-tone separations.

Ellen's parents escaped from Germany just before the outbreak of World War II when she was still a baby. She had a miserable childhood while both her parents worked long hours in sweat shops to survive. So much for the American dream as it was experienced by that generation. As she grew up she took refuge in the fantasy world of the cinema. Film stars, pictured within frameworks that somehow evoked the qualities they have for her as cult heroes, have formed her subject matter and, appropriately, she had a retrospective at the National Film Theatre in 1973.

When she first came to London she made prints at a studio run by the Swedish artist Birgit Skiold who must take the credit for launching the first shared workshop in England, an idea which has spread remarkably. Subsequently, however, Ellen set up her own printing facility, choosing screenprinting because it involved no heavy presses. This meant she was able to house it on an upper floor of her own home.

The print of Al Capone that she is seen making in this book, is part of a series dealing with immigration generally. It appears, at first sight, a departure from the preoccupations of recent years. In fact, it is closely related. Capone also became a kind of cult hero, taking one of the few ways open to an immigrant of making it in his own society. 'I wanted to make some kind of moral statement,' said Ellen, 'which is maybe one of the few perks of being an artist.'

97

31

29 E. KUHN *Bonnie and Clyde I*
colour screenprint 1978

30 E. KUHN *Rudolph II* colour
screenprint 1972

31 E. KUHN *Bogart II* colour
screenprint 1979

32 G. WINNER *Slow* screenprint 1972

33 G. WINNER illustration from *Arabian Walls* 1980

33

Step by step Screenprinting

The following sequences show how two artists made screenprints. Both made sophisticated photoscreenprints, but Ellen Kuhn did all her own preparation and printing, whereas Gerd Winner was assisted by printers at Kelpra Studio.

Although Ellen's print, illustrated in colour on page 92, had several subsequent photographic stages. We show her making her one hand-cut direct stencil (that used for Al Capone's flesh) and then printing it. The photographic stencils she later used would have been made in much the same way as those at Kelpra Studio. Sequences photographed at Kelpra Studio show how photographic information was extracted from a negative and transferred to a screen in the making of Gerd Winner's print. Much less complicated ways for amateurs to make screenprints are described in the Do-it-yourself section beginning on page 129 for those who would like to try screenprinting themselves.

Ellen Kuhn's hand cut stencil

Ellen works on a light box which allows her to see the drawing guiding her through the green film stencil she is cutting.

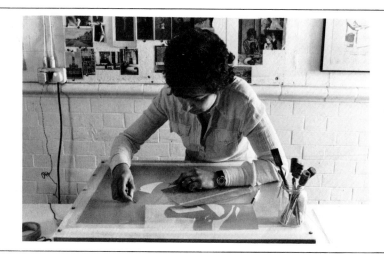
34

The stencil is made of a thin transparent layer which will be adhered to the screen. This layer is attached to a clear polyester support but can be peeled easily from it when cut.
 The stencil knife cuts through the upper layer, but not the support so that the areas to be printed through can be cleared away.

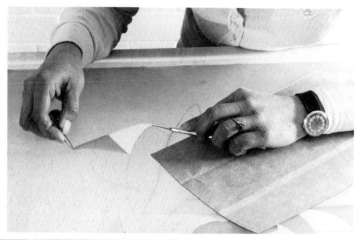
35

The prepared green film stencil with open areas corresponding to the relevant part of Ellen's design is now set on a bed of newspaper, stencil layer uppermost. The screen, a frame across which a fabric mesh has been tautly stretched, is placed over the newspaper and the stencil is adhered to the mesh by damping it with a mixture of alcohol and water and then ironing it dry. When the adhesion of the stencil is completed, the polyester support backing it is stripped away, and the mesh is blocked in some parts but open in others.

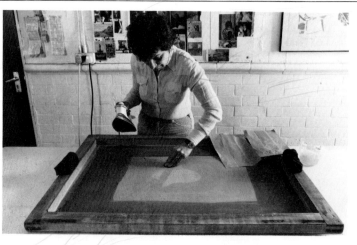
36

Using a print on acetate to help in registration, the bed of the press is now marked with small tabs which tell the artist where to align the paper. Vacuum suction prevents the sheet moving during printing.

Ink, with the consistency of cream, is poured into the blocked out wells near one side of the frame and the squeegee, a kind of blade attached to a device which ensures even pressure, wipes the colour across the mesh.

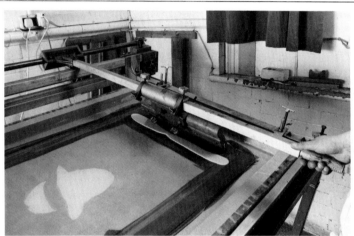

The first wipe merely floods the screen while the frame is raised off the bed of the press. In the next wipe however, moving in the opposite direction, the screen mesh will be in contact with the paper and the wipe will transfer ink on to it through the cut away areas of the stencil attached to the mesh.

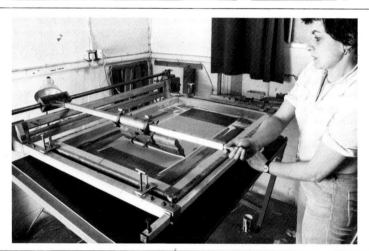

When the screen is raised, the sheet which was below it during printing reveals a perfect impression through the shapes Ellen cut.

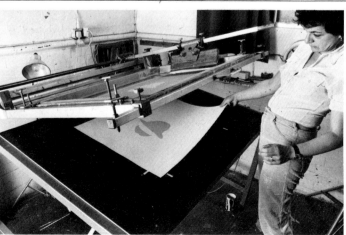

Gerd Winner's screenprint

The following sequences show the
printing of this image from Gerd
Winner's book on Arabian walls

Gerd Winner arrives at Kelpra Studio
to discuss with Chris Prater his ideas
for a series of prints based on the city
of Riyadh photographed on his travels
in Saudi Arabia. Gerd has used his
camera on the trip as earlier artists
might have used a sketchbook.

The cameraman, Dennis Francis,
working from a continuous tone
photograph supplied by the artist,
employs his process camera to make
images suitable for photographic
screenprinting without using a half
tone dot. These are scaled up high-
contrast negative or positive images on
transparent film. By the length of the
exposure the cameraman can extract
various amounts of detail in steps from
the original negatives converting the
continuous tones of Gerd's photo-
graphy into effects of mass and line.

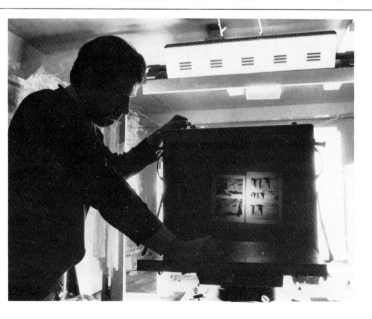

Gerd rarely asks for more than four
photographic stages – to provide the
ground colour which will gleam
through later printings as highlight; to
model that first colour; to give relief
and structure, and finally to convey the
deepest shadow. Possibly because of
the intense sunlight in the Middle
East and the starkness of the shadows
it throws, only three photographic
extractions were needed for this print.

 Of these three images in black on
transparent film, the first, to be printed
in a rusty orange, defines the brick-
work and rubble and also powders the
sky on the left.

Another deepens the shadows by
means of a trichromatic cyan printing
– a brilliant transparent turquoise –
which on top of the preceding warm
colour creates a dull greenish black.

The intermediate stage, printed a
transparent leaf green to obtain a tan
when printed over the orange, was
applied to the left hand side of the
print only.

After crucial discussions with the artist about the way hand-cut stencils will be united with the photographic ones, Chris Prater makes cut stencils for the warm beige ground colour and the pinkish-cream of three walls on the right. He uses a special kind of masking material comprising a coloured emulsion on a clear polyester base and works on a light box using the cameraman's scaled up photographic positive as a cutting guide.

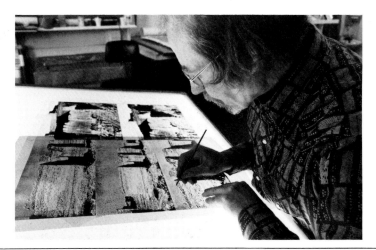

47

The stencil knife cuts through the emulsion, allowing parts of it to be stripped away from its polyester backing. Rather than making a direct stencil to adhere to the screen, like Ellen, Chris strips away the areas he does *not* want to print so that the masking material he retains coincides with the shape to be printed. The reason for working at one remove like this, is that if the screen is damaged the cutting already done can be used a second time. These hand-cut masks are used to protect a sheet of sensitised gelatine film when it is exposed to light.

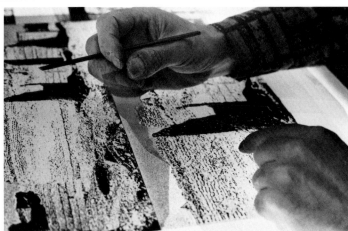

48

At the next stage, Tony Holt takes the sheet of masking film hand cut by Chris, puts it on to a light box, places a photostencil made of presensitised gelatine attached to a clear base over the top and exposes it to ultraviolet light. Although Chris could see through the film when cutting, it will not allow ultra-violet light to pass.

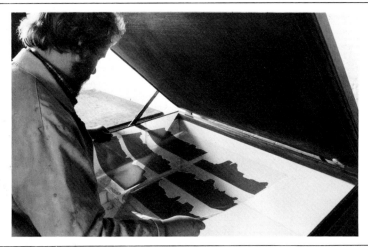

49

Immediately after exposure he takes the sheet of film . . .

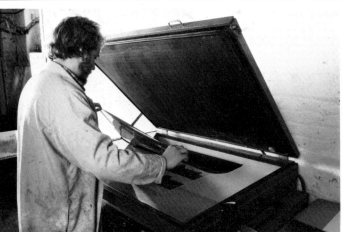

50

. . . and places it in a chemical bath which hardens the areas which have been exposed.

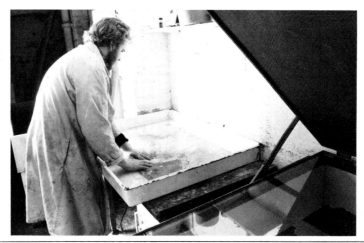

51

The developed sheet is then placed in a sink and sprayed with warm water which . . .

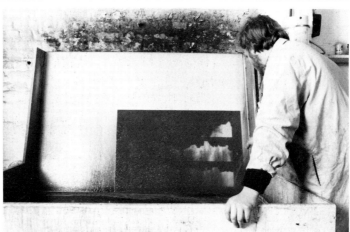

52

. . . gradually clears away the gelatine which has not hardened in the places where the hand-cut masking material has protected it from light.

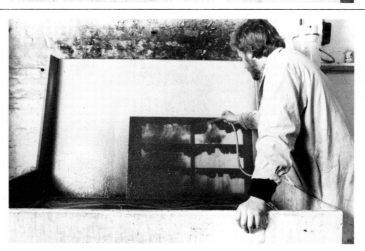

53

The stencil thus produced is then adhered to a perfectly clean screen made from a terylene mesh fabric stretched on a metal frame.

Where the gelatine has dissolved, open areas in the stencil will allow the passage of ink through the screen.

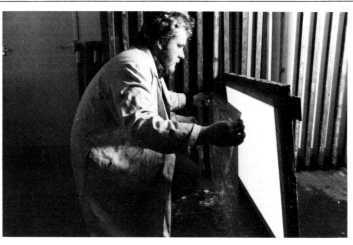

54

First it is smoothed on to the screen with a small squeegee . . .

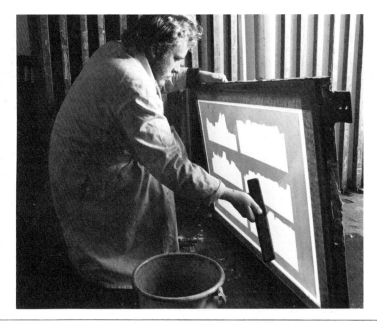

. . . then it is rolled gently in contact with absorbent paper to remove all traces of moisture. When it is completely dry the clear base which has supported the gelatine so far, is peeled away.

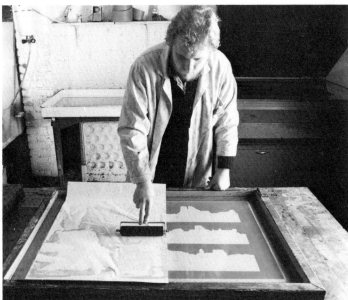

The time for printing has now arrived. Chris Prater mixes the colours the artist has specified. Drying, and absorption by previously printed colours can alter shades in a remarkable way. Only skill and long experience help the printer predict this and tell how transparent inks will work over existing colours.

The printer, Richard Luppi, sets up his screen, covering the gaps between the photostencil and the limits of the mesh to provide an area into which the ink can be poured before it is drawn across the screen. The bed on which the screen rests will have been prepared with register marks, and a print on acetate taken to make it easier to position subsequent colours.
Only the three images, one above the other on the left side of the screen, are actually being printed. Those on the right hand side will be used for another print later and are temporarily covered so no ink will go through.

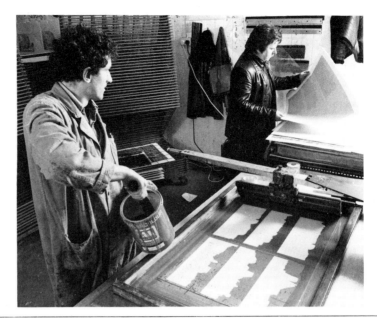

The print is taken in much the same way as Ellen's. The extension handle helps to make pressure even and protracted editioning less tiring.

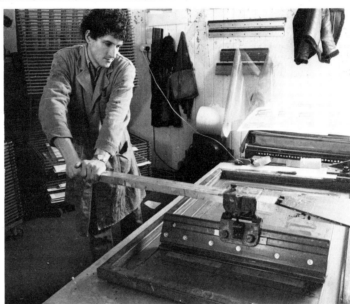

Colours are built up one by one until the screen bearing the final photo-stencil is brought in to print the transparent cyan, darkening the shadows.

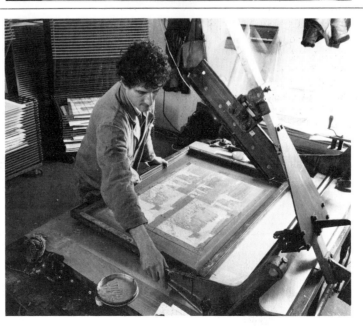

Finally Chris and Gerd look at a completed proof in order to decide whether changes are needed, or whether to proceed with the edition on the basis of the work already accomplished.

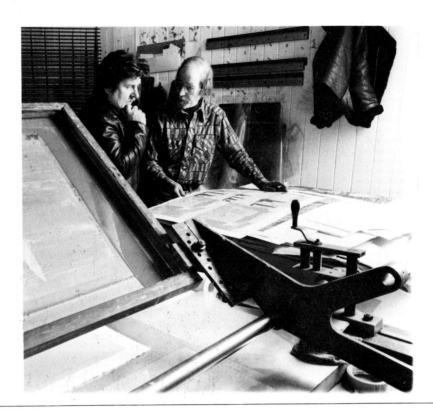

Colour printing

Artists who work from photographic sources are often told, as if it were a criticism, that their prints are 'only photographs'. But even between the photomechanical methods of commercial trichromatic screenprinting and the sort of procedure adopted by an artist like Gerd Winner, there are major differences. The rather intriguing problem of illustrating these is that since all colour in this book must be printed photolithographically using trichromatic half-tones, we have to try to illustrate two different procedures by the same means. To put it another way; in real life, Gerd Winner's print would reveal no half-tone dots. In terms of the production of this book, there is no way to avoid it.

The method by which a black and white continuous tone photographic illustration is screened to make a 'half tone' which gives the illusion of a range of tonal values despite being printed only in monochrome has been described on page 31.

Colour half tone is founded on the principle that all the colour values in the world can be approximated by mixtures of the three primary colours together with black. A colour transparency is photographed four times through coloured filters which allow each of the trichromatic colour components to be recorded in their correct proportion on separate continuous tone negatives. These are screened, breaking each separation up into thousands of tiny dots which must be balanced in such a way that when yellow, cyan (process blue) and magenta (process red) are overprinted, together with a toning black, the colours in the original are built up. This basic principle is applied to colour printing in all four main graphic printing processes. Because it involves four passages through the press – for four different inkings – it is more expensive than monochrome printing. Colour printing has usually involved colour correction of the photographic separations by skilful retouching, but nowadays more and more is being done automatically by electronic scanners.

Either way, colour is created not by mixing the inks (which is what Gerd Winner and his printers would do) but by allowing dots of three colours to mix optically in the viewer's eye. Based on developing colour theory, it was on this principle that Seurat, the famous nineteenth-century French painter, built up his paintings in separate colour dots.

His dots however, were intended to be obvious, whereas a photomechanical half-tone is usually meant to be below the threshold of normal vision and can only be perceived with the help of a magnifying glass.

The print reproduced here –
'Autumn in New York' – came from a
colour transparency the artist took in
the Italian quarter of that city. A
trichromatic breakdown of the original
transparency shows how it might have
been reproduced had the most
economic process printing, requiring
only four colours, been used. This is
the process employed for most cheap
reproductions.

62 Gerd Winner's colour transparency
showing part of the Italian Quarter in New
York. Not all of it was used by the artist.

63 The portion selected by the artist for
his screenprint.

62

63

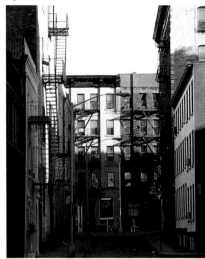

64 Trichromatic breakdown of the selected
area on the transparency showing how
process colours overprint to build up
the image.

64

Yellow

Magenta

Cyan

Black

Yellow + Magenta

Yellow + Magenta + Cyan

Yellow + Magenta + Cyan + Black

Gerd Winner, on the other hand, used nine printings. He wanted to emphasise a particular mood by stressing the warm glow on the brick-work and to focus on the fascinating patterns created by sunlight casting the shadows of the fire escapes.

Only the last four printings were from photographic stencils. The first five colours were set down by hand-cut

next two photostencils were a deep peach then a strong turquoise blue. However, the turquoise struck the artist as harsh and he replaced it with a slate blue. The final screens were printed in Vandyke brown and transparent black; the latter if printed on its own looks more like a water-colour grey. The three tan/peach tonalities and the three greys are so

65 Six proof stages of *Autumn in New York* by Gerd Winner, nine-colour screenprint 1980, and swatches showing the order in which the colours built up the final print.

65

stencils – an all-over ochre ground, then light tan and pinkish brown for the basic shapes of the buildings. The windows, lamps and pavements were added in a mid-grey and then the whole sheet overprinted with a transparent white which subtly muted and unified all the previous colours. When the print was first proofed, the

close that they will be difficult to convey exactly in the pages of this book. This fact serves to emphasise the difference between a photomechanical translation and a print in which the artist and his printer have deliberately manipulated colour in pursuit of a particular expressive purpose.

Commercial Screenprinting

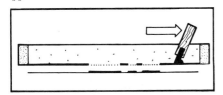

66

Screenprinting was developed for commercial uses long before artists borrowed the technique. In the early, fairly primitive, days it was used for signs and point-of-sale material. Various natural cloths – silk, organdie and so on – were used to carry the stencil while brushes and rollers pushed the ink through the mesh.

The presses used in the step-by-step section have vacuum suction beds to keep the paper from moving and one arm squeegees to facilitate printing. Presses along much the same lines are used for the printing of posters. Very large ones are usually printed in sections which are later joined by the billposter on the hoardings.

Screenprinting has some important applications in textile printing. In the past this required an enormous amount of room with batteries of printing tables and a hanging system on which the continuous lengths of cloth could be festooned for drying. Such printing was done by hand and guide rails were used along the side of the table to ensure correct placing of the screens.

Recent developments, however, have included a rotary screen which dispenses with the need for long tables. The craze for printed 'T' shirts has led to the development of rotating printing beds like sawn-off ironing boards to carry the shirts and speed up multi-colour printing.

Screenprinting offers a way of transferring designs and lettering to objects which cannot be printed directly by transferring the image from one surface to the other. It is possible even to screenprint on to bottles or

67 When screenprinting bottles the screenframe moves laterally while the bottle is rotated underneath it

68 Rotating printing beds are used for printing 'T' shirts

67

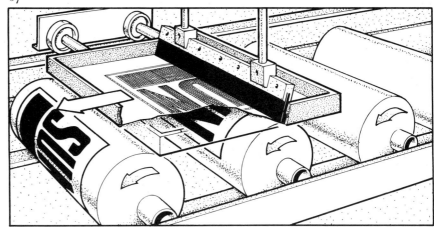

68

drums. The screen frame moves laterally while the bottle is rotated underneath it.

One of the most important developments has been in the electronics industry. Screenprinted circuits were first used by the US army during World War II to produce miniaturised circuitry for aerial warfare fuses. After the war, radio and television manufacturers in particular realised costly hand-wiring operations could be replaced and circuits could be mass-produced by printing. Screen process was able to deposit the necessary heavy layers of conductive inks and resist compounds. One method of printing circuits involves a metallic compound suspended in a compatible liquid to form a printable paste which is able to conduct electricity. It would be printed in exactly the same way as a poster except that the printing stock will be a non-conducting substance like mica, pyrex, or porcelain. The deposit is usually baked to ensure adhesion and durability.

This process, and others related to it, has tremendous implications for computer circuitry. To meet the growing requirements, complex screenprinting machines have been developed with rotary feed suckers passing the stock on to automatic belts where an electrically operated squeegee, which cuts out in case of misregistration, prints on a suction printing base before the stock moves onward to the drying belts. Inks have been developed for printing on to metal, ceramic tiles, glass, plastics and food and there is even an ink which expands after printing. 'Ink' therefore is anything that can be passed through a mesh and printing stock anything that can be placed under that mesh to receive it.

69 Screenprinting machines used in the manufacture of electronic circuits.

69

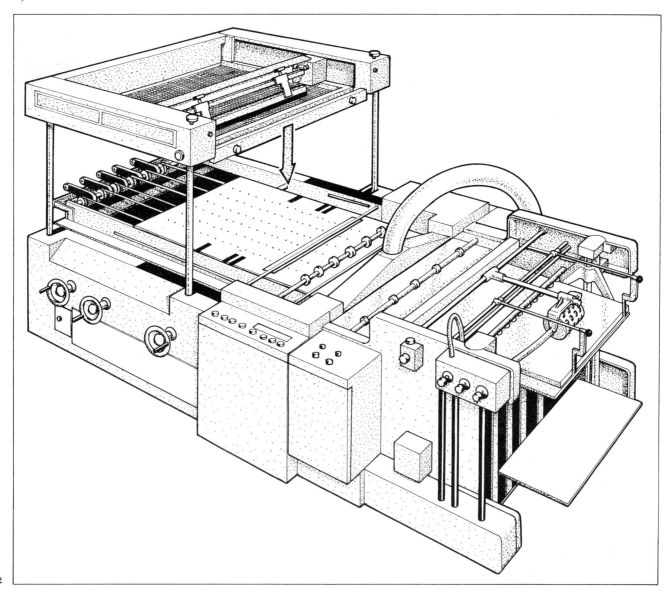

Originals & Reproductions

The word 'original' in relation to prints causes considerable difficulty because people cannot imagine how a print, as a repeatable image, can be described by an adjective implying uniqueness.

Yet if one imagines a work by an artist who, perhaps without any preparatory drawing, has cut an image into a woodblock with the intention of pulling an edition from it, it is clear that no original is being copied. Instead, what an engineer would call a 'tool' has been fashioned to create a series of identical impressions. The woodblock – a three-dimensional relief carrying the image back to front in a way possibly difficult for the spectator to decipher – is not the 'original' and may be discarded. It is simply a means to the end of multiple originals, each one of which will embody the artist's intention. Whenever the artist works on the actual printing surface we describe the result as 'autographic' or an 'original print'.

The situation is very different from that of the same artist whose painting, made without a print in mind, is later photomechanically copied by technicians without the originator being involved at all. Such a print is what we customarily call by the term 'reproduction'.

Things never fall into opposite camps as neatly as that, however. Take Matisse's 'Odalisque with Magnolia', which the artist certainly drew lithographically himself. It shows one of his models, as if in an Eastern harem, lying on a striped bed with the plant of the title beside her. Except that the composition is reversed (a natural outcome of printing on a direct press), the subject matter is fundamentally the same as that in a painting of the same title. Even if we could establish in which medium the idea was first stated (the painting's later date might only mean it took longer), can either one of these works be said to 'reproduce' the other? Or are they variations on a theme – one painted in colour, the other always intended as a monochrome lithograph? The photolithographic reproductions here are actually no substitute for either.

1

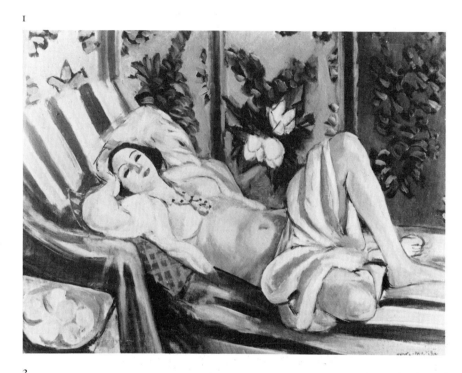

2

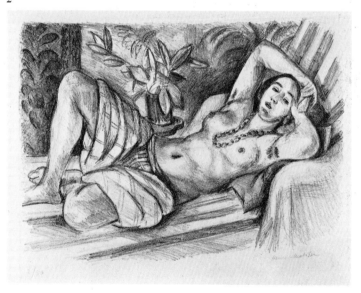

1 H. MATISSE *Odalisque au Magnolia* painting 1924

2 H. MATISSE *Odalisque au Magnolia* lithograph 1923

3 J. CONSTABLE *The Cornfield* black and white photograph of 1826 oil painting, National Gallery

4 T. COLE after CONSTABLE *The Cornfield* wood engraving 1899

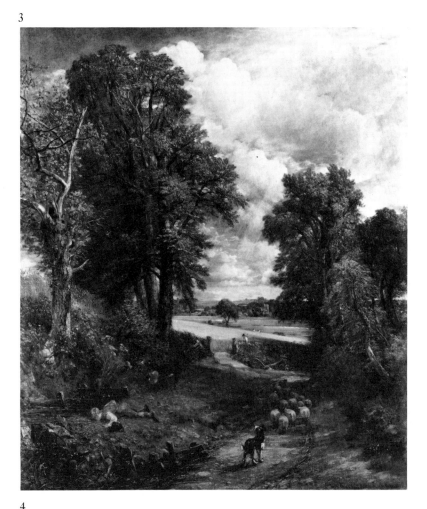

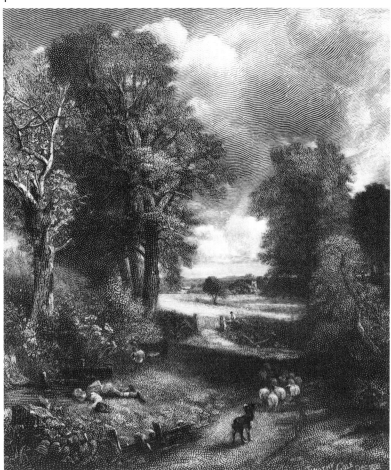

Until photography, discovered in 1839, began to cloud the issue, all prints were handmade, and history cared relatively little about differentiating between the reproductive and the original. Although certain artists (Rembrandt, for example) always made prints for their expressive power, on the whole it was assumed it was the job of printmakers to convey information, including that about unique works of art. The possibility that had always existed for prints to do otherwise began to be distinguished in the second half of the nineteenth century in reaction, often defensive, to the development of photomechanical technology.

When Constable painted his famous 'Cornfield' in 1826, for example, there was no way for him to circulate visual information about it except by making prints himself or employing an engraver to do it for him. Yet he felt the need to campaign against the low esteem in which his kind of painting was held by those 'preferring the shaggy posterior of a Satyr (i.e. classical subject matter) to the moral feeling of a landscape'. So in 1829 he began collaborating with the mezzotint artist, David Lucas, on a publication

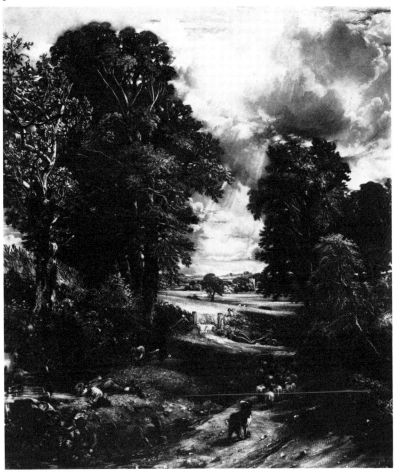

called 'English Landscape Scenery'. This was probably to emulate his rival Turner's 'Liber Studiorum' – a systematic survey of the categories of landscape painting begun a quarter of a century earlier.

Mezzotint, described on page 46 was, in the hands of David Lucas, ideal for conveying the fascination Constable has for the glinting lights in nature which help to give his pictures their vitality. Letters he wrote to Lucas however, and the corrected proofs that abound, show that he asked his engraver to make constant revisions so that the prints are like poems translated into another tongue with the assistance of the original executant. Moreover, when he worked with Lucas Constable was deeply affected by his wife's premature death. Darker skies, and storm clouds in the prints, reveal that he caused another man to interpret his melancholy and despair. The prints are substantially different from the paintings inspiring them. 'The Cornfield', one of a pair of mezzotints on a larger scale undertaken by Lucas for himself, is also to be considered a reinterpretation rather than a reproduction. The view, a lane leading down the slopes of the valley

towards Dedham, shows the path the painter would have taken on his way to school as a boy. The painting was the first chosen to represent him when it was presented to the National Gallery in the year of his death.

It is fascinating to compare this mezzotint with another print after 'The Cornfield' made in December 1899, just before the dawning of the twentieth century. This time the interpreter was Timothy Cole, an American wood engraver who had developed an idiosyncratic white dot and line technique for the translation of works of art into relief prints. This job he did for the 'Century Magazine' with incredible intelligence and fidelity, from 1884 to 1910. In fact, Cole and engravers like him were already technically obsolescent, for half-tone reproduction became feasible just before his project began. Nevertheless, perhaps the clear visibility of the 'code' into which he has translated his message and the skill with which he deployed it, go some way towards explaining the contemporary fascination for his work. Wood engraving however, was to be taken up by artists working directly in the medium rather than copying other

works of art. We tend nowadays to think of the photograph as liberating us from the interference such graphic codes imposed on the viewer. Yet the darkened silver salts in photographic paper are not unlike the subliminal codes of a mezzotint (although both are actually conveyed here by means of photolithographic half tones). Whether manual or photographic, all these representations are symbolic reports about the three dimensional world on a two dimensional surface – as indeed, the original painting was.

Accepting reproduction of other works as its natural role, as painting changed, the conventions of printmaking changed. Italian painting of the fifteenth century for example, consisted largely of outline infilled with colour. Marcantonio Raimondi, printmaker to Raphael, an illustrious Renaissance painter, devised his engraving system to communicate volume by line as the painter did. Marcantonio's style, ignoring surface texture in favour of the sculptural depiction of form, became the model for reproductive engraving for several centuries. Moreover, in a way which illuminates the importance printmaking had in circulating ideas for painters, the trio sitting on the right-hand side of 'The Judgement of Paris' from a lost Raphael drawing are said to have been borrowed at least thirty times by other artists. Manet's transcription of them into the 'Déjeuner sur l'herbe' in the nineteenth century was perhaps the most notorious. Alain Jacquet was still quoting it quite recently.

As oils became juicier and pictures increasingly painterly and less like coloured drawings, printmaking had to convey tonal nuance. Mezzotint, discovered in the seventeenth century, proved admirable for the purpose. During its high point in England a century later, J. R. Smith made several hundred prints after portraits by the first president of the Royal Academy, Sir Joshua Reynolds. That of the ballet dancer Giovanna Baccelli as a Bacchante, was judged 'most truthful' by her contemporaries. Described in the press as 'of the higher order of impures' Baccelli, mistress of the third Duke of Dorset, is reputed to have worn his Order of the Garter ribbon as a bandeau at the Paris Opera. So she must have compensated for the cockeyed look and her ski-run of a nose, by a beautiful temperament.

Neither reproductive engravers or mezzotinters professed to be making facsimiles (or exact imitations) of their originals. In the nineteenth century however, that was precisely the aim of incredibly gifted cutters like the Dalziel Brothers, who translated into wood intricate pen drawings made specially for illustrations by Pre-Raphaelite artists such as Millais. Corrections on the proof show how closely artist and cutter collaborated.

Blake's earlier wood engraved illustrations were of a very different order. He loathed the 'blots and blurs' of painters like Reynolds. Whilst not

7

particularly characteristic of his work, these prints commissioned from him for a rather crudely printed schoolboy edition of Virgil, inspired many followers by their innovatory freshness. What makes them particularly fascinating in the context of a discussion of originals versus reproductions is that when Sir Geoffrey Keynes discovered Blake's original

8

9

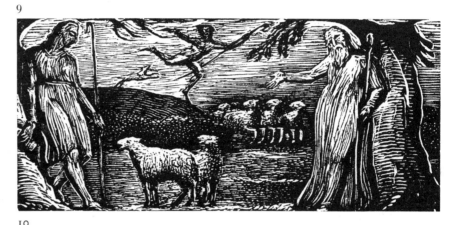

10

6 M. RAIMONDI after Raphael *Judgement of Paris* engraving 1510

7 J. R. SMITH after Sir Joshua Reynolds *Giovanni Baccelli as Bacchante* mezzotint 1783

8 Enlarged photo comparison of 1937 electrotype and recent proof from original wood block

9 W. BLAKE *Thenot remonstrates with Colinet, Lightfoot in the distance* for Thornton's 'Virgil' wood engraving from original 1821 block printed recently

10 J. E. MILLAIS Annotated proof from 'Framley Parsonage' wood engraving 1861

wood blocks in 1937, he had facsimiles made from metal casts taken from the wood. These facsimiles, and even more a painstakingly careful printing on fine paper from the original blocks recently sanctioned by the British Museum, both reveal more detail than Blake himself would have seen in his lifetime, because the Virgil was badly printed on inferior paper.

It is an indication of the way notions of the exclusive so often win, that the British Museum permitted an expensive limited edition to be taken from the original wood, rather than marketing a cheaply unlimited printing from new and improved electrotype casts, for it is often impossible to distinguish between prints from the wood and electrotype facsimiles. Nevertheless, the exercise is an illuminating one, for if the eye at normal viewing distance can be foiled by facsimiles, as other fine reproductions of Blake by the Trianon Press have shown, then some reproductions can provide aesthetic experience little different from highly prized (and highly priced) originals.

11

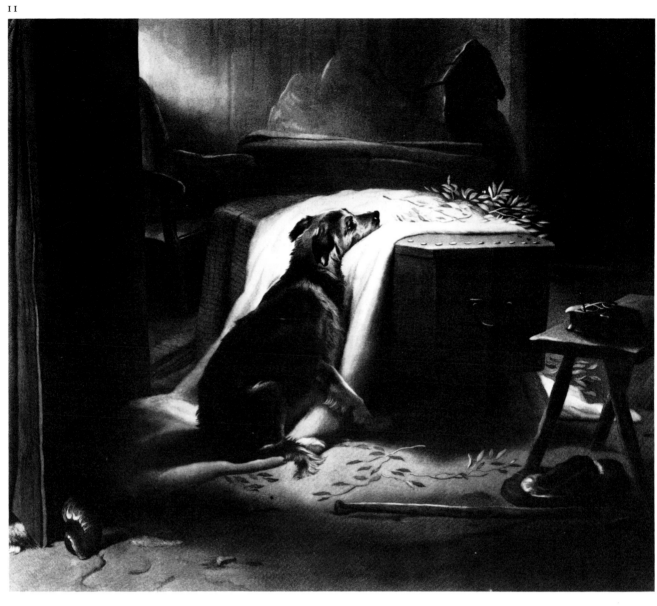

12

13

118

It was in an attempt to establish the virtue of the hand-made in competition with photography that artists rethought printmaking in terms of each graphic medium rather than using it reproductively. At the time that the most important photographic discoveries were being made, the prevailing fashion was for complex intaglio prints reproducing popular Victorian paintings. Indeed, it was often the custom for artists to produce paintings with an eye to the very profitable sale of engraving rights. Such prints were as much a feature of Victorian home life as television is of our life today.

Sir Edwin Landseer, Queen Victoria's favourite painter, exhibited his painting of a dog mourning its owner at the Royal Academy of 1837; by 1869 F. Hollyer had engraved the picture, and an edition of a hundred 'artist's proofs' had been recorded as the special part of a much higher total edition.

The new steel plates and towards the end of the century photogravure, actually made limitation quite unnecessary. However, commercial gain and snob appeal established hierarchies of proofs at ascending prices. The cheapest proofs were lettered, those 'before letters' were slightly dearer. The artist's proofs often had added marginal motifs or were on special paper. The Printsellers' Association, which registered 126 printsellers and nearly 5000 plates between 1847 and 1894, kept an account of the number of special proofs issued; in this way the limited edition was born.

It was in protest against the domination of reproductive engraving of this kind that Sir Francis Seymour-Haden, a surgeon and rather good amateur etcher, campaigned. An admirer of Rembrandt and a believer in spontaneous drawing on the etching plate, he formed the Society of Painter Etchers for those who made original prints. His aim was to force the Royal Academy to admit original printmakers as full Academicians. In 1812 the Academy had actually excluded engravers on the grounds that their art was 'wholly devoid of those intellectual qualities of invention and composition' which painting possessed. Even when in 1855 they relented, it was only towards reproductive engravers; it never seems to have occurred to them that original prints were possible.

The elegant etchings and lithographs of Haden's brother-in-law, the American artist Whistler, can be seen as the complete antithesis to repro-

14

15

ductive engraving. Yet although on the one hand he attacked connoisseurship by trimming the margins of his etchings (for which collectors had, and still have, a weakness) he also sold lithographs with large margins and signature for four guineas, against those unsigned on smaller paper for two guineas. Thus he suggested that one should pay as much for extrinsic factors as for the image itself. His guiding philosophy of 'art for art's sake', together with the artificial preciousness of limited editions, became the hallmark of those hand-made prints seeking to establish their superiority to the 'mechanised'.

This activity has to be seen against the background of the first mechanical half-tone screen used in a New York newspaper. This technology is now behind every cheap reproduction that tries the impossible task of converting the vital brushwork of a painter such

11 F. HOLLYER after SIR EDWIN LANDSEER *The Old Shepherd's Chief Mourner* engraving of 1869 after a painting of 1837

12 SIR F. SEYMOUR HADEN *A sunset in Tipperary No.XV* from *Etudes a L'Eau Forte* etching

13 J. M. WHISTLER *Confidences in the Garden* lithograph 1894

14 First half tone newspaper illustration *Shanty Town New York*, reproduced in the 'New York Daily Graphic' for 4 March 1880

15 V. VAN GOGH *Cornfield with Cypresses* photomechanical reproduction after National Gallery painting 1889

as Van Gogh into the flat surface of a printed sheet.

The alternative to betrayal by photomechanics was to design with its limitation in mind.

Although artists reacted to printing by adopting what Walter Benjamin has called a 'fetishistic fundamentally anti-technological notion of art', Aubrey Beardsley took a different view.

Beardsley's chance came as illustrator of Sir Thomas Malory's 'Le Morte d'Arthur'. This did not have hand-engraved wood blocks like those used by William Morris at the Kelmscott Press, but was aimed at a wider readership and illustrated by the much cheaper photographically made relief line block.

Beardsley designed a graphic framework including ornaments and illustrations realising that photographic process, in converting his black and white drawings into printing blocks, could actually enhance the originals. Since the rather foggy half tones of the day were unequal to adequately reproducing washes, Beardsley also invented ways of creating a tone block. To this end his 'embroideries' for Alexander Pope's 'Rape of the Lock' employ dotted crinolines, curtains swagged and wigs combed with parallel lines and psychedelically patterned gentlemen's costumes.

Beardsley's forceful line block of 'How Queen Guenever rode on maying' is interesting to compare with Arthur Rackham's version. Four colour process half tones had been available for some time at this date, but whereas Beardsley had used the line block to do what it could do extremely well, artists like Rackham were apt to find the delicacy of their original watercolours muddied because of the limitations of the process.

16

When the Dadaists and Surrealists wanted, after World War I, to shock the bourgoisie by their anti-art gestures, one sure way of doing it was by suggesting photography, or the even more despised photomechanical print processes could be imaginatively used by artists. Man Ray, the American Dada photographer, made his semi-automatic Rayograms by arranging objects on a sheet of light-sensitive paper and allowing them to

17

18

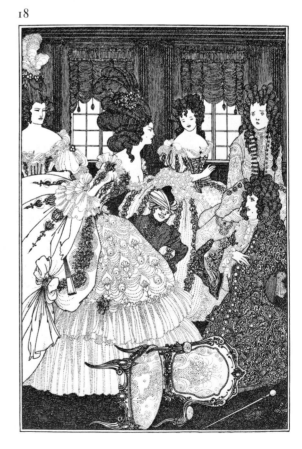

16 A. BEARDSLEY *How Queen Guenever rode on maying* illustration for Malory's 'Morte d'Arthur' line block 1893

17 A. RACKHAM version of same subject in Malory's 'The Romance of King Arthur' colour half tone 1917

18 A. BEARDSLEY illustration for *Rape of the Lock* line block 1896

19 M. RAY *Rayogram 1923*

20 M. ERNST *Quietude* from 'La Femme 100 Tetes' collage book 1929

19

20

21

22

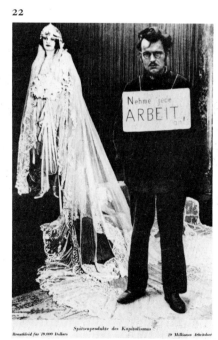

21 M. ERNST *Santa Conversazione* 'photo-graphic' 1920

22 J. HEARTFIELD *The Finest Products of Capitalism* lineblock from photo-montage 1932

'draw' themselves. Max Ernst sent what he called a 'Photo-graphic', made of collage elements stuck together and rephotographed, as his contribution to a portfolio of original prints; it was rejected. He later fashioned some of the most original books ever made by taking pages from conventionally wood-engraved melodramas and neatly inserting alien imagery into them. The printing process actually completed these works by concealing the origin of their component parts. Nevertheless the books were omitted from an important American exhibition as recently as the 1960s because they were not 'autographic'. John Heartfield used his photomontages in the political struggle. Destroying his paintings as irrelevant to the time, he repeatedly attacked Hitler in works such as that juxtaposing luxury products with an unemployed worker under the title 'The Finest Products of Capitalism' – a comment, alas still as pertinent to our society as when he first made it in Nazi Germany.

23 G. ROUAULT *Qui ne se grime pas?* from
Miserere et Guerre 1922 aquatint
published 1948

24 A. JONES image from *Life Class* litho
and photo-litho 1968

25 E. PAOLOZZI *Metalisation of a Dream*
screenprint 1963

23

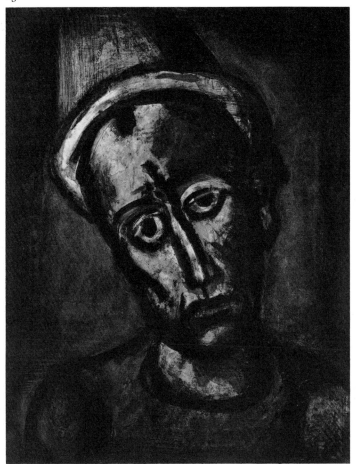

The activity of Dada and Surrealist
artists between the two world wars in
adapting commercial techniques to art
was not substantially built upon
until the 1960s.

Conservatism and the importance
still attached to the 'hand made' can be
read in the reaction to a magnificent
suite of large prints which Rouault
completed between the wars, but
which were not published until 1948.
The publisher Vollard had commis-
sioned a number of grand illustrated
books from the artist, among them
'Miserere' an album which eventually
comprised fifty-eight images. A perfec-
tionist, Vollard often delayed his
publications, but there is a possibility
that the innovatory nature of Rouault's
technique may have contributed to his

24

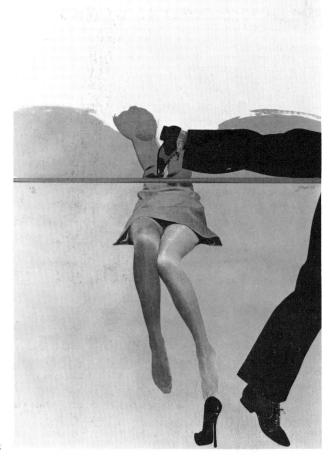

25

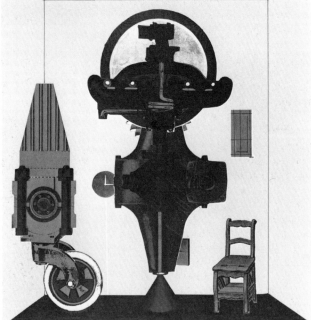

26 R. OPAŁKA *Adam and Eve* From *A Description of the World* photo-etching printed relief 1968

27 M. KIDNER *Square and Circle 2* photo-etching 1977

27

hesitation in this case. For preparatory indian ink drawings were transferred to the copper plates photomechanically by photogravure. Even though Rouault worked over the plates using every conceivable manual intaglio technique, their 'originality', has since often been called into question.

With the emergence of Pop Art however, the idea that it is legitimate for artists to work with the enormous wealth of photomechanical imagery thrown up by the various communications media, took stronger root though it was not entirely free from attack. Paolozzi, who had looked at Surrealist collages in Paris, was among the first to work creatively in photo-screenprinting with Chris Prater at Kelpra Studio. He had to defend himself in 1967 in 'The Guardian' with the justification that commercial processes could provide a 'complexity and range, impossible by normal art/craft printing methods . . .' His *Metalisation of a Dream* of 1963 was particularly intriguing because the colours were permutated throughout the editioning so that in fact each print in the apparently 'mechanically' produced edition was paradoxically unique.

Once screenprinting had led the way, works in other techniques followed. Instead of drawing a model, as artists had done for centuries in a traditional lifeclass, Allen Jones directed a photographic session at Vogue House and wittily combined photolithographs of the model's lower half with elements hand drawn on the plate. The Polish artist, Roman Opałka, hand-burnishing the figures of Adam and Eve at the centre of the population explosion, spent three months completing his plate, after systematically reduced details from a crowd photograph had been transferred photomechanically to the metal.

Michael Kidner made his subtle photo-etching to reveal an ingenious device he had been using to generate shapes for drawings and paintings. It comprised the kind of stretch elastic used for ladies' undergarments by means of which he was able to distort and mutate various geometric forms. Kidner belongs to the British branch of a movement known as Constructivism which has opposed mystique and has always believed art must keep pace with modern technology and materials. In 1978 Kidner won a major prize with this image at an international print Biennale. It is a sobering thought that a decade or two earlier, prejudice would have been such that a jury would not have hung a work with a photographic history, never mind giving it a prize.

Ideas of exclusiveness, uniqueness and the hand-made are obviously closely connected with the desire of dealers to restrict the market supply so as to be able to control the price.

While Hayter records that it was difficult even to give a print away before World War II, School of Paris artists such as Picasso, Braque and Chagall became immensely popular afterwards. Their original prints were marketed as a superior alternative to cheap photomechanical prints which were frowned on as betraying the originals they purported to reproduce as they often did.

The post-war boom in the original print market however was accompanied by a move towards greater limitation and exclusivity and the increasing use and misuse of the artist's signature as a sort of 'good housekeeping seal of approval' and marketing device.

By some fluke the suite of a hundred etchings by Picasso, known as The Vollard Suite and made between 1930 and 1936, was not signed. A dealer who purchased the edition after Vollard's death, later persuaded

28 P. PICASSO *Boy and Sleeper by Candlelight* plate 26 from *The Vollard Suite*, etching and aquatint c. 1935

29 O. KOKOSCHKA *Roses at Villeneuve* colour collotype Pallas Gallery 1973

30 O. KOKOSCHKA *Summer Flowers with Roses* lithographic reproduction Marlborough Fine Art 1973

Picasso to sign about half of them. At one period the signed ones would regularly fetch twice as much as an identical sheet from the edition which was unsigned, although there was absolutely no aesthetic difference. Today, Sothebys, the auctioneers, say the price difference is narrowing but so, mysteriously, is the incidence of unsigned sheets from the suite!

The questionable advantage of a signature (which may not even mean

the artist looked at the sheet since Dali is known to have signed blank sheets of paper before the printer ever got to them!) is even more confusing when it is applied to reproductions, especially if the fact that one is buying a reproduction is masked by the euphemism 'artist's proof'.

Two Kokoschkas available on the market in 1973 demonstrate again the differences in price that can occur. Kokoschka actually supervised both

28

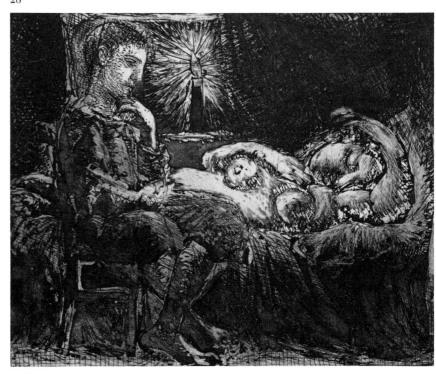

29

30

reproductions from his watercolours and approved proofs. The Pallas print, costing £5 was made by seven printings in collotype, a medium that can reproduce watercolour faithfully without resorting to half tone. The Marlborough Fine Art print, which today costs £1300, was copied from the watercolour by lithographic hand craftsmen in Zurich who printed it from fifteen stones. It was published in an edition of 150 copies, each signed in pencil by the artist. Aesthetically, however, there is little to choose between them.

The case of many a Lowry print on the market can be even more thought provoking. His 'Level Crossing', a 1973 print from a 1926 painting, is sold for £7.50 without the signature, but for £80 with his autograph pencilled in the right hand corner. Yet even Turner's autograph on its own would only fetch £5.

One of the wittiest comments on this situation and the attitudes that put art into the same category as stocks and shares, was made by the Belgian poet and artist Marcel Broodthaers. The left sheet of his 'Poem Exchange' consists entirely of his signed initials MB. On the right hand sheet these are gathered together in the bureau de change to emerge as deutschmarks, French francs, pounds and dollars.

31

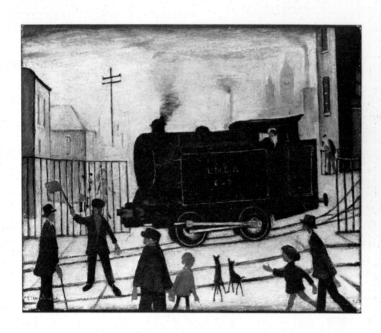

32

The result of the print boom of the 1960s and the way Pop artists used images already processed photo-mechanically in the communications media, led to a revaluation of formerly despised processes. Thus photography, hitherto a medium outlawed by various bodies trying to define an 'original print', was at last allowed into the canon of fine art where it can now be explored not only as a surrogate for reality, but as a tool of the imagination.

Among other things, we have begun to question the nature of photographs, to analyse 'truth' and 'reality' in the light of the inevitable way any visual communication we receive must be manipulated by the characteristics of the medium through which we receive it. As Estelle Jussin wrote of television in her book 'Visual Communication and the Graphic Arts' '. . . perhaps the constant barrage of shifting images from television and film are increasing our ability to comprehend flux . . . on the other hand, there seems to be serious evidence that these media may be conditioning us to expect, want and seek *only* flux, to expect, want and seek *only* constant stimulation'.

Of all artists working in recent years no one has explored the effects of media and the systems giving rise to illusion as consistently as Richard Hamilton. As an American print curator wrote of him, he 'strives to widen our awareness of how we ourselves are processed by the media, how we are shaped emotionally and

31 L. S. LOWRY *Level Crossing* signed photo-litho of 1973 from a painting of 1926

32 M. BROODTHAERS *Poème, Change, Exchange, Weschel* screenprint 1973

associatively by the unexpectedly vast and varied forms of modern representations'.

In 'People' a print editioned as a photograph in which he questioned photographic 'truth', Hamilton enlarged a detail of a photographic postcard to the point where legibility was threatened and the human beings had become abstractions. He then interfered with the image by screen-printing on it and making hand additions in ways ranging from the obvious to the imperceptible.

'I'm Dreaming of a Black Christmas' is at the end of a series of prints stemming from a 35mm colour reversal frame from a 1954 Bing Crosby film – the first one shot in Panavision. Hamilton's variations on the theme included a lithograph, a hand-retouched colour photographic print, a dye transfer print to make the fugitive photograph more permanent, a screenprint, and, using a negative colour transparency of an intervening painting, the image reproduced here which is a collotype with twenty-four

34

screenprintings which simulate graphic manipulation. Thus the image has been batted from process to process and from negative to positive many times, while a kind of 'Alice through the Looking Glass' fascination for the mirror world of colour reversal, shows how technical advances continually make possible new ways of seeing the world.

'Kent State', in its turn, took a cool look at television and the way it communicated the image of an American university student, shot on his campus, in a political confrontation with the National Guard. The degradation of the image as it passes from ciné camera to television, to orbiting satellite, to a magnetic, tape-recording device for further transmission via British television, is also part of the subject. Hamilton snapped the image on television with a camera and the colour transparency was processed into the print without half-tones. 'Fifteen layers of pigment,' wrote Hamilton 'a chorus monotonously chanting an oft repeated

story. In one eye and out the other.'

Most of Hamilton's images circulate in the élitist world of the expensive limited edition which, despite their contribution to intellectual life and general awareness, precludes them from a very widespread influence. 'Kent State' however, was one of a series published in very large editions by Dorothea Leonhart of Munich. Since 'Kent State' was not only commenting on the degradation of imagery in media processing, but 'an expression of moral shock' by political action in a so-called democracy, Hamilton chose it for this venture thinking it would be 'more effective if spread wide'.

34 R. HAMILTON *People* photo with collage, printed and painted additions 1968

35 R. HAMILTON *I'm Dreaming of a Black Christmas* screenprint on collotype plus collage and wash additions 1971

36 R. HAMILTON *Kent State* screenprint 1970

35

36

Since the incursion of photography into printmaking, the technical improvement of photographic materials themselves has led more and more artists to the use of pure photographs. Phillippa Ecobichon, who lives on the Isle of Wight, is essentially a landscape artist who uses the serial possibilities of photography to register the passage of time and record the growth and regeneration cycles in the countryside. The works can vary from monumental wall pieces charting the weekly changes in a wheatfield over a year, to smaller cycles.

One of the results of the inclusion of photography into the canon of fine art has been that the limited edition syndrome has afflicted it too. Phillippa, for example, whose works have been bought by several national institutions, had to announce and limit the edition size of her sets of photographs before she could negotiate a purchase. She finds the limited edition counter-productive and sees photographs and conventional prints as basically the same, the natural characteristic being their repeatability.

There has been a growing tendency for some artists who have worked photographically however, like Richard Long, to make extremely inexpensive books and prints, in addition to rarified unique works. Long's £2 photolitho 'Roisin Dubh', published by the Arts Council, was made from a colour transparency the artist took on one of his ritualised walks in Ireland. Its caption records his displacement of stones in the landscape. This fusion of imagery and poetry interpreted through commercial process demonstrates one of the ways in which artists can attempt to make their work available to more than the narrow and élite circle of people who have traditionally been able to enjoy it.

37 P. ECOBICHON *The Chalk Field and The Sea* colour photographs 1979

38 R. LONG *Roisin Dubh* photo-lithograph published by Arts Council 1976

37

38

ROISIN DUBH

A Slow Air

A THOUSAND STONES MOVED ONE STEP FORWARD ALONG A SEVENTY FOUR MILE WALK IN COUNTY CLARE

Do-it-yourself

Some ways of making prints are complex and need access to specialised equipment and attendance at classes. Other techniques are so simple that a child could use them. A great deal of fun is to be had from making linocuts, or improvising from found objects using a simply made stamping pad to ink them. It's possible, as enthusiasm grows, to make one's own greetings cards, print decorative wrapping papers, personalise notepaper, and even work on fabric. Relief printing, stencilling and screenprinting are the techniques it is easiest to take up on one's own at home.

The products referred to in the text which follows are those I have used myself successfully at home and have found to be effective. There are, however, a number of other products which may do the job equally well; likewise, a number of other methods and recipes.

Relief printing

The relief principle, including lino cutting and wood engraving, has already been dealt with on pages 23 to 30. Although the relief artists who demonstrated their techniques for this book used presses to make their prints, Ian Mortimer showed it was possible to transfer the colour from block to paper with nothing more complicated than the bowl of a spoon. Here he demonstrates another way of getting an impression from a woodcut without even the bother of inking it. (1) by placing a sheet of paper over the top of the cut blocks and rubbing a soft crayon over the surface. (2) it is possible to see how a print is progressing, or take an edition of several impressions. This is the technique the Surrealist painter, Max Ernst, called 'frottage'. But it is also the way many people, using a solid black wax called cobbler's heel ball, take rubbings from ornamental brasses in churches.

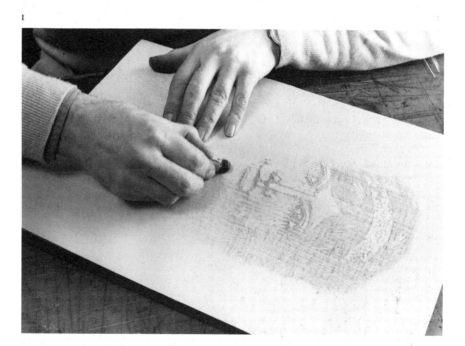

1

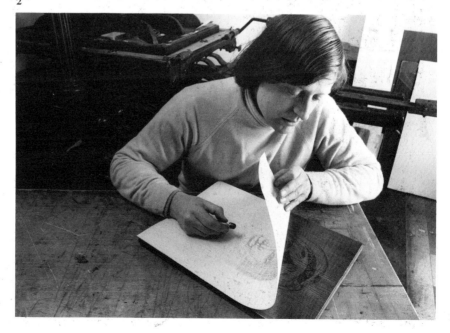

2

Basic printing kit for work on paper

Use cheap newsprint for tryouts; cartridge or soft imitation Japanese paper for finished prints; a palette knife (or icing knife) for mixing ink on a glass or plastic slab; a $\frac{1}{4}$–$\frac{1}{2}$ inch (6–12mm) foam plastic printing pad of sufficient area to accommodate blocks; oil ink and white spirit solvent, or watersoluble thickened colours as used in fabric printing; paper cups or jam jars for mixing; rags; newspaper; a sharp craft knife.

If a block is to be inked, however, there are several ways of doing it.

(3) An oil-based ink, thickened water colour or fabric dye, can be painted on to the object.

(4) A tacky ink (either water or oil-based) bought in tubes or small tins, can be rolled out onto a sheet of plastic or glass and then evenly distributed over the block by roller.

(5) A rectangle of $\frac{1}{4}-\frac{1}{2}$ inch (6mm–12mm) foam plastic, placed perhaps on an enamel plate, can be used to print small blocks or found scraps as if they were rubber date stamps. It is important to fill but not overload the pad initially and then to replenish it by spreading ink evenly with a knife each time that the surface area needs more.

3

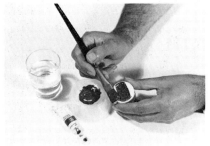

4

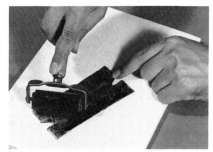

5

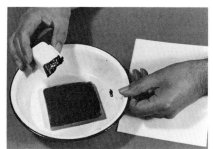

Here are some of the things that can be printed by one or other of these three methods.

Blocks can be cut from: lino; rubber vinyl tiles left over from floor laying; hardboard or chipboard; pieces of cardboard or plywood stuck with waterproof glue to handles made from cotton reels or wooden drawer pulls; balsa wood (a lightweight, easily cut wood used for model-making and so soft that objects can be impressed into it and leave their shapes indented); sheets of cork or polystyrene; or even artgum erasers.

Blocks can be built up by sticking with waterproof glue to a base: various kinds of string; dried cereals or uncooked pasta made into a pattern and lightly sandpapered to give the ink a 'tooth' to hold on to; felt shapes; tacks or drawing pins evenly hammered into the block to form a pattern; beads or buttons; crumpled silver paper; embossed left-over wallpaper protected by a thin coat of nail varnish.

Natural objects such as: grasses; leaves (although not glossy or awkwardly shaped ones like holly); feathers, stones, vegetables and fruit such as potato, carrot, cabbage, onion, turnip, apple etc.

6

7

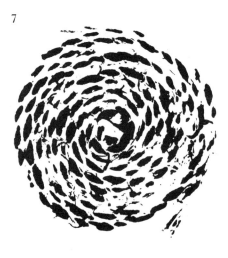

8

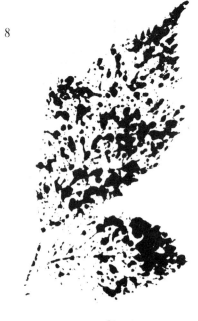

Improvised printing devices can be made from: pipe cleaners; corks; corrugated cardboard; washers, metal scraps and end sections; cotton reels; polystyrene scrap; cardboard tubes; lids; ends of pencils for small spot patterns; old nailbrushes, suede-brushes or toothbrushes; objects pressed into a small rectangle of plasticine which is then inked up; perforated grids and meshes; plastic foam sponge cut into shapes.

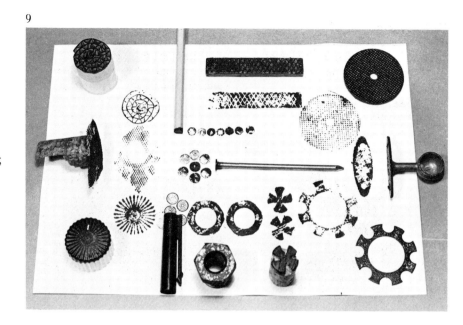

Printing on Fabric

The printing techniques described at (5) above can also be used with water-based dyes and pigments for fabric printing. Small blocks with too shiny a surface (like lino) have to be flocked to hold the colour. For this, a special adhesive known as flocking mordant is rolled on to the surface as an oil-based ink would be. The mordant is cleaned off the roller with white spirit. Then a finely chopped fluff called flocking powder is sieved on to the surface so that it can stick there and form a felt-like surface which will carry dye. Two coats can be applied, but each must be allowed to dry completely overnight under pressure. Before using the block, the excess fluff is brushed off so there is no loose matter to foul the ink.

General purpose ink or dye

Redimix Liquid Tempera (Reeves/Dryad)

This tempera paint in 24 colours can be mixed with various additives to give a whole range of uses.

Gelmix thickens Redimix to make the paint suitable for screenprinting;

Blockmix provides printing colour suitable for relief printing;

Dyemix transforms Redimix into a fabric colour with a certain amount of wash resistance after it has been fixed by ironing.

All these pastes can be washed out of the screen or off the block etc by cold water

Pigment systems

Craft Dyes (Reeves/Dryad)

For pad, block stencil and screenprinting. Thin with water, thicken with sodium alginate (sold by chemists or under the trade name Manutex). Use extender for paler tints. Air dry, then coat with fixer and exclude air for four hours by rolling in a plastic bag.

Printex (Winsor and Newton)

Fifteen concentrated colours can be diluted in Printex Binder – a colourless emulsion. One part of colour is mixed to 10–20 parts of binder. The colours are translucent unless opaque white is added. Fixing is done by pressing the fabric on the reverse with a domestic iron for 5–10 minutes per sq. foot (7000sq.cm).

Cooltex (Sericol)

Mix 100 parts of coloured base (different colours, ready mixed) to 4 parts of catalyst by volume. No heat curing necessary, but air dry for 4–7 days before washing. Can be used for block printing, and screenprinting.

Many fabric colours used in the trade need complicated finishing processes such as steaming, but there are also fabric colours which can be used with comparative ease at home. They divide into two main kinds – pigment systems and dyes.

Pigment systems, which have the consistency of double cream, can be screenprinted, or relief printed by stamping the block on a pad or painting the block with colour. These systems involve either ready-mixed colours which can be combined together, or a colourless base, usually called a binder, to which a small amount of concentrated pigment is added to obtain the desired shade.

Any mixture must be mixed very thoroughly to avoid streaks. All such fabric colours are soluble in cold water while still wet, but become impervious when dry, thus allowing the fabric to be washed. If they are used for screenprinting they must never be allowed to dry in the mesh, because the colour will clog and become immovable. Sometimes a catalyst is needed to fix the colour. This usually means the mixture has a limited 'pot life' so that if it is not used within a certain time, it will not fix properly. It also implies that leftovers cannot be kept. However, such leftovers can be reactivated with fresh catalyst, or if not, can be kept in jam jars and used for printing on paper where fixing is of no importance.

Unless white printing paste is added, such colours are transparent, so that a blue printed over a yellow will produce green. The proper fixing of the colour on cloth usually involves some kind of heat 'curing'. Sometimes this simply means leaving the printed cloth in a warm place for some time, sometimes it means ironing the fabric at the highest temperature it can sustain, for a given period. Undoubtedly such systems are very easy to use. Their disadvantage is that although they have improved tremendously over the years and handle quite softly on the cloth, they leave a kind of film behind which clogs up a fine fabric such as silk, and robs it of some of its shine. For this reason, once past

Reactive Fabric Dyes

ICI Procion MX dyes; Dylon Cold Dye and Ultra Batik Dyes Cold water reactive dyes work on natural fibres (cotton, silk, linen etc) but not on synthetics or fabrics with crease resistant finishes etc. The dyes are permanent and form an unbreakable chemical bond with the cloth. Such dyes require sodium carbonate as a fixative (introduced in the form of soda ash, a solution of washing soda crystals, or the trade product Dylon Cold Fix). Some recipes introduce the fixative into the printing paste, but this limits its useful 'pot life' so I introduce it into the cloth separately before printing. For block and screenprinting, the dyes are thickened with sodium alginate – a colourless substance, once mixed, which thickens the dye so it can be carried on to the cloth, but is washed out after the dyes have been fixed. It can be bought at good manufacturing chemists or as proprietary products such as Manutex or Super Paintex from craft shops. The latter has the other necessary chemicals, apart from the fixative, mixed with it.

the beginner's stage, it is worth progressing to printing with dyes, even if it takes a little more trouble.

Dyes are printed by being carried on to the cloth in a thickener. Subsequently, when the dye has been fixed and the cloth has accepted the

Stages of printing with reactive dyes:

1 Prepare the cloth by washing it to preshrink it and remove any starch, as this could inhibit the dye. Soak the cloth in a solution of 2 teaspoons of sodium carbonate powder, or 4 teaspoons of common soda crystals dissolved in each pint of water necessary to cover the cloth. Dry cloth *without rinsing* and iron.

2 Mix 10 level teaspoons of urea (a solution assistant) with 8 fl. oz of warm water not exceeding 70 deg. C. Use this solution to dissolve up to 5 teaspoons of dye powder. It can be scaled down to make smaller amounts.

3 Make Binder in advance by sprinkling 4 tablespoons of sodium alginate granules into a litre of water softened by 1 tablespoon of a phosphate-based water softener such as Calgon. Measure 14 fl. oz of the thickener and gradually add the liquid dye to it, beating well. When cool add 1 teaspoon of a mild oxidising agent – such as Resist Salt L or Matexil PA-L liquid.

4 The longer the dye remains wet on the cloth, the better the colour fixes. Hanging the cloth in a steamy atmosphere is ideal or it can be pressed with a steam iron. The material is finally processed by running it under cold water which dislodges unfixed dye and softens the thickener which is then washed out in hot detergent solution.

colour, the thickening agent is washed away, leaving only the colour behind. The best dyes for relatively simple home use are reactive dyes, available from specialist craft shops and widely sold in the form of Dylon Cold dyes.

11

(11) A small improvised fabric printing area can be made by taping a sheet of plastic down over an underlying bed of newspapers on a kitchen table. I made a removable fabric printing table top to extend my kitchen table by stretching some heavy duty sheet plastic (available from hardware merchants) over normal felt carpet underlay and tacking it to the underside of a 3 × 5ft (1 × 1½ metres) sheet of ¾ inch (19mm) thick chipboard. On such a table top, it is possible to print lengths of fabric. The cloth can be cellotaped to the surface to keep it from shifting during printing and then moved on by draping the printed area over a clothes horse. Care must be taken that the wet dye does not offset however, as the length is moved. To help align patterns printed on cloth, fine white threads can be taped across the fabric and fastened to the table with cellotape. This helps position blocks or screens.

Alternatively, the fabric can be marked with dressmaker's chalk which will later wash out.

Another way of relief patterning cloth, is to dye a length of it with an even shade using a direct dye like Dylon Multipurpose dye and then selectively discharge it by stamp printing with a dye remover such as 'Dygon'. This is made into a printing paste and applied by stamp printing from an impregnated pad.

It is also possible to print wax in the same way, to create a resist before length dyeing with cold dye. The dye must be cold so the wax does not melt before the patterning has occurred.

Dygon Printing Paste For discharging colour on fabrics dyed with Dylon Multipurpose dyes. Add 1 tablespoon of Dygon to 2 tablespoons of boiling water. Mix with sodium alginate thickener until the right consistency is obtained.

Use a mixture of paraffin wax and beeswax as sold by craft shops for batik and melt it over water in a double boiler. To print this, make a bed of felt in a tin large enough to accommodate whatever size of block is to be used for printing. Pour the heated wax on to the felt and keep the tin on a warming plate so the wax remains liquid and does not solidify. For this purpose it is even possible to rig up a night light in a coffee tin with holes pierced in its lid. Never use an open flame, as wax is highly flammable. Print the wax on to the cloth where it will solidify, forming a resist which will keep the cold dye out. Warm the blocks too, so that they do not cool the printing pad and cause the wax to set prematurely.

Although only time and experience will lead to the creation of sophisticated designs, it's amazing what can be achieved simply by organising into a pattern the shapes made by stamp printing 'found' objects. A random offcut of polystyrene can be organised into a cellular all-over pattern (12); a small plastic electrical connector, inked for every third print, gives tonal variety by the use of only a single colour, while an aluminium channel section, plus a spot print from the end of a hexagonal pencil, is able to ring several pattern changes. In one print, the forms printed by the aluminium are locked together in a way reminiscent of a Greek key pattern (13). By placing a piece of paper across the corners of the printed cloth at an angle of 45 degrees, the pattern can be neatly and symmetrically turned at right angles. Such small patterns, with the added advantage of colour, would make attractive dolls clothes, blouse material, ties, edgings for serviettes or place mats, while larger blocks might be adapted for cushions, aprons, tea towels, beach bags and so on . . .

13

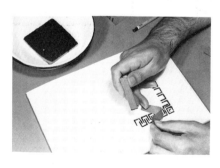

12

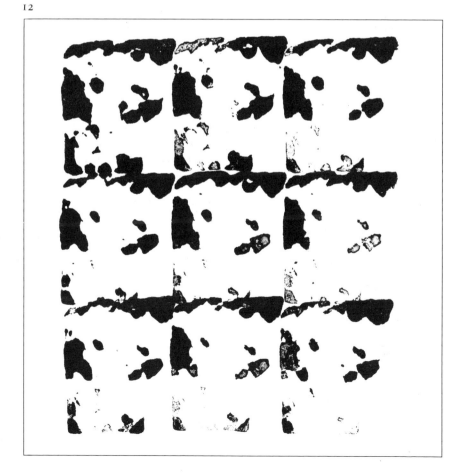

Stencilling

Stencilling is a way of patterning by cutting areas out of a protective mask and brushing, rolling, dabbing or spraying ink or paint through them. The colour should ideally be relatively thick, so it does not run under the edges of the stencil if dabbed on with special stubby stencil brushes. If sprayed on, it must be quick drying.

Cecil Collins, the visionary artist whose paintings and prints can be seen at the Tate Gallery, was travelling about during wartime without normal printing equipment, so he improvised by using those familiar wax stencils, normally cut by typewriter. The artist devised various ways of drawing through the wax – by a stylus (like an inkless biro), by using a sharp knife to remove whole slivers of the stencil, and by texturing some prints by grazing the wax with sandpaper. Necessity is always the mother of invention and images like Cecil's 'Tree Spirit' (14) were editioned by placing the wax stencils on to the paper to be printed and rolling ink through them.

Secretaries nowadays might have access to the office duplicator and run an edition of greetings cards or pictorial letter headings, quite speedily.

Cartridge paper can be varnished to make a home-made stencil paper. It is also possible to buy commercial stencil paper – a kind of stout oiled card. Designs have to be cut in such a way that no sections of the pattern fall out from the stencil. In the decorative wrapping paper illustrated (15), a silver aerosol has been used to spray through a mask on to sheets of fine tissue paper.

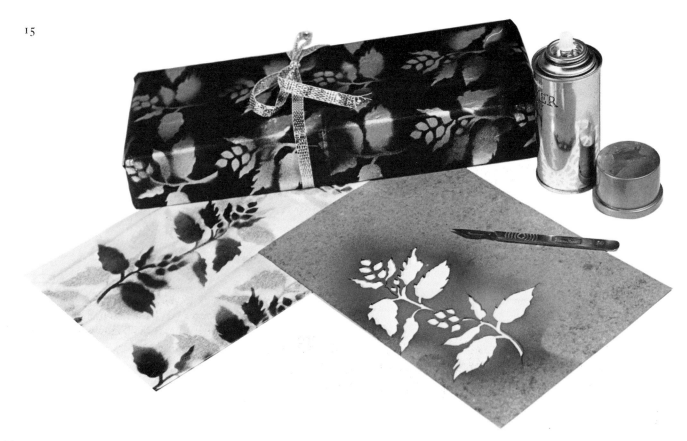

It is also possible to print colour through a shape cut out of a sheet of paper which is used as a masking device.In the illustrated design (16) for another wrapping paper, the vase has been defined by printing it in this way using thin plastic foam sheeting wrapped round a cotton reel as a block. The flowers come from a simple knife-cut cork and a hexagonal pencil end, while the repeated leaf was cut with scissors from fine perforated metal sheet pinned to a cork to make it printable.

Stencils can be reversed so that from one piece of stencil paper it is possible to make a symmetrical pattern, very simply by turning it. This pair of birds, planned for stencilling on to wallpaper (17) together with a design of leaves, will be sprayed in iridescent car body colours of off-white, pale green and silvery blue, on to lengths of cheap lining paper roller painted with blue-grey emulsion.

17

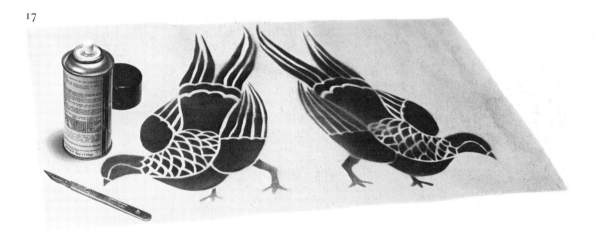

18

As long as suitable lettering styles which avoid loose islands are used, paper stencils can be useful for printing posters.

Screenprinting

Screenprinting can be undertaken at almost any level. Sophisticated forms of the technique have already been described between pages 100 and 107.

This section aims to describe the relatively simple equipment which anyone could set up in their own home. Once a screen frame has been made, it can be used for work either on paper or fabric. Naturally the simpler and cheaper the equipment, the less high precision work one would expect to be able to do. The stability, tautness and fineness of the stretched mesh is critical here.

If used on textiles, the screen needs no base board. But if it is used for making prints on paper, then a bed is

(19) A simple silk screen frame can be constructed of lengths of 2 × 1 inch (50 × 25mm) soft wood timber. It should be several inches larger in each direction than the actual printing area required. The corners can have mitred, lap or simple butt joints and should also be fixed with waterproof glue. Angle irons at the corners help reinforce the frame and keep it rigid. The surface of the wood should be smooth and rounded, particularly where it is in contact with the covering mesh, while a coat of exterior quality varnish will help prevent warping and make the frame easier to keep clean.

(20) Durable rubber or composition strip (2 inch × $\frac{1}{4}$–$\frac{3}{8}$ inch (50mm × 6–9mm)) can be purchased from specialist stockists and sandwiched between wooden strips held by brass screws, to make the squeegee. The blade should be about 1$\frac{1}{2}$ inch (37mm) shorter than the inside of the frame and can have an extended strip of wood or dowelling to rest on so that it will not fall into the ink or dye in the well of the screen.

(21) For most purposes the squeegee blade needs a sharp square edge. This can be maintained by rubbing the squeegee at right angles to a sandpaper block whenever it gets blunt.

usually constructed consisting of a base-board with the screen hinged to it (22). On this bed, the registration marks are laid. A formica-topped board is ideal and should be a little larger than the screen. A drop stick at the side is used to hold the screen up when the printer wants to remove the printed sheet.

The frame is covered with a fabric which has an open mesh structure. Once upon a time, silk was commonly used. Nowadays it is more often a synthetic like terylene which can withstand most of the chemicals used in the process. Meshes vary greatly both in the type of weave and its fineness. Beginners however, usually use the cheapest of fabrics – such as cotton organdie or an inexpensive synthetic weave.

There are many recommended ways to stretch a screen. The most important thing is to get the fabric as taut as possible and to keep the warp and the weft (the fibres crossing each other) at right angles (23). I usually begin by stretching the selvedge (the woven edging of the cloth) along the longest side of the screen (AB) keeping the fabric under tension. The screen covering must be cut a little bigger than the screen frame in every direction and any raw edges must be turned

22

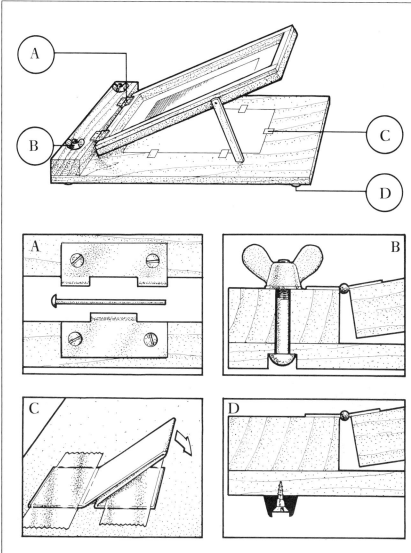

24

in as they are tacked on (24). Next I pull a thread along the short side (AD) to help me to keep that side at 90 degrees to the first. I turn the corner neatly and keeping the line where the thread has been removed parallel to the edge of the frame, I again fix the fabric to the wood, still keeping it under tension. I use a trigger tacker to drive staples into the wood. Then the second short side at the opposite end (BC) is pulled so that the mesh is stretched between the two opposite ends and outwards to corner C simultaneously. Another thread can be pulled for guidance, to indicate parallels. Finally on the last side, I work from the middle out to each end, making sure once again that the crossing threads remain at 90 degrees to one another, so the screen is less likely to go baggy.

23

Before printing, the working area must be set out so that everything is to hand and there is somewhere to put prints to dry. (25) Pegs or spring clips can be suspended on a line. If there is space or the work is large, wooden frames made of plaster lath, with a central cross-strip or crossed strings can be used.

(26) The screen frame is prepared for printing by sticking 2 inch (50mm) gum strip or sticky plastic tape to the edges and building it up until the printing rectangle has been defined and there are adequate wells at two opposite ends to accommodate the ink. Gum strip is also angled inside the screen at the place where the fabric meets the wood to prevent any colour leakage. The gumstrip can then be varnished to make it impermeable.

A stencil is a way of selectively blocking the mesh. This can be done with paper, by using special cut films (one of which was demonstrated on page 100), by using colloids such as gum or proprietary block-outs, or by photographic means.

Stencil materials include: torn or cut paper such as newsprint, butcher's paper and greaseproof or tracing paper; found stencils such as paper doyleys, computer tape, netting or lace, gummed paper shapes; proprietary knife-cut stencils in which a thin layer on a transparent support is cut and then adhered to the mesh either by ironing or dabbing with a solvent chosen to harmonise with the ink to be used; proprietary water based or cellulose based fillers or liquid fish glue (such as Lepages) which can be painted, printed, squeegeed, or sponged on to the screen; nail polish, cellulose ink or lacquer; candlewax, both solid and liquid; powders such as Fuller's earth or French chalk or talcum.

Paper stencils – torn or cut – can be used for short printing runs. The sheet of paper to be printed is placed on the printing bed, the cut or torn paper stencil is set on top of it and is then picked up with the first wipe of ink which also adheres it to the screen.

To make a negative block-out stencil (27), a drawing of the design can be placed on the printing bed, the screen frame lowered on to it and the image traced in pencil on to the mesh. The screen is then raised on small blocks and proprietary screen filler or glue is painted on to the mesh through which one does *not* wish to print.

The basic principle is that whatever the stencil is made of must be resistant to the ink solvent with which the screen has to be cleaned. Thus water inks cannot be used with a water-based glue filler, cellulose lacquer cannot be used as a filler with cellulosic inks. On the other hand, cellulose lacquer is a good multipurpose filler for both oil-based and water-based inks because their respective solvents (white spirit or warm water) do not affect it.

25

26

27

A way of drawing the positive design to be printed (rather than the negative parts not to be printed) is by the tusche resist method (28). Tusche is the greasy medium used in lithography and available from specialist print shops in liquid or stick form. Greasy crayon or candlewax can also be used. Solid sticks of any of these can be used to make rubbings directly on to the mesh of the screen being careful to fill the pores. The liquid variety can be used for a freely drawn image. When this is dry, a good fish glue or water-based filler is poured into the well of the screen and wiped across with a scraper of cardboard, a plastic ruler or composition tile. The greasy drawing rejects the water-based filler which occupies the mesh in every other part of the screen. When the glue is completely dry, the screen is put on a bed of newspaper and white spirit is sprinkled on. To avoid disturbing the glue but prevent evaporation of the solvent, this can be held against the mesh by a sheet of glass. The white spirit dissolves the tusche or wax, but not the glue, which will remain to form the stencil. An oil-based ink can then be wiped through the open spaces in the mesh where the drawing once was. To do the same thing with water-based ink, one would draw in glue and use an oil-based varnish to block out the screen.

28

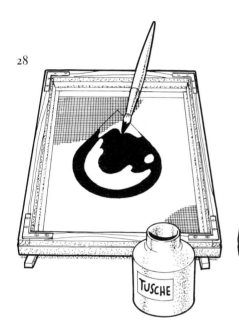 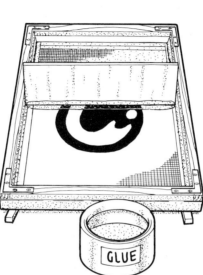 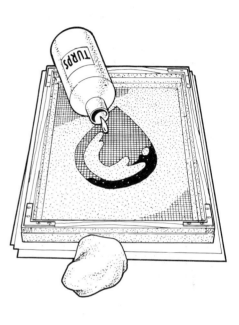

29

French chalk or talcum powder can also be used as a screen filler. It can be sieved onto a sheet of dark paper, as in the chalk drawing illustrated, using objects to mask the fall – such as feathers, paper clips, washers or wire meshes etc. Once it has fallen, it can also be drawn into using brushes, combs, fingers, feathers and nails. A screen is then placed over the chalk image and oil based ink is squeegeed across. The ink combines with the chalk to block the screen and will survive for perhaps fifteen prints.

29 French chalk image to be picked up by the screen as a stencil.

Direct photographic stencils
Stencils made from photographic film exposed as a separate sheet and then adhered to the mesh were shown on page 105, but it is also possible to make photostencils by applying a light-sensitive emulsion directly to the screen.

There are a number of ways of hand-making positives for transfer by light to such directly sensitised screens. For example, the screen can be coated and dried and then exposed to light with leaves or grasses (30), torn or cut black paper shapes, perforated zinc meshes or jig-saw pieces protecting part of the emulsion. Dense black drawing ink (like TT Rapidograph), photopaque (a water soluble compound), or ruby spirit markers, can be used on tracing paper or proprietary drawing films (such as Kodatrace or Permatrace) to make linear positives. Dry transfer numbers, textures and symbols such as Letraset or Mecanorma etc, can be transferred to any transparent sheet and will also produce photographic positives. Many photocopying shops will make an opaque image on a transparent sheet from a typed or photographic original. Drawing, typing or even brass rubbings made on ordinary thin white paper, can be transformed into transparent positives by wiping the paper with liquid paraffin which makes it translucent. Then natural objects, such as leaves, can be inked in an oily black ink by one roller and picked up on another roller with a diameter large enough to accommodate the object's entire surface. Transferred or 'offset' on to transparent sheeting (31), these

30
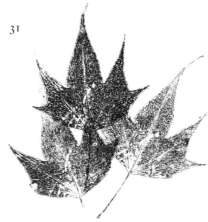

31

32

also will make positives. This is how the leaves were set onto transparent film for the fabric illustrated (32).

Those with access to photographic equipment, including an enlarger, can use elementary photographic knowledge to make their own photographic positives from conventional black and white photographs. To do this, orthochromatic film, which must be handled in safelight conditions, is used to make a high contrast image which converts the continuous tone negatives of normal photography into an opaque black image on a transparent base. This makes it possible for it to be contact-printed on to the sensitised emulsion on the screen.

To make a light contrast positive for transfer to sensitised screens

1 Produce a high contrast negative by copying on ordinary black and white photographic negative on to a graphic art film such as Kodalith Ortho film 6556, type 3; or Agfa Gevaert LITEX film 0810p.

2 Use the high contrast negative in an enlarger to produce a positive of the required size on a sheet of the same kind of film. Develop and fix in proprietary developing and fixing products (such as Kodalith Super-liquid Developer or Agfa Gevaert Developers G90T or G7C and Agfa Gevaert fixer G333c or Kodafix solution) following the manufacturers' instructions.

33

The screenprinted 'T' shirt illustrated (33) was printed on an ironing board. It was made in Heath Robinson conditions in an ordinary household, where a bathroom without windows served as a darkroom. The screen was prepared by coating with a direct photostencil emulsion called Dirasol Superstrip by Sericol. This relatively new product is safer than dichromate sensitised emulsions and comes in a pack containing a coloured base emulsion to which a diazo sensitiser must be added. Once mixed, the emulsion can be kept for four months in a household refrigerator. The product comes with an informative instruction sheet.

For use with this product the screen is best covered with a synthetic mesh (nylon, polyester etc.) which must be degreased before it is coated. I use a dry cleaning fluid (in a well ventilated area) and then water containing washing-up liquid.

(34) Although special coating troughs are used in the trade, the emulsion can be squeegeed on to the screen with two wipes, using a plastic ruler, piece of stiff card, or composition tile (A). The screen must then be left to dry horizontally in a dark room, although occasional weak illumination is not harmful. After a couple of hours or so (which can be reduced if a fan is used to assist drying) the screen is ready for exposure. It can be exposed in sunlight (which requires anything from ten minutes to two hours, depending on the brightness of the day) or by using one of the several recommended lamps. Ultra violet light is efficient and I fixed an ordinary sun ray lamp to a camera stand and exposed the emulsion to it for 15 minutes including the warming-up time.

To ensure close contact between the positive and the emulsion, I make a sandwich, building up a platform inside the screen with large books covered by a layer of foam plastic sheeting on top (B). The positive is then placed in contact with the emulsion so that the image would appear the correct way round if one were looking from the inside of the screen. A sheet of glass a little larger than the area being exposed is then placed over the positive or objects to prevent them curling in the heat. None of this needs to take place in safelight conditions, because the reaction to light by the emulsion is relatively slow.

Immediately the exposure is over, the screen is sprayed with cold water (C). Where the emulsion has been har-

34

A Composition tile

PHOTOSENSITIVE EMULSION

B Ultra violet light source

Glass

Foam Film positive

Screen

Books for padding

C

dened by light it remains in the mesh forming a block-out. Where the opaque image has prevented light reaching it, it softens and washes away.

The best feature of all is that after use, Dirasol Superstrip can be very easily removed from the screen with ordinary household bleach. This is why a synthetic mesh should be used, as bleach rots cotton organdie.

People with enthusiasm for experiment and able to follow the simple

instructions provided by manufacturers, or in the many manuals on print processes, will be able to get a long way by themselves in relief or screenprinting and have a great deal of fun in the process. Other printmaking techniques – lithography and etching for example – because of the specialised presses and equipment necessary are more likely to need access to institutions providing instruction. A network of adult education evening institutes exists all over the country. There are also community print workshops where help and advice with a whole variety of printing possibilities can be obtained.

One can even find occasional privately inspired classes such as those run by Fred and Mary Seyd at Grayshott near Hindhead in Surrey. Mary Seyd is one of those warm and eternally enthusiastic human beings ready to share a knowledge of art and craft built up over many years as a teacher with anyone interested enough to want to learn. When she retired from full-time teaching, she and her husband opened up their studio called 'Pigeonhole' as an arts and crafts centre. For a tiny annual subscription people can, among other things, attend courses on painting, share a model for life drawing, or learn to do batik, enamelling and various kinds of work in clay. The Regional Arts Association – Southern Arts – made a small initial grant to the centre which helped pay for equipment. There is a lively children's Saturday club and there have been lino and screenprinting courses at the centre using an improvised press, both for the more advanced and for those who have never tried printing before. Make enquiries: there may be something similar only just around the corner in your neighbourhood.

35 Denis May teaching relief printing to a group of enthusiasts at 'Pigeonhole', an art and crafts centre started by Mary Seyd (third from left).

A word of caution
Most products in general supply present no unacceptable health hazards. Nevertheless their use requires common sense. Work in well ventilated areas so fumes and vapours from solvents and chemicals do not irritate the respiratory system; don't smoke where solvents or other flammable materials, such as cleaning rags full of spirit, might lead to a fire; keep chemicals away from eyes and prevent them being in prolonged contact with the skin by using rubber gloves; do not eat food after working, without washing first, do not allow children to do so either.

A list of suppliers of printing materials which you may find useful is available from:

The Crafts Council
12 Waterloo Place
London SW1Y 4AN

(*Please enclose a stamped and addressed envelope*)

35

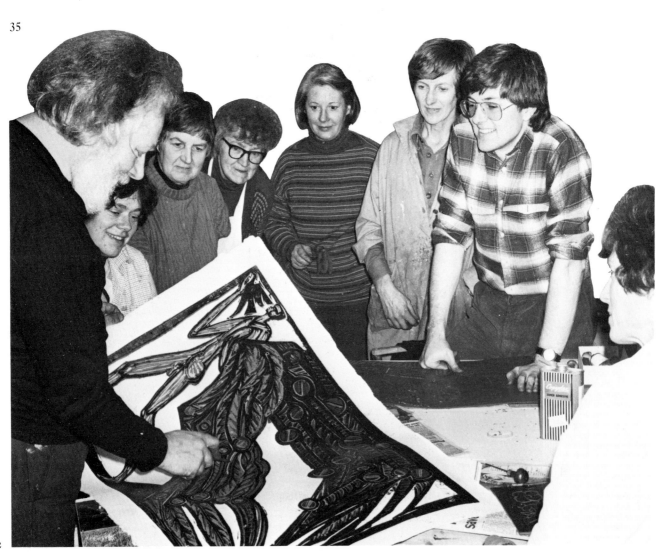

Appendix of print workshops

Your local Education Authority will be able to tell you of evening classes in print-making in your area. In addition, there is a growing network of community print workshops across the country where facilities can be used and occasionally some tuition given.

For general information about workshops contact:

Printmaker's Council,
Clerkenwell Workshop,
31 Clerkenwell Close,
LONDON EC1
Tel: 01-253 0923

Key to techniques available
● Relief
■ Intaglio
★ Lithography
† Screenprinting

All addresses are correct at time of going to press.

Peacock Printmakers, Peacocks Close, Castle St. ABERDEEN, Scotland. ●■★†

Arts Lab Press, 11 Gosta Green, BIRMINGHAM 4. ★

Saltley Print and Media, 7 Washwood Heath Rd., BIRMINGHAM 8. ★†

South Hill Park Arts Centre, BRACKNELL, Berks. ●■★†

Bradford Printshop, 127 Thornton Rd., BRADFORD. †

Moorland House Printmaking Workshop, Burrow Bridge, BRIDGWATER, Somerset. ■★

Brighton & Hove Community Resources Centre, North Rd., BRIGHTON, Sussex.

North Star Studios, 65 Ditchling Rd., BRIGHTON, Sussex. ■

Association of Artists & Designers Building, Tyndall St., CARDIFF, S. Glam. ■★

Graphic Studio, 18 Upper Mount St., DUBLIN, Eire. ●■★

Dundee Printmakers Workshop Ltd., Dudhope Arts Centre, St. Mary Place, DUNDEE, DD18 5RB. ●■★†

Glasgow Print Studios, 128 Ingram St., GLASGOW, G1 1ET, Scotland. ●■★†

Yorkshire Printmakers Ltd., The Gatehouse, Globe Mills, Victoria Rd., LEEDS 11. ■★

The Bridewell Print Workshop, Prescot St., LIVERPOOL 7. †

Lowick House Printmaking Trust, Lowick Green, LOWICK, Nr. Ulverston, Cumbria. ●■★†

Manchester Print Workshop, Meadow Buildings, Salford University, SALFORD. ★†

Manchester Etching Workshop, 3-5 Union St., off Church St., MANCHESTER, M4 1PB. ■

Kirk Tower House Studio, Kirkton of Craig, MONTROSE, Angus, Scotland. ●■

Charlotte Press, 5 Charlotte Sq., NEWCASTLE UPON TYNE, NE1 4XF. ●■★

Spectro Print Workshop, Bell Court, Pilgrim Street, NEWCASTLE UPON TYNE. †

Oxford Printmakers Cooperative, Christadelphian Hall, Tyndale Rd., OXFORD. ●■★†

Penwith Print Workshop, Back Rd. West, ST IVES, Cornwall. ●■★†

Bracken Press, 2 Roscoe St., SCARBOROUGH, North Yorkshire, YO12 7BX. ■

Crescent Arts Workshop, Crescent Art Gallery, SCARBOROUGH, N. Yorkshire, YO11 2PW. †

Yorkshire Arts Space Society, Washington Works, 86 Eldon St., SHEFFIELD, S1 4GH. ■★

Weavers Lane Print Workshop, Gainsborough's House, SUDBURY, Suffolk. †

Ceolfrith Gallery Print Workshop, 17 Grance Ter., Stockton Rd., SUNDERLAND. †

London Workshops:

The Albany Printshop, Creek Rd., Deptford SE8. †

Battersea Arts Centre, Lavender Hill, SW11. †

Camden Arts Centre, Arkwright Rd., NW3. †

Centreprise, 136 Kingsland High St., E8. †

Interaction Community Resource Centre, 15 Wilkin St., NW5. †

Oval House Printshop, Kennington Lane, SE11. ★

Paddington Printshop, The Basement, 1 Elgin Avenue, W9. ★

WITHDRAWN

Acknowledgment is due to the following for permission to reproduce illustrations:

A.D.A.G.P. © Paris 1981 p.16 no.14, p.17 no.17, p.36 no.12, p.40 no.20 & 21, p.65 no.13, p.68 no.19, p.70 no.24; IAN BAIN p.117 no.9; BRADFORD CITY ART GALLERY p.93 no.16; BBC p.61 nos.2 & 3, p.83 no.68, p.84 nos. 69 & 70; TRUSTEES OF THE BRITISH MUSEUM p.14 no.8, p.33 no.1, p.37 no.15; MRS BROODTHAERS p.125 no.32; LEO CASTELLI GALLERY. NEW YORK p.66 no.16, p.94 no.21; CECIL COLLINS p.134 no.14; COLUMBIA UNIVERSITY p.119 no.14; COURTAULD INSTITUTE GALLERIES. LONDON p.14 no.9, p.113 no.1 (photo); CURWEN STUDIO (Stanley Jones) p.74 no.35; EDITIONS ALECTO LTD p.90 no.9, p.122 no.24 & 25; PAT GILMOUR p.130 nos.6–8, p.133 no.12, p.140 no.33; WOLFGANG HAINKE p.89 no.5; H.J. HJELLE p.19. no.23; GALERIE LOUISE LEIRIS. PARIS p.19 no.24, p.64 no.11, p.65 no.12; MUNCH-MUSEET. OSLO p.15 no.11; MUNICH. LENBACHHAUS GALLERY p.40 no.21; MUSEUM OF MODERN ART. NEW YORK Robert Rauschenberg. Accident 1963. Lithograph printed in dark grey and black. Comp: $38\frac{1}{2} \times 27\frac{1}{4}''$. Gift of Celeste and Armand P. Bartos Foundation, p.67 no.17; Jean Dubuffet. Carrot Nose 1962. Colour lithograph. $23\frac{13}{16} \times 14\frac{7}{8}''$. Gift of Mr and Mrs Ralph F. Colin, p.70 no.23; NATIONAL GALLERY. LONDON p.114 no.3, p.119 no.15; PARASOL PRESS, SA p.95 no.22; PETERSBURG PRESS p.70 no.25; RADIO TIMES p.60; ROWAN GALLERY p.94 no.20; JOHN RYLANDS LIBRARY. MANCHESTER p.11 no.1, p.12 no.4; SERICOL p.111 no.69; SOTHEBYS p.69 no.21; S.P.A.D.E.M. © Paris, 1981 p.19 no.24, p.36 no.11, p.41 no.25, p.54 no.66, p.63 nos.6 & 8, p.64 no.11, p.65 no.12 & 14, p.89 no.6, p.94 no.19, p.113 nos.1 & 2, p.121 nos.20 & 21, p.122 no.23, p.124 no.28; TATE GALLERY. LONDON p.90 no.8; VICTORIA & ALBERT MUSEUM. LONDON p.38 no.17, p.40 no.22, p.116 no.6; GERD WINNER p.97 no.27, all p.109.

EILEEN TWEEDIE photographed p.91 no.11 at the ARTS COUNCIL; p.11 no.2, p.12 no.3, p.13 nos.5 & 6, p.15 no.13, p.33 nos.2–4, p.34 no.6, p.37 no.14, p.38 no.16, p.39 nos.18 & 19, p.62 no.4, p.63 no.6, p.66 no.15, p.66 no.16, p.94 no.21, p.115 no.5, p.117 no.10, at the BRITISH MUSEUM. LONDON; p.36 no.12, p.64 no.10, p.91 no.12, p.93 no.17, p.96 nos.24 & 25 at the TATE GALLERY. LONDON; p.16 no.15, p.19 no.23, p.34 nos.5 & 7, p.35 no.8, p.37 no.13, p.61 no.1, p.62 no.5, p.63 no.7, p.64 no.9, p.67 no.18, p.69 no.20, p.113 no.2, p.116 no.7, p.118 nos.11 & 12, p.121 no.19, p.122 no.25 at the VICTORIA & ALBERT MUSEUM. LONDON; p.13 no.7, p.16 no.16, p.17 no.17, p.36 no.11, p.63 no.8, p.87 no.1, p.89 no.6, p.120 nos.16–18, p.121 no.20, at the VICTORIA & ALBERT LIBRARY;

PRUDENCE CUMMINGS photographed p.69 no.22 at the ARTS COUNCIL;

ROGER FLETCHER photographed p.52 no.61, p.86 no.72, p.130 nos.3–5, p.131 no.9, p.133 no.13, p.134 no.15, p.135 no.17, p.140 nos.30–32;

BOB KOMAR photographed p.17 no.19, all p.18, 20–31, p.35 no.9, p.36 no.10, p.41 no.24, all pp.42–51, p.52 no.60, all p.53, p.54 nos.65, 67, 68, all pp.55–58, p.65 no.14, p.70 no.25, all pp.71–73, p.74 nos.34 & 36, all pp.75–82, p.89 no.7, p.90 no.10, all p.92, p.97 no.28, all pp.98–108, all p.110, p.119 no.15, p.123 nos.26 & 27, p.125 no.31, p.127 no.35, p.128 no.38, p.129, Front Cover & all on back cover except middle picture.

The diagrams and cut-away illustrations throughout the book are by Len Huxter